Past, Present, East and West

Past, Present, East and West

Sherman E. Lee

George Braziller • New York

Acknowledgments

The following articles are reprinted with the kind permission of the original publishers: "The Idea of an Art Museum" from *The American Review*, vol. 13, no. 3 (April 1969), pp. 56–61; "The Art Museum in Today's Society," from *Bulletin of The Dayton Art Institute*, vol. 27, no. 3 (March 1969), pp. 2–6; "Eye Object," from *Art News*, vol. 71, no. 7 (November 1972), pp. 36–37; "Art Against Things," the Art Association of Australia, Sydney, 1976; "Art Museums and Education," from *Art International*, vol. 21, no. 1 (1977), pp. 48–51; "Life, Liberty, and the Pursuit of . . . What?" from *College Art Journal*, vol. 37, no. 4 (Summer 1978), pp. 322–326; "The Illustrative and Landscape Watercolors of Charles Demuth," from *Art Quarterly*, vol. 5, no. 2 (Spring 1942), pp. 158–176; "Contrasts in Chinese and Japanese Art," from *Journal of Aesthetics and Art Criticism*, vol. 21, no. 1 (Fall 1962), pp. 3–12; "The Water and the Moon in Chinese and Modern Painting," from *Art International*, vol. 14, no. 1 (20 January 1970), pp. 47–59; "Zen in Art: Art in Zen," from *The Bulletin of The Cleveland Museum of Art,* vol. 59, no. 9 (November 1972), pp. 237–259; "Early Ming Painting at the Imperial Court," from *The Bulletin of The Cleveland Museum of Art,* vol. 62, no. 8 (October 1975), pp. 241–259; "Quality in Painting," from *Quality: Its Image in the Arts*, edited by Louis Kronenberger, New York, Atheneum, 1969, pp. 115–145.

Published in the United States
of America in 1983 by George Braziller, Inc.

Library of Congress Cataloging in Publication Data

Lee, Sherman E.
 Past, present, East and West.

 A collection of previously published articles.
 "Sherman E. Lee, a bibliography from 1941-1982,
compiled by Georgina Gy. Toth": p.
 Includes bibliographical references and index.
 1. Art museums—Addresses, essays, lectures.
2. Art—Addresses, essays, lectures. I. Title.
N410.L43 1983 069'.97 83-2559
ISBN 0-8076-1064-X

Printed in the United States of America
First Printing

Designed by Lorraine Wild

Contents

Introductory Note

Ideally, the director of a major art museum should be an art historian, a connoisseur, an administrator, and a diplomat. He should be able to recognize broadly based criteria of excellence in all fields while especially appreciating values specific to a particular culture. He must allow for critical nuances when determining which works among the many urged for acquisition by his curators are most important for his museum's collections. In short, he must constantly judge apples against oranges (as well as peaches and plums) and determine which is the better of its kind and which is most needed. He must have the requirements of the entire collections constantly in mind, but not allow the rare masterpiece to elude him.

He should be a keen judge of ability and character in others and place staff members where they can work to the museum's best advantage. He must be capable of convincing others to accept his decisions while refraining from peremptory demands. He must maintain a compatible relationship with trustees, staff, colleagues, and public. He should adhere to high ethical principles, establish reasonable priorities, know when to stand firm and when to judge that the end does justify compromise.

All his thoughts and actions should be guided by well-conceived convictions about the nature of art and art museums. He must be aware that he and his institution are accountable to connoisseurship and scholarship, both present and future, and that he is also responsible to the general public. At the same time, he must discern the distinction between education and entertainment.

The ideal director of an art museum is indeed a man for all seasons, and there are precious few. The following essays demonstrate that Sherman Lee is one of them. It has been an education, a privilege, and a pleasure to have worked with him for more than thirty years.

We are grateful to the original copyright holders in each instance for permission to reprint the articles and essays gathered here. The texts are complete as originally published, but some original illustrations have been omitted because they were unavailable or for lack of space. Footnotes appear at the back of the book. Thanks are due Eleanor Scheifele, who assembled the illustrations, and Georgina Toth, who compiled the bibliography.

Edward B. Henning
Cleveland, Ohio, 1982

Preface

A writer in *Time* magazine (16 September 1966) once referred
to The Cleveland Museum of Art as an "aristocrat" among museums. But Sherman
E. Lee, then its director, in an address of later years spoke rather of "elitism,"
defending the word and its meaning from its detractors. The word "aristocracy," let
us note in passing, is to be distinguished from the word "noble," associated with
the Old Régime. As a Balzac character put it in his novel *Ursule Mirouet*, there are
no nobles, there are only aristocrats. And in the sense Balzac meant it, the aristo-
crats of today are less likely to be institutions such as museums, or their directors
and curators, than their boards of trustees, since they are associated with the
money necessary to maintain and augment the holdings of museums. Today, one
hundred fifty years after Balzac, a neo-Hegelian might put it otherwise: art is dead,
there are only museums. Contemporary art and artists notwithstanding, he could
make an excellent case defending this historical-philosophical opinion. It was a
thought not far from the opinions of Quatremère de Quincy, sculptor turned anti-
quarian and perpetual secretary of the reformed Academy of Painting and Sculpture
now turned into the Classe des Beaux-Arts of the Institut. Contemporary of the
painter J. L. David as well as of Hegel, Quatremère saw the status and role of the
arts transformed in the course of the French Revolution and the new bourgeois
and secular society which was taking form in the early decades of the nineteenth
century. Quatremère did not like museums; he knew they were the signs of a radical
change in the role and function of art in the new society. Today's directors of mu-
seums, though living in different times in which museums are well-established
institutions, often prestigious, and, indeed, often establishment institutions,
nevertheless must face some of the same problems which Quatremère first perceived.

These allusions to Balzac, Hegel, and Quatremère are thus neither farfetched
nor out of place in a preface of essays by the former director of a prestigious mu-
seum. For the problems of museums today are much the same as the problems
of art in our society which took form in the early nineteenth century to develop into
its two extreme, complementary, contemporary forms, the United States and the
USSR, the two powers which, as Napoleon had foreseen, would dominate the
future. Had Quatremère been asked to write this preface, he undoubtedly would
have evoked the question of materialism as he understood it, namely, to consider art
as luxury objects to be carefully preserved, or objects of rarity and therefore of
high price, or else regard them as an aspect of fashion, and even commission works
only to put them in museums. The questions for directors today are not so differ-
ent. Indeed, any director of an art museum in the United States today will find
him- or herself in an historically unique situation which is inseparable from the

larger question of "art" in our society. This particular situation arose out of the historical conditions of "art" in the American Republic.

One should not forget that James Jackson Jarves, the first American art historian, as the first American aesthetician, but also the first American collector of Italian primitives, could not sell his collection and had to give it away. His taste was, as Edith Wharton put it in the title of her novel based on his life, a "False Dawn." Art as Jarves understood it, as linked to religion, history, and explained on the basis of philosophical idealism, was, when he gave away his collection, still something essentially foreign to Americans. Landscapes and portraits may have been understood to be art, or painting, but madonnas and saints, and primitive at that, often naive in appearance, could hardly be such. But Americans are extremists and by 1900 Jarves's *Art Thoughts* and the *Art Idea* had taken hold and there was, even in the land of J. P. Morgan and Teddy Roosevelt, a veritable cult of art which, though justified on the basis of idealism, nevertheless took a particularly American and bourgeois form of appreciating art; as an energetic, aggressive, worldwide drive to acquire Art, damn the cost. This particular bent was so pronounced it was noticed by European novelists and Henry James who, when he visited the United States, considered that acquisition, more than any other consideration, was the driving force behind the foundation of the brand new Metropolitan Museum of Art in New York. Art was acquiring all the best things, *all* the best things.

However, this gluttony was also masked by something equally in the American grain, to wit, a contrary virtue. For those who accumulated and acquired also generously endowed, founded museums because other men and women had told them that art possessed a moral dimension and purpose and was thereby of inestimable educational value. The founders of American museums were like Henry James's Mr. Verver, who loved art and collecting but also thought of leaving his collection as a monument to himself and a gracious gift to the community. This emphasis on the moral purpose and educational value of art was also inherited. It too, like art, was a foreign importation, in this case British, and as such it fell on fertile ground. Jarves collected not only Italian primitives but also John Ruskin's ideas on art; for he had met Ruskin and remained his friend. Another friend of Ruskin, Charles Eliot Norton, would be the first professor of art in the United States, at Harvard. When one considers that at the same time, after the Civil War to the period of about 1900, art history was also taught by reverends, that is, doctors of divinity who sometimes confused or conflated art and religion—easy to do as disciples of Ruskin—one can readily see the peculiar nature of the problematics of "Art" in the United States.

By 1900 Americans had become art-conscious as probably no one else. Paul Bourget, a French novelist and excellent observer of the cosmopolitan set which also coincided in many respects with the art set, and certainly the collecting set, since collecting was done abroad, came to the United States in 1903 and found that among Americans the eye was their most developed sense. He too was struck

by the magnificence of the accumulated treasures in the villas of Newport and elsewhere, and admitted readily that over the past thirty or forty years, that is from about 1870 onwards, the Americans had picked the best from all parts of the world. Present directors, curators, art historians, and art educators might find Bourget's judgment about the American eye curious and might even doubt it. But they are probably wrong. There are few countries in which visual education is as developed as in this country. Whether what is learned in schools or museums is carried over into the public domain or the "American scene," to borrow from James, is another matter, which has to do with building codes, commercialism, and democracy. But complaints about the status of art in the United States are unfounded and may be due to a lingering and unfounded complex of cultural inferiority. Indeed, it may well be that, funding aside, the troubles or problems of museums and their directors may stem not so much from the lack of status of art in the United States, as from overenthusiasm for art and erroneous expectations as to what art can or is supposed to do for individuals and society.

These very American tendencies toward gluttonous acquisition and virtuous justification for art are still with us. Museums make coups on the art market as financiers make killings on "the Street" or at the Bourse. But museums also offer art education courses, while there is probably no other country in the world in which there are as many art history courses given in colleges or universities as in this country. The educational effort goes toward the explanation of that strange phenomenon, and that curious existence, Art, and interest in Art. Art needs explaining; for the United States from its very beginnings as a society was an artless society, because it was Puritan first, more than High Church; Republican, rather than monarchical; Roman more than Greek, despite the Greek revival; bourgeois more than noble; neoclassic more than baroque; managerial more than princely. In bustling, dynamic, expanding, productive, aggressive America there was indeed very little place for art or artists, or even gentlemen, as Ned Rosier, one of Henry James's characters understood. Fortunately there were women, and while the men made the money, the women were left to become interested in "Art." Thus, in contrast to the preindustrial societies of the past regimes, art in the United States found its first "natural habitat" precisely where Quatremère thought it to be "unnatural," the museum. To be sure, the millionaires who had impressed Bourget had filled their Newport and Fifth Avenue mansions with art, but these mansions were themselves museumlike in that they were imitations of former architectural styles also associated with "Art." In the past, art had been inseparable from the church, the palace, the town house, the villa, the garden, or the piazza. In the United States it was inseparable from the museum. From this peculiarly American association of art, museums, and art education comes the concomitant fervor and near-religious aura about art, and by extension old religious questions are posed as aesthetic questions: the definition of art, the relation of art to society, the corruption of art by money, the artist and integrity, and even art as a species of possible salvation. This is not

to say that there are no aesthetes in Europe or the East, but merely that thanks to the intensity of art education in this country, Americans still pose themselves such questions today, still tend to think of art in moral or aesthetic terms rather than historically.

This situation of art in our society and the role assigned museums poses particular questions for directors of American museums. Museums are sometimes asked to be something they are not; they are confused with art centers. In Europe and the East museums are repositories of the national patrimony and directors and curators are perhaps more likely to be accepted as conservators than here, where directors especially have also to be other things, often contradictory. In short, they are pulled by the contradictory forces at work in a bourgeois and democratic society. Lee, trained as an art historian in the United States and associated for some years with one of the founders of art education in the United States, the late Thomas Munro who, like his predecessors Jarves and Norton, was also an aesthetician and long-time editor of the *Journal of Aesthetics and Art Criticism*, inherited as director of The Cleveland Museum of Art all the character traits which we have outlined as particular to the American historical situation and which a Marxist might amusingly call the internal contradictions of bourgeois aesthetics in its hypercritical American state.

Yet, being also a scholar of Chinese art and civilization, Lee managed, in thought and deed, directorship and scholarship, to steer an appropriately Confucian middle way between the extremes of the American situation. This was no mean feat. As director he had to acquire, and he did: not à la Morgan, but ever with discretion and exquisite taste. The driving force was not acquisition for its own sake but the construction of a collection with scholarly as well as aesthetic dimensions. As director he had to allow the existing art education department to educate; and he did, but never to excess. As a director in the age of business schools and cost accounting, he had to allow a sales desk; and he did, but it remained remarkably limited and was never allowed to expand into a museum wing. And though the Chinese scholars he admired like their food and drink, The Cleveland Museum of Art never expanded into the restaurant business.

Choosing the middle way was not to choose the easy way, nor the narrow path. It implied, indeed, fencing on two fronts, left and right. One is tempted here to speak of Japanese swordplay. We are used, from Japanese films, to associate the swift flashing and slashing of samurai swords with hissing, shouting, and gushing of blood. But there are no severed heads, limbs, or bodies along the middle way. The adversaries left and right of the way have been kept at a distance by the tip of the foil. The adversaries are the two polar attitudes which dominate the philosophy of art and museums, historically given attitudes taking new forms in the course of time, but ever the same: money and moral utilitarianism, which meant in the past, art as acquisition or art as education, and which mean today, consumerism

and communitarianism. The man in the middle asks himself questions concerning democratic liberties and true values, the relation of art to mere things, the place of education in museums, but also the role of art in a word- and thing-oriented society. These are new versions of old questions already posed by Jarves and Norton and others, old questions still very much with us.

Now the fencing necessary to maintain the middle way is not, doctrinally speaking, a metaphor for aestheticism. This is one possible answer to what Charles Eliot Norton saw as the American predicament over art, a predicament he summed up in one telling phrase ever expounded to his students, "the horrible vulgarity of it all," his reference to powerful, energetic, expanding, bustling America. James's characters tended to flee to something called "culture," presumably to be found in Europe. It was the Jamesian version of Proust's Guermantes way. But after a few years Proust and his narrator Marcel saw through it all. The aesthete might build an ivory tower; but the aesthete does not fence, though he might, verbally, as an *amuseur* in the salons of the rich which he pretends to despise, all the while envying them. Fencing to maintain a middle way implies something far rarer than aestheticism: it implies aesthetic action. This is something closer to the late seventeenth- and eighteenth-century gentleman and man of taste than to the aesthetes of the late nineteenth century.

Aestheticism in 1900 meant marking one's distance from the community, from others; it meant, ultimately, snobbism, not elitism. No museum director in the United States can mark his distance from the community in a manner which shows disdain, or contempt, or snobbism. Fencing for the middle way meant, then, the exercise of taste as aesthetic judgment, choice, and action based on a consensus of other men of taste, itself ultimately based on tradition and history. The man who would oppose both the marketing mentality and vulgar Marxism is the *true* conservative, as any museum director ought to be, since museums by definition conserve. We emphasize the word *true*, for the land is filled with false conservatives who are simply radicals without knowing it. The true conservative stance accepts the contemporary world and its art, but judges it within the dimensions of history and the art also produced in the past which, let us not forget, is still present; the conservative accepts education, but not without scepticism; the conservative accepts as givens the conditions in which he must live and work in the present, but without surrendering to the unacceptable. In the context of museums, this means a refusal to turn them into what they were never meant to be or cannot be.

This conservatism as sense of history, as a keen sense of the *durée* in the realm of art, is one of the more interesting aspects of Lee's thinking on museums and art. It informed his policies as director as it informs his scholarship. This sense of history, of the continuity of the past into the present, indeed, of the presence of the past in the present, sets him apart from the all-too-usual critics, commentators, and even art historians for whom the past is merely their area of specialization. It

also distinguishes him from aestheticians who try to define art in the abstract. The middle way rests on historical knowledge, historical perspective, and to maintain this way is no easy task in a world dominated by instant "isms," a variety of ideologies which find their way into aesthetics and criticism, and art movements which turn over as rapidly as fashions so that they take on the aspect of seasons. Sometimes the way chosen seems a rearguard action.

As concerns Lee, this is as it should be. For his position as an aesthetic, that is, neither that of an aesthete nor an aesthetician, is par excellence the position of a disinterested man of taste informed by knowledge and history. It is not a partisan position. The middle way is that of the scholar in a world more and more utilitarian, more and more commercial, and more and more given to a criticism of catchwords, catchphrases, and "in" doctrines. It is a difficult position to maintain because the work of art must be regarded neither as document nor as mere object of sense and enjoyment. The work of art is neither a document nor a bibelot. It is precisely between these extremes, and it is precisely this distinction which also illuminates Lee's approach to art as a scholar.

Thus as regards the discipline of art history, taught in universities and colleges, Lee's middle way is not without fruitful lessons. It implies not losing the sense of the concrete, of the object itself, of the work which is regarded ever as a work of art, not something else, such as document or a pretext for a discourse in another medium. This emphasis may seem obvious, but it is not. For art history is taught with slides, which are substitutes, and unsatisfactory ones at that, so that the discourse of art history is at two, sometimes three removes from the object of discourse. And art history, being discourse upon slides projected in a darkened enclosed space with a captive audience, is like literary analysis all too often subject to abstraction and what Gilson called the imperialism of language.

The problem of the relation of words to pictures, words to objects, discourse to art is a constant preoccupation with Lee. For him art is above all visual art. It is a position easy to understand for a man who exercises his action and thought in a museum. But as a student of Chinese painting, he also has come to consider the relation of art to literature in a rather novel way in our world of overspecialization. Art is on an equal level with literature, and so art history deserves to be an integral part of any humanities program of studies. One ought to expect this from a man well acquainted with the literati painters of the Ming Dynasty. Whether compartmentalized professors in universities could teach up to the level of that ideal is another question. It is the ideal of a man of taste, of the amateur in the best sense of the word, of the virtuoso as Shaftesbury understood the term at the end of the seventeenth century. What is certain is that art has an enormous source of information to offer to literature, as well as to history, philosophy, and the study of religions. Yet, it is possible that in his emphasis on the image as against the word, in what appears as a defensive position vis-à-vis the word, Lee perhaps overstates the

case; for the dangers to the image come not from the word as such, but from new forces which relegate both visual art and literature to mere monuments of past civilizations, on an equal basis in museum and library. The danger to the image and the visual arts stems not from literature, but autonomous discourse in the form of the journalistic word, media chatter, ideological discourse, and pervasive consumerism. The middle way remains the difficult way even in the supposed grove of academe. But then, to return to our speculation concerning a rearguard action, these are often noble ideals, and as a student of Japanese civilization Lee surely knows about the nobility of failure.

The essays which follow are occasional pieces: addresses, bulletin articles, articles for art journals. We reprint them here not only as homage to a great museum director, scholar, and friend, but more importantly, perhaps, because what is said in the part of this book concerning museums and art in today's world is worth repeating and recalling. The fencing must go on. Museums, art, letters are never safe, ought perhaps never be safe, and must ever maintain their positions.

As for the essays in the second section, these deal with problems of art history rather than museums. We have chosen them because they represent, at least to our view, Lee's wide-ranging interest and expertise, his taste, and also his *tour d'esprit*, or if you will his particular bent or turn of mind when dealing with such problems. We have chosen these out of many published in a variety of journals because, although they are occasional pieces and so not always apt to add up to a book, these concern general subjects which can be of interest not so much to the specialist as to that elusive character also engaged in a rearguard action, the general reader. These articles are models of Lee's particular way of writing art history, which in a museum must be different from what issues forth from universities. They are distinguished by a close scrutiny of image and object with a thorough knowledge of their historical background, as well as an acute awareness of the limits of historical discourse. They are based on aesthetic as well as historical appreciation. They range from comparisons of art East and West to contrasts of Chinese and Japanese art. But it is also obvious that even in these articles the preoccupations discerned in the various addresses on museums, education, and the contemporary world, are also evident in the author's asides and in the way questions are posed, so that we are once more at the beginning: art as a middle way, defined by the refusal to separate the eye from the word, the eye from the mind, and sensibility from sense.

Rémy G. Saisselin
Rochester, New York, 1982

Foreword

Museum directors, more than other people, ought to think hard and often about what they are doing and why. Most don't. Sherman Lee does, and the result is a superb museum and some penetrating papers. Both by example and by argument, he has made his views on museums so clear and convincing that nothing more is needed to strengthen his case, or would be likely to lessen the widespread and stubborn opposition to it.

Underlying his views is a deep and constant concern with the interrelationship between art and ideas. Here he has had to overcome the double drawback of being a museum director and an art historian; for while museums and art history do not always work against both art and ideas, they tend to frown on any intercourse between the two. Lee insists that art and ideas belong together, and examines how they should interact.

That is not easy. In a key passage, he writes:

> *The art museum is not fundamentally concerned with therapy, illustrating history, social action, entertainment or scientific research. . . . The museum . . . is a* primary source *of wonder and delight for mind and heart. In this, the art museum is comparable to a permanent storage battery, or to a library of original manuscripts.*

The accent on delight might be taken as an endorsement of what I have called the "tingle-immersion" theory of art, were the delight not specified to be of the *mind* as well as of the heart, or if the art museum were not so improbably compared both to a battery and to a library of manuscripts. Here Lee, after stressing what a museum is not, uses startling similes to suggest what a museum is.

Later he zeroes in on a virulent confusion. So long as education is taken to be entirely verbal, the main function of a museum is not educational; but in the "world of visual images," he contends, the museum is the chief instrument of education; and "the original worth of visual images" must be "reincorporated into a basic concept of education as the transmission of *all* knowledge." We cannot tolerate "the submission of vision to literacy."

Education, indeed, cannot be exclusively verbal in either its ends or its means; for it consists not merely of adding to knowledge—to true beliefs—but of the overall advancement of understanding. And understanding a painting, for example, involves discerning its special stylistic and other visual properties—learning how to see it and to see in terms of it. Such learning is as inquisitive, as cognitive, a process as grasping a mathematical theorem or a scientific concept, but it cannot be reduced to or induced by words alone. It requires accessibility of works, pointed

juxtapositions for comparison and contrast, everything that encourages hard looking and aids intelligent seeing. Of course words can help too; words may illuminate pictures as pictures may illuminate words. Neither the verbal nor the nonverbal gives way to the other; they both participate in the growth of understanding, and interact as equals.

Just this conviction that art is not for passive absorption but for active visual inquiry, that understanding pictures means grasping ideas (albeit nonverbal ideas), and that painting and literature and science are allies rather than enemies, might have been partly responsible for Sherman Lee's special interest in oriental art, the subject of all but two of the papers in the second part of this book. For in the first place, the westerner usually finds that with oriental works his problem of understanding is more insistently present and his processes thus more open to observation than with most works of his own culture. And in the second place, the Orient has a venerable tradition of intimate association among artists and writers and scholars, among painting and poetry and learning and thinking of all kinds. And one might conjecture that Sherman Lee's lack of interest in American Indian and other primitive arts may be partly due to their having no such background, though he would surely agree that they likewise demand thoughtful seeing.

The reader of these papers will be stimulated, informed, enlightened, and sometimes astonished. On reading that Japanese art exaggerates some features of Chinese art, he may wonder whether such "exaggeration" might not rather be described as a shift in emphasis prophetic of some important developments in modern western art; but one disputes Sherman Lee with trepidation. Consider, for example, his paper on Demuth's illustrational watercolors. Written at the age of twenty-four, this perceptive and thorough study sometimes reads a little like a document supporting an earnest application for entry into the establishment of art historians, but it must have shocked many of them by the opening pronouncement that Marin and Demuth are the greatest American watercolorists—a fair enough judgment now, but hardly orthodox in 1942. In those days, you could get a basketful of Demuths for a single Homer.

The Cleveland Museum and these essays on various arts serve surpassingly well their common end: to better the understanding of the works in question, to make these works work.

Nelson Goodman
Cambridge, Massachusetts, 1982

PART I: Art, Museums, and Collecting

The Idea of an Art Museum

This essay originally appeared in The American Review, *volume 13, no. 3 (April 1969). While attitudes towards museums and about museums change, Lee's thoughts mark him as a conservative in the true sense of the word, and as an articulate and influential thinker on the subject.*

I am not overfond of museums. Many of them are admirable, none are delightful. Delight has little to do with the principles of classification, conservation, and public utility, clear and reasonable though these may be.

Paul Valéry's words are, on the whole, just; they recognize that the art museum is with us, that is has a raison d'être, that it can be admirable, that a major gift of art is delight. I could not ask for more.

Modern usage of the term "art museum" seems to me a blanket covering a multitude of huddled shapes—some vague, others with a more definite topography, all overlaid with fuzzy rationalizations.

In one city, art museum may really mean community art center, an institution dedicated to participation in the arts. The arts, in this case, might be an ill-defined complex ranging in activity from puppets and modelling in clay to painting (as distinct from paintings) and the performing arts.

Another city may envision an art museum as a hall of temporary exhibitions, a mirror of the available arts of the day—Picasso and Wyeth, creative photography and good design. This pragmatic acceptance of the art museum as a "good thing," this often frantic activity, hardly provides the proper environment for observation, thought, and choice of direction.

The evaluation of the historic position of the art museum in our modern society is often lost in the shuffle of doing; or, worse, deliberately avoided in the daily pressures of economic necessity and the peripheral demands of various segments of society that use art for their own, not always unselfish, purposes. In view of this confusion and despite the temptation to "let one thousand flowers bloom," I should like to examine the idea of an art museum.

The word "museum," coming from a Greek word meaning a place connected with the Muses, and hence with the arts, gives comfort to the advocates of multiplicity. But the word "art" gives us pause. Originally connoting skill—the art of painting, the art of war—the word came to encompass the products of skill and, more importantly, of visual imagination.

Later still, just before and during the Renaissance, art was construed to apply especially to painting and sculpture, to a higher, finer art than that produced merely by skill. (Such a hierarchy had already been anticipated by the Chinese in their escalating classification of painters into skillful, wonderful, and divine; and in their castigation of the lowly artisan, including the sculptor.)

From this particular development arose the concept of the art gallery as a museum of pictures alone, and of the museum of fine arts, for painting and sculpture. This view seemed more and more parochial as the horizon of the Occidental historian widened to include the Middle Ages, the Orient, and finally what we call primitive man, for whom easel paintings or the figure in the round were simply not accepted vehicles of artistic expression. Clearly a broader foundation for art, including both what had been called fine art and minor art, had to be established.

In the twentieth century numerous writers have stressed the formal visual values of art as underlying all its manifestations. Clive Bell's "significant form" and Berenson's "tactile values" are but two of many examples. It remained for Henri Focillon, the great medievalist, most movingly and poetically to express this view on a solid base of historical knowledge and to welcome the values largely neglected by others.

Focillon believed that the artist—whether sculptor, painter, potter, or goldsmith—thought, felt, imagined, and above all worked in forms. Words for the writer and sounds for the musician, but forms for the artist.

Let us return to the Western museum before 1900. Begun in the sixteenth century as a *Wunderkammer* in the North or an *Antiquarium* or *Galleria* in the South, it developed, for example, into the National Gallery of London, for pictures only, and the Louvre, a general museum of art and what were called antiquities. But London and Paris were, with other centers, dedicated to the preservation and display of worthy art of the past. The museums were used by educators as *sources;* for original experience before original works of art, for schooling in technique, for the study of art history or iconology.

It was the Victoria and Albert, founded by the Prince Consort as a museum to further the industries and crafts of England, that first fully embodied the concept of the museum as an educational institution with the works themselves as a *means* of public education. The concept was particularly amenable to the rising American sense of democratic education, and by the mid-twentieth century the art museum has come to flourish as a center of art education for the community.

Since the Second World War this use of works of art as a means of achieving the good life has often been assumed to be the primary function of the art museum. Indeed, the educational programs of our museums have been much admired by some foreign visitors and their precepts carried back to the Old World—not, by any means, to meet with wholehearted acceptance.

* * * *

Today we are confronted with two radically differing and currently irreconcilable museum philosophies. One is summarized with appalling simplicity by Theodore Low in his wartime study, *The Museum as a Social Instrument*:

> *In short, they {men today} recognize that the* only real *justification for the existence of a museum lies in its degree of usefulness to society as a whole.*

We have all seen this museum before; at the end of its long and narrow gallery hangs an enormous canvas covered with bulging muscles and heroically stern eyes. The title is interchangeable: "The Party," "The Heroic Working Class," or "The Master Race."

A more subtle variation of this concept, derived from Alexander Dorner, is given by Samuel Cauman in *The Living Museum* (1958). Cauman sees the art museum as an instrument of evolution "to assist in the transformation of society by the creative energies of our moment in time."

This echo of the Bauhaus, a proper one for a school or institute, continues:

> *The living museum holds our past and present together, not by imposing the past upon the present, but by showing its relation to the present. The new movements are seen as the leading edge of change; older works are seen as traces of the transforming process of the other days.*

Opposed to what they consider a "mythology" of ancient art, Dorner and Cauman wish to replace myth with science. As science progresses, new discoveries, new theories *supersede* old ones; today's science is condemned to obsolescence. And so it is, they say, with art.

The second theory, by no means a new and progressive one, was summarized in 1918 by Benjamin Ives Gilman in his *Museum Ideals of Purpose and Method*. (It is not without grim significance that he is not mentioned by Cauman, nor is the book listed in Low's bibliography.) Gilman's formula is quite plainly summarized:

> *While museums of other kinds are at bottom educational institutions, a museum of fine art is not didactic but aesthetic in primary purpose . . . {the} conception of an art museum is not that of an educational institution having art for its teaching material, but that of an artistic institution with educational uses and demands.*

Such a formulation recognizes that art and science are neither antagonistic nor at all the same thing. It recognizes that progress or evolution in science is paralleled by progress or evolution in the techniques or means of organizing works of art. However, as art—as meaning in form—its qualities may change, but Sung painting, Phidias, or Gislebertus are *not* superseded and obsolete.

I follow Gilman. The art museum has three major functions—preservation, exhibition, research and education. These are the assigned roles of the art museum

in modern society. To this, except for a few fortunate institutions, is added the role of an indigent, marginal suitor for private or public funds.

If the art museum is to be a force, whether an obvious or a subtle one, it must take a lesson from the art of war: the numerically inferior army does not disperse its limited powers, but by husbanding its resources and concentrating its blows makes its presence felt. And this presence is a visual one, not so much supported as confused by the simultaneous use of the sounds of Muzak or the words of Acousti-guide.

It is poetic justice that the rise of the art museum parallels that of industrialization. One can almost conceive of the art museum as a guilt-offering by industrial society, a place to preserve what is threatened with destruction. The first assigned function of the art museum is to preserve; its curators are keepers. And it is precisely because this preservation function may be an unconscious expression of guilt for the destruction of art that this function is nearer to the truth of the museum than the more conscious justifications of education, encouragement of the arts, and research.

These are all worthy, of course, but certainly they are secondary. Preservation is the basic need both for the present and for posterity. One cannot have the remotest idea of what Rembrandt is all about unless one can see a Rembrandt painting in reasonably good condition—in brief, well preserved.

Once we admit the precedence of preservation, we are largely committed to the past. The argument that this concept of the museum is unworthy of "the living present" is the argument of those who are antihistorical, who fancy opinion over tradition and historically constructed taste, of fashion over style, of news over history. If man is the sum of his past and thinks he makes his present preferable to his past, then it is just the past that needs preserving.

But preserve what? In an art museum, art: those products of the visual imagination that the history of taste has established as art—whether a Chinese painting or a Vincennes porcelain. We have our exalted *and* selective idea of the art of the past precisely because we see it filtered through the taste of generations of connoisseurs.

Anyone familiar with the dregs of the art market or of the storage rooms of old repositories knows how dreary the nonart past can be. As Hume noted in *On the Standard of Taste*,

> *The same Homer, who pleased at Athens and Rome two thousand years ago, is still admired at Paris and London. All the changes of climate, government, religion, and language have not been able to obscure his glory. Authority or prejudice may give a temporary vogue to a bad poet or orator; but his reputation will never be durable or general.*

We preserve art by acquisition and selection, by rejection and deletion, by science and by taste. I cannot here go into the complex politics of acquisition by purchase

or by gift. One aspect of preservation, however, may be of special significance, that of conservation, or more rudely, the care, cleaning, and restoration of works of art. This involves a distinction between the primary function of an art museum— the preservation of the artist's image—and the secondary consideration of the work of art as a physical object in the world of things.

A continuing and bitter controversy over the cleaning of pictures in the National Gallery in London has pointed up the problem. (I am not concerned here with controversies about particular pictures.) The more articulate complainers about "cleaned" pictures cite the importance of the painting as image, while the defenders build their defence about the painting as a physical thing.

But no painting today is the thing it was originally. It changes from year to year, decade to decade, in itself. The carmines are often fugitive, the greens blacken, glazes of thin color are abraded by too assiduous butlers.

It is pointless to reconstitute a painting or preserve it in a present falsity. As an image, not a thing, it can never be quite the image it was at its origin, but, considered as a visual image rather than as a combination of chemicals, it can be a work of art. The preservation of the image can only be achieved by a combination of taste, respect, and sympathy with physical or chemical science. What must be left on the canvas is not just the pigments, each in its best present condition, but a moving and unified work of art.

Such a crucial and subtle problem is a vital concern of a true art museum. It cannot be solved by hasty or dilatory gestures sandwiched between frenetic peripheral activities.

The works preserved should be exhibited. They were made for the delectation of a beholder. Again, there can be no halfway measures for the art museum. Exhibition means that the individual work may be seen in a sympathetic environment and that by the juxtaposition of numerous works of art, one may evaluate, discern, and compare.

In the development of taste, comparison is the imperative means. Special exhibitions of works borrowed from afar and exposed to injury by travel or change of environment are justifiable only if the comparisons they allow are meaningful and contribute to more than local knowledge. The exhibition as theater, in which defenseless pictures become part of a jazzed-up dumb show, the exhibition à la mode, the exhibition of art as a history of things, or the documentation of history by an unselective juxtaposition of inferior and superior works of art—all are confusions of the value of works of art.

And what of contemporary art, the art of our own generation? Where does it fit into this idea of an art *museum*, rather than an art *center* or *institute?*

In a sense—and not in any way a derogatory one—contemporary art has not yet

been evaluated by taste. As we all know from reading newspapers or art news magazines, it is very much of the marketplace. Some publications even carry a page of current quotations in the art "bourse." We would all love to be right in such a marketplace. But immediate judgments are hardly necessary since contemporary works are not usually in grave danger of destruction, and the support of the contemporary artist should come from the healthy patronage of his contemporaries.

The art museum must acquire and show, within reason, works of contemporary art. Special exhibitions are a legitimate function of the art museum today, a function previously performed by salons, academies, and special splinter-groups.

But, again, the exercise of selective judgment is essential. The museum should have the courage to represent an honorably chosen position and to judge. Such an attitude is commonly accepted in literary and musical criticism. If art museums do not show all the works of art that ever existed—i.e., history rather than taste— they would be even more wrong to show what is news, that is, merely report on the current state of all art activity.

The idea of an art museum may not be exciting in the current usage of that word. But it is one that remains true to the idea of art as images worth preserving. It makes of the museum a living source of original visual knowledge, available to all. It accepts the occasional need for dilution, but it rejects adulteration. And it ensures, so long as it is possible of preservation, that the still living art of the immediate and distant past will remain visible.

The Art Museum in Today's Society

This essay was given as the keynote address at the celebration of the fiftieth anniversary of The Dayton Art Institute on 28 February 1969, and subsequently published in The Institute's Bulletin, *volume 27, no. 3 (March 1969).*

One could begin with the Lamentations of Jeremiah:

The adversary hath spread out his hand upon all her pleasant things: for she hath seen that the heathen entered into her sanctuary, whom Thou didst command that they should not enter into Thy congregation.

All her people sigh, they seek bread; they have given their pleasant things for meat to relieve the soul: See, O Lord, and consider; for I am become vile. (1:10, 11)

But then there are other catastrophes nearer to hand. The director of The Museum of Contemporary Art in Chicago, Jan van der Marck, can write about the current "packaging" of his museum by Christo,

With the whole idea of a modern museum and its usefulness somewhat {sic.} up for grabs, Christo's packaged monument succeeds in parodying all the associations a museum evokes: a mausoleum, a repository for precious contents, an intent to "wrap up" all of art history.[1]

Clearly Tinguely's self-destroying sculptures have had their day to be replaced by cheerfully self-exploding museum directors.

Or we can cite an even more famous and ultimately more sinister happening in an art museum in today's society, *Harlem on {His} Mind* with its extraordinary accompanying comments by The Metropolitan Museum's director, Thomas Hoving.

This exhibition is an unusual event, particularly at The Metropolitan Museum of Art. Some people will see it, read it and listen to it, and their lives and minds and bodies {!} will change for the better. Others will reject it and criticize the wisdom of indeed having such a show at The Metropolitan. Why not strict art? They will cry out; why not have this environmental and overall cultural show at some armory or some other place? Some will wield the word political *at the show and attempt to bludgeon it. . . .*

We have this remarkable show because the city and country need it. We put it on because this great cultural institution is indeed a crusading force attempting to enhance the quality of our life and to support and buttress and confirm the deep and abiding importance of humanism. Harlem on My Mind *is humanism.*[2]

Thus the catalog introduction: and then the current *Bulletin*.

> *"Practical life" in this day can mean nothing less than involvement, an active and thoughtful participation in the events of our time. For too long museums have drifted passively away from the center of things, out to the periphery where they play an often brilliant but usually tangential role in the multiple lives of the nation.*[3]

Clearly there are philosophical and logical problems, as well as semantic ones, posed by these words. "Confrontation" occurs in Mr. Hoving's text: and this currently fashionable word is symbolic of the whole problem posed. The art museum is assumed to have once been in the center, the vortex of society, and to have now drifted away. The art museum should confront the "multiple" problems of society and "actively" attempt to reform society and "enhance the quality of life." The art museum is asked by these men to remake the world while the understanding of art is at best imperfect, and in most cases, chaotic. By their texts the authors consciously or unconsciously attest to their loss of faith in works of art to move men to order, compassion and delight. What a distance from an original radical, John Stuart Mill, when confronted with a reforming materialist's doubts about the life of pleasure.

> *They {Wordsworth's poems} expressed not mere outward beauty, but states of feeling under the excitement of beauty . . . In them I seemed to draw from a source of inward joy, of sympathetic and imaginative pleasure, which could be shared by all human beings: which had no connexion with struggle or imperfection, but would be made richer by every improvement in the physical or social condition of mankind. From them I seemed to learn what would be the perennial source of happiness when all the greater evils of life have been removed.*[4]

Mill realized very well what today even Herbert Marcuse, the mentor of the student revolt, understands about the function of art in his distinction between "culture," which is free and spiritual, and "civilization," which is bound by necessity, work and activity.[5] Indeed the paintings on the walls and the objects in the cases of museums provide models of a revolutionary order and relevance to any time, far more militant and germane than countless acres of press photography and canned sound. The visual image of a Poussin, Chardin, Cézanne, or Mondrian is a trumpet call to order and meaning for those committed to the arts rather than to social and political action. The two can be complementary; they should not be confused, especially by anyone professionally beholden to the visual arts.

Perhaps we can more positively attack our problem by reconsidering our title in reverse word order—Society, Today, Museum, and Art.

One cannot really objectively, scientifically demonstrate what society ought to be. Even to define what it is or has been usually becomes a tangle with what the

observer judges it ought to be. Many men in the United States, one hopes a major-
ity, choose to live in a pluralistic society rather than a homogeneous one. Such a
society recognizes the rights, privileges, and interests of various groups ranging in
size from large numbers of Republicans and Democrats, football fans and bridge
nuts, to smaller numbers of art fans and chess players. The smallest unit, the
person, should be esteemed as most precious of all in such a society. W. H. Auden
has emphasized the distinction between an "individual," a biological numerical
entity, and a "person."

> *. . . that, as persons, we are called into existence not by any biological*
> *process but by other persons: God, our parents, our siblings, our friends . . .*
> *As persons we are capable of deeds, of choosing to do this rather than that,*
> *and accepting responsibilities for the consequences, whatever they may turn*
> *out to be. As persons we are uncountable, incomparable, irreplaceable.*[6]

In short we are not a mass to be moved by an all encompassing predetermined
environment. It is not yet 1984; God willing, it never will be.

Inherent in this kind of society is the positive notion of provinciality, of different
styles of doing and saying things. A Brooklyn accent is far more beautiful, varied
and meaningful than "Newspeak." And so it is with art museums; provincial may
have acquired a hick connotation; but the word "provincial" can be restored to its
place as a differential term if one looks at American, British, Italian, or German
art museums. The local style, the provincial variation of artistic quality is and
should be treasured and preserved despite the quite fitting and desirable grandeur
and power of national museums. If the Louvre tends to swallow the movable
masterpieces in France, one can take no small pride in having to go to Dayton to
see a great Baroque altarpiece, or to visit Cleveland to see unique monuments of
early Christian art. There are greater possible areas for varieties of style and flavor
to be found in the periphery of the circle than in the vortex.

And what of the word "today"? The fashion pages and men's clothing flyers,
among other forms of higher literature, urge us to be part of the scene, to be "with
it." But of what does "today" consist? The answer, an objective rather than an
evaluative one, is that today is made up of what survives from the past and what
exists now. Such a spectrum is, of course, unbelievably broad—but there it is.
Nothing is so dead today as the Twist—or so alive as Velasquez' paintings or those
of early man at Lascaux. It is physically impossible for one to react to all that makes
today; one must evaluate, judge and choose. Alexander Pope's "Whatever is, is
right" is as ironical as anything spoken by Voltaire's straw man Pangloss—and both
authors belong to the Age of Enlightenment.

Some would discard the past, or at least relegate it to a bit-player's prologue.
Such an answer accepts the idea of progress, of inevitable determinism. While this
may be true of technological history, where one literally builds on his predecessor,
the idea is properly discarded in the arts. A former director of the Metropolitan,

Herbert Winlock, and Picasso are at one in denying progress—indeed, Winlock opted for the idea of a continuous decline in art from that of prehistoric man. In any case, what was and is cannot be swallowed completely; nor should it be. Judgment and selection are required of anyone concerned with the arts. The "naturalistic fallacy"—that if a thing is done it ought to be done—has been properly destroyed by many, including G. E. Moore. The fallacy dies hard however and its most recent large scale public appearance is in the electronic-mechanical determinism of Marshall McLuhan. As hypnotic as Medusa, McLuhan's mirror of part of today is assumed to be all of today *and* tomorrow; but Medusa was slain, and as Christopher Ricks neatly puts it, "Perseus' mirror wouldn't have been very much use if he'd forgotten to bring along his sword."[7]

If "today" is not, therefore, so simply defined as some would have it, what of that even smaller unit, the "museum"? If today is at least in part made up of yesterday, how can the museum fail to discharge its given role, however derisively denied, of mausoleum, of conservator of the past for today and tomorrow? Such a mission is historically crucial, though performed by institutions that antedate by far the relatively recent museum. Thus 215 monastic communities of Europe and the Near East, but 22 of them with a status permitting the presence of bishops, transmitted the greater part of Classical and Early Christian culture through the troubled centuries before A.D. 700. Who preserves the arts of the past today? No one, if not the museums. Such a concern is paralleled by that polarised about the world's threatened parks and wilderness areas. A more distant but valid parallel is that with the pursuit of pure science in the face of demands for technology— usefulness here and now. The pure and apparently useless researches on the mathematical definition of information by Leo Szilard in 1929 waited twenty years before they were used to revolutionize modern electronic communications. Uselessness can be dangerously useful. Communications make the preservation of the past, even of those seemingly useless works of art, particularly important as George Orwell taught us in his Party slogan of *1984,*

> *Who controls the past controls the future; who controls the present controls the past.*[8]

Free access to this past is the inalienable right of free men. We do not ask that we return to an earlier "golden time"; but we do insist that the gold continue to be available to the persons of each generation so that they may make up their own minds about the validity of any or all of it. Such a perpetual holding action, by alert contemporaries of each generation, is an honorable if not spectacular task. We simply cannot afford to wait for Eddington's apes to fulfill the laws of probability by ultimately typing out the complete works of Shakespeare. With the visual arts the risk is even greater, if we are to judge by the simian artifacts from the Baltimore zoo.

Impatience with these prosaic tasks is not confined to some museum directors and avant-garde critics of museums. A nervous, driven desire to be at the vortex, to outrun the past, is omnipresent today in all the arts. The "Living Theatre," the theater of confrontation and commitment, is an even more and properly so, dramatic example of this cultural Oedipus complex. As Robert Brustein puts it:

> *Guilt-ridden, indecisive, flaccid, hating authority and enamored of influence, they surrendered principles they had once affirmed, accepting again what was so hateful in the past. In a time when intelligence is needed more than ever before, they encouraged a form of intellectual decomposition, becoming fellow travelers of a movement they could never hope to join, which would in time, proceed to swallow them up.* [9]

Confrontation, involvement and commitment have relevance for the visual arts within the context of those arts. But the words are defined and used today in a different context—a political and social one involving the exercise of power. Such a vortex has a way of swallowing the arts—the fully committed art of Stalinist and post-Stalinist Russia and Hitlerian Germany could not tolerate Suprematism or Expressionism.

Which brings us at long last to the word "art." I would reaffirm that art is above all a matter of quality and that quality is determined by comparison, most firmly and wisely in the light of historical judgment, if less firmly in contemporary evaluation. Still, no one deeply committed to the visual arts in general, rather than to a specialty, should wish to evade the responsibility of showing and choosing the most creative and qualitatively rewarding work of the immediate present.

In this concern for quality, for the good of the thing being made, he is *homo ludens*, man the player, in Huizinga's words, partaking of,

> *A free activity . . . absorbing the player intensely and utterly . . .* [10]

Thus the artist occupies a privileged position, one well recognized by conservative and radical alike. Again, Herbert Marcuse, while deploring the traditional "civilizations," recognizes the quality and freedom of "cultures:"

> *. . . the privileged position of culture, the gap between the material civilization and the intellectual culture, between necessity and freedom, was also the gap which protected the realm of non-scientific culture as a "reservation." There literature and the arts could attain and communicate truths which were denied or repressed in the established reality . . .* [11]

It is precisely this separation, this privilege, this not being at the center, that permits the freedom of art to be enjoyed and understood as an almost Platonic model of perfection. Hence the ludicrous position taken by some that the art of the past, or that politically uncommitted contemporary art, is dead.

Picasso knows better:

> *The art of the Greeks, of Egyptians, of the great painters who lived in other times, is not an art of the past; perhaps it is more alive today than ever it was.*

Given the preservation and display of the work of art, and these two words cover an enormous expenditure, of intelligence, time, and energy by the museum, what is to be done with them? Who looks at them? How? What kind of intellectual or emotional transaction can take place between the work and the beholder? The key to the relationship is the singular nature of each partner. Masses, groups, couples may be practically convenient units within equally convenient and ultimately meaningless attendance figures. The true confrontation is between the work of art and a person. Here, Cato's comment expresses everything: "Never is he more active than when he does nothing, never is he less alone than when he is by himself." The person can be educated, can be made wiser and more informed by instruction and experience, but ultimately and properly he is on his own. The educational process is an important one for museums. They cannot and should not avoid it. But there are various ways of education and appropriate times for its application—in the museum, before and/or after contemplation, not by squawk box or arrowed diagrams with the works. And the museum cannot assume responsibility for the artistic education of two hundred million citizens, or even two million persons. This is the task of the various school, college and university systems, one that has been done badly or not at all if we are to judge by the quality of our environment, or by the pathetically mistaken policies urged by some art museums and even by the museums' own professional organization. The art museum is not fundamentally concerned with therapy, illustrating history, social action, entertainment, or scientific research. By now, I hope the art museum's fundamental responsibility of preserving, displaying, and elucidating the works of art as such is clear. The museum is, therefore, a *primary source* of wonder and delight for mind and heart. In this the art museum is comparable to a permanent storage battery, or to a library of original manuscripts.

Is it any wonder then that your speaker comes to you with the troubled musing of a minor Jeremiah? He fears for the integrity and the very life of this creative by-product of the modern age. He observes the usual problem of ends and means, of assumed good ends to be achieved by totally inartistic means. And he remembers that the library at Alexandria, the greatest cultural repository of the Classical World was destroyed by Christians who then falsely attributed the catastrophe to the machinations of Muhammadans.

Like a Freudian morality play, a script appears; already it is being played in some institutions. First comes the guilt complex about art as the product of a prosperous high culture which battens on a poor, low culture. Secondly, we have the simulta-

neous entry of debasement and atonement: the former reducing the high culture
to a popular civilization, the museum to the used-car lot; the latter, atonement,
achieving its purposes by doing good with the high culture (actually the *least* valued
of the holdings of the righteous, judging from the strictly limited funds available
for cultural affairs). And finally we have the fulfillment of the subconscious desire of
the moralist that useless, uncommitted, irrelevant, mere art—uncomfortable, un-
settling, and therefore secretly feared, mere art—must, like hard-working, worn-
out Boxer in Orwell's *Animal Farm*, be carted off to the glue factory.

> *All the animals took up the cry of "Get out, Boxer, get out!" But the van
> was already gathering speed and drawing away from them. It was uncertain
> whether Boxer had understood what they had said . . . there was the
> sound of a tremendous drumming of hoofs inside the van . . . The time had
> been when a few kicks from Boxer's hoofs would have smashed the van to
> matchwood. But alas! his strength had left him; and in a few moments the
> sound of drumming hoofs grew fainter and died away.* [12]

Those concerned with the art museum in society today have much to understand.
The museum has indispensable functions uniquely its own, worth doing well,
and in being done, reflecting the intellectual and emotional order of the works of
art which are the justification for its existence.

Eye Object

"Eye Object" first appeared in Art News, *volume 71, no. 7 (November 1972). Practicing artists were the intended audience.*

The Cubist paintings of Picasso and Braque strike one as ravishing objects at the same time they begin that process of destroying the visual appearance of objects in nature which has only today reached the extreme position of so-called "conceptual" art, where the object is totally denied by being reduced to words, computer programs or unspoken, unwritten, undiagrammed ideas existing only in the mind of the artist, or in the imagination of the audience.

In the sound of my title, "I object," and in the words of that title, "Eye Object," I have taken as my subject the object made by the artist to be seen. This includes sculpture, ceramics or even "handpieces," those small sculptures primarily meant to be known by tactile sensation. For these works can be known, and have been since time immemorial, through vision, that particularly acute sense which conveys to our mind images translatable by the accumulated cultural structure of that mind into verifiable tactile sensations of smoothness, roughness, surface tension, weight, etc.

The "art object," persuasively characterized by Harold Rosenberg in the marvelous title of his book, *The Anxious Object*, is now thoroughly attacked, and on the whole largely discredited, by the current leaders of the avant-garde, whether one labels them "Minimalists" or "Conceptualists." While the first consciously aimed blow may have been Cubism, later attacks became more obvious and their weapons bludgeons. The rise of Action Painting in the forties left the canvas almost as a discarded object, valuable only for the residual evidence it might reveal of the real work of art, the act of the artist in producing it. In a sense the canvas contained a series of clues available to the detective trying to reconstruct the crime. This was, you will remember, the time of a film of Picasso drawing with a lighted wand, and of Mathieu with his theatrical reenactment of the Battle of Agincourt as an act of painting before an audience. Action Painting and its successors—Op, Pop, and Color Field alike—also attacked the art-object concept by being produced on extremely large canvases or grounds—so large that they could only be called objects with a certain irony, as many New York cliff dwellers found to their dismay when they tried to bring in and install their acquisitions.

Then came the "self-destroying" works of art, notably those produced by Tinguely designed to self-destruct before an appropriate audience—a kind of action painting or sculpture in reverse. To these we should probably add still another class of "self-destructs," works made with the inadvertently or deliberately careless use of either fugitive materials or poor technique or both.

But Minimal and Conceptual art remain as the most thorough and philosophically conscious assaults on the art object yet mounted. Their emphasis on an often uncompromising and tough-minded logic as expression of compulsively pure and disinterested minds, through nonvisual means, has effectively destroyed the art-object concept for the new believers.

And, since they are at least intelligent believers, even if idealists, they have a point. The mindless delight in decorative paintings involving only color and surface texture, the thousands of gimmicky mobiles and light sculptures, the luxurious walnut-and-chromium abstract sculptures, the often debased commerce in meretricious pacifiers posing as works of art—all these and more have played their parts in requiring a reassertion of the need for mind and intellectual integrity in the artist. A balance between the means of art (materials and technique) and its ends (concept or image) is much needed.

But ultimately, pure mind is indeed boring. Jokes about hell and heaven bear witness to our justified belief that the Inferno is by all odds the better part of Dante's *Divine Comedy*, as Milton's *Paradise Lost* finds more sympathy than *Paradise Regained*—though I note that an interesting by-product of the present Conceptualist-Structuralist boom is an increase in scholarly quotations from the latter work. Our new avant-garde seems bent on reversing the work of the Lord in Genesis; where He produced matter, objects out of pure mind, they would produce mind by eliminating matter. The mind-to-matter process is irreversible once begun and the traditional creative process requiring perfect fusion of mind and matter still is central to art. The Biblical sentence, "And the Word was made Flesh," tells us everything about the creative process.

There is yet another method of attacking the art object, and this is political in origin. The object, from the time of its completion, becomes subject to society's inexorable structure—it becomes a piece of property, belonging first to the artist, then to subsequent owners. It has value, can be bought and sold, rented, or used as collateral. The abuses of the private-property system are believed in various shades of revolutionary opinion to be inherent in that system; the immorality of the system, it is assumed, implacably taints the art object until it seems to be saturated with the color of the system. Recent developments which institutionalize informal practices of the past include the formation of art investment trusts, a calculated formalization of the traditional dealer's practice of "buying shares" in a given work of art in the hope of sharing in the profit from its sale. The obvious temptation to manipulate the art market through concerted efforts in advertising, marketing, interested criticism, and artificial price structures through rigged markets and auctions is always present, and those who give in to the temptation only provide more fuel for the fire consuming the integrity of the work of art.

But is the assumed taint a real one? The politicization of the art object is assumed by those who wish to leave the object behind as a useless, privileged relic of the

capitalist system. In fact, the taint is not *in* the object. For as long as man has existed as a thinking and object-making being, the art object has existed, whether in religious, magical, medieval, slave, enlightened or whatever kind of society. Like a white screen, it can reflect the longings or the prejudices of a society that makes it, treasures it, or uses it. Delacroix's *Liberty Leading the People*, Courbet's *Roadmenders*, or Picasso's *Guernica* mean different things at different times and in different places. If politics and art are inseparable, why then does the *Guernica* capture our imagination as an essential image, while the same artist's *Massacre in Korea* does not? How can a slave society produce the sculptural paragons of the Maya at Palenque? How can a preliterate African tribal society produce the visual sophistication of the images of the Bena Lulua? The answer is clearly that the making of art objects is a human activity and that there are qualitative differences within given categories as in flora, fauna, or homo sapiens. Good, better, and best are concepts as valid in the making of art as they are in survival. The residual qualities in the art object are their reason for being *as art objects*, and these qualities are put there by the artist. It is the task of art criticism to find these essential art qualities in the object, defenseless against whatever political interpretations may be placed upon it. But to do this the critic must become an historian.

For the art object has a history; it was made by an artist in a given society at a given time. To truly understand the African image it is not enough to admire and understand its forms and their interplay. One must know the mind embodied in the image; and to know that, one must know history and its allied disciplines. This does not mean that the image has no discernible esthetic content. For the early artist, though steeped in magical lore, still made the image by an esthetic act within the rules of the game as it was played then. Of course, an Italian Trecento icon like Duccio's *Maesta* was an image of the Virgin and Child with accompanying scenes from the life of Christ. One cannot begin to understand its visual appearance without knowing that and more, through the study of history—for it was long ago. We can know from documents that the work was bought and paid for, an article of commerce. But the reason all of Siena accompanied it from the studio of Duccio to the cathedral was a mixed one, including, for at least a good fraction, its quality as a work from the greatest master of the city.

Magic, religion, and history—even the latter had its day as a motivation for producing art. Poussin's classical mythologies, *The Rape of the Sabine Women*, *The Death of Germanicus*, and others, are not merely arrangements of visual components, but concretions of ancient history made meaningful for the seventeenth century in terms of both ancient Classicism and the Baroque. Their distinction is the fusion of their carefully thought out meaning with their visual means. Sensuous mind-lessness is not to be found in our examples, hence their invulnerability to analysis by the critic or the historian alone.

The diversity we see in the art object not only exists through time—that is, history

—but through humanity at any one time, even the present. To return to Dante, the *Inferno* is interesting because it is varied; the *Paradise* is boring because of its monotony. Our understanding of this comes from the Renaissance and particularly from the later Age of Enlightenment. The single chorus chanting forever the singular praise of anyone may well be our ultimate fate, but it does not produce great music. Diversity is in the nature of mankind; it lives as a mosaic and who is to say which *tessera* among the hundred stones is the best or most interesting? Thus the need for numerous art objects, not only individual ones within a class of objects but also for a number of classes. I would hope we could be spared a society where all the dinnerware was Sèvres—or Bennington. I would hope that all within a class would be good.

The Japanese useful arts of all periods provide an interesting lesson in this matter. In the medieval epoch there was a high art associated with the court and its imitators and a folk art associated with farms and rural villages. Both categories had their good, better and best. While the art of the folk continued but declined in rustic simplicity and ingenuity, by the sixteenth century high art was imitating, or better, sublimating, the rustic virtues of informality and naturalness—so much so that the two *tesserae* of the art mosaic often became indistinguishable. This in turn affected the folk art, until by the twentieth century it was in large part being continued and preserved by a cultural elite. The one could not live without the other: their interplay was life to each. The simplistic universal solution, however sophisticated and apparently well motivated, may well be Paradise, but one must be dead before taking up residence. Diversity and variety as represented in the arts by the objects of individual artists are the evidence provided throughout history that these works fulfill a profound human need for those who receive them and, more important, for those who make them.

The makers are the artists; and as Mark Tobey has said on more than one occasion, there are artists and *real* artists. The works of the latter present us with palpable images that affect our vision, our minds and our imaginations—in a very real sense they restructure our vision. After seeing a real work of art one cannot look upon the world, however representational or "abstract" the controlling image, in one's accustomed manner again. Something has changed and the real artist has changed it. To do this requires more than skillful squiggling or apparently miraculous exercises in verisimilitude. Please note that I said *more*, rather than *other*, for one of the larger bogs on the moor is reserved for those with inadequate means of expression. The Chinese master, thoroughly disciplined in the use of the brush, used archaism and apparent amateurishness as a means of conveying noble, upright, and unflawed character to a landscape image. "More than technique" means the fusion of mind, imagination, and technique into a single art object, compelling in its imagery and convincing in its integrity—Gorky, not Warhol; Morris Louis, not Paul Jenkins.

What you, the artist, make, the eye object, is what you are known by, no matter what you may be as a person. In the fourteenth century the Chinese scholar T'ang Hou wrote this poem on a painting of an ancient moss-covered tree and some bamboo:

> *Set forth your heart, without reserve,*
> *And your brush will be inspired.*
> *Writing and painting serve a single aim,*
> *The revelation of innate character.*
> *Here are two companions,*
> *An old tree and tall bamboo,*
> *Metamorphosed by his unreined hand,*
> *Finished in an instant.*
> *The embodiment of a single moment*
> *Is the treasure of a hundred ages,*
> *And one feels, unrolling it, a fondness,*
> *As if seeing the man himself.*

Art Against Things

"Art Against Things" was given as the first Franz Philipp Lecture in the History of Art at the second annual conference of the Art Association of Australia, Sydney, 20–22 August 1976.

I must be cruel, only to be kind.　　　　　Hamlet *(act III, scene 4)*

Hamlet's admonition to his guilt-stricken mother, Gertrude, was never more needed than now. The beginning of my essay may well be cruelly boring, but it is planned so, and for good reason. It is not enough simply to state or explain the thing-oriented attitudes that play such a large role in our art world today. One must experience this calculated boringness to understand the nature of our subject—the growing accommodation of art to some now widely held standards of advanced twentieth-century societies, both capitalist and Marxist, and both thing-oriented.

Having savored the aroma of things, I plan to see how real things, rocks, may be transformed in the mind's eye—removed from their thingness and their environment into the larger view of nature in traditional China. With this foundation we can finally look at the preservation and study of art today, searching for the place of this art in any modern industrial society—or does it have any place *within* such a society? Perhaps its proper task is to be "against the grain" if we are to retain humane images to be loved rather than endured.

I begin by boring—both in the dictionary sense of drilling a hole, making nothing of what was something, and by boring you. Perhaps it is not without significance that the first meaning of the word bore, a material, thing-like meaning comes from the German, while the second meaning of *ennui*, aswim with nuance and value judgments, comes from the French.

But both of the following quotations come from contemporary French writing—which indicates that the implied distinction of our beginning, derived from national origins, is false—or that the German thing-heavy meaning has become more universal than we know.

Alain Robbe-Grillet writes in *The Voyeur*:

> *The lamp is made of brass and clear glass. From its square base rises a cylindrical, fluted stem supporting the oil reservoir—a half-globe with its convexity underneath. This reservoir is half-full of a brownish liquid which*

does not resemble commercial oil. On its upper part is a flange of stamped metal an inch and a half high into which is screwed the glass—a perpendicular tube widening slightly at the base. It is this perforated flange, brightly lighted from within which can be seen most clearly of all the articles in the room. It consists of two superimposed series of equal tangent circles—rings, more exactly, since their centres are hollow—each ring of the upper series being exactly above a ring of the lower row to which it is joined for a fraction of an inch.

The flame itself, produced from a circular wick, appears in profile in the form of a triangle deeply scalloped at the apex therefore exhibiting two points rather than just one. One of these is much higher than the other, and sharper as well; the two joints are united by a concave curve—two asymmetrical, ascending branches on each side of a rounded depression.[1]

Yet another author, a Belgian, Denise Thomas-Goorieckx, writes:

The metallographic study yields still further information about the manufacture of these various screws. When comparing types I and II with type III —the very long pointed variety used on the verticals of the frame—one can easily see that all three types are made from similar raw material, namely as fig. 57 illustrates, a soft iron interspersed with extremely drawn-out dross inclusions. The initial material must have been either puddled iron or iron obtained by direct processing. The metal fibres and dross inclusions in types I and II are not oriented in a parallel direction to the screw arbor; these screws must therefore have been fashioned by forging, whereas screw III, whose fibres are parallel, was produced by the later more advanced process of wire drawing. The improved manufacturing technique of screw III is revealed also in the speed-cut threading which produces no hammer-hardening along the helical ridges.[2]

To these thing-oriented quotations one should add the productions of "concrete music" where, as in many works by John Cage, the discrete sounds, widely separated by zones of silence, are heard as concrete thing-sounds. Or in the visual arts one can conjure up the quintessential thing—the *Campbell's Soup Can* of Andy Warhol—by the artist's own affirmative admission, boring (Fig. 1).

The literature by artists and critics about much avant-garde work reinforces a growing preoccupation with things. Don Judd writes in *Arts Magazine*:

Things that exist, exist, and everything is on their side. They're here, which is pretty puzzling. Nothing can be said of things that don't exist. Things exist in the same way if that is all that is considered—which may be because

we feel that or because that is what the word means or both. Everything is equal, just existing, and the values and interests they have are only adventitious.[3]

and in *Perspecta*:

A shape, a volume, a color, a surface is something itself. It shouldn't be concealed as part of a fairly different whole. The shapes and materials shouldn't be altered by their context. One or four boxes in a row, any single thing or such a series, is local order, just an arrangement, barely order at all. The series is mine, someone's, and clearly not some larger order. It has nothing to do with either order or disorder in general. Both are matters of fact. The series of four or six doesn't change the galvanized steel or whatever the boxes are made of.[4]

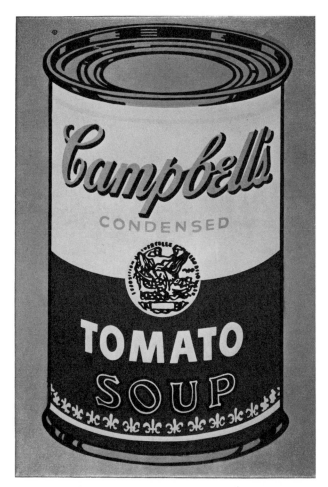

1 Andy Warhol, *Campbell's Soup Can*, 1965.

And finally, a critic, Marcia Tucker, writing of the work of Robert Morris:

> *The experience of this art is distinguished* quantitatively, *not* qualitatively, *from that of natural events or objects. . . . Finally, Morris' work* shows *us, rather than* tells *us, about ourselves and the world By showing, Morris renders the literal question, "What does it mean?" irrelevant. The central issue becomes instead, "What does it do?" The implications of this change in attitude have become crucial to an understanding of the major art of our time.*[5]

Some conservative critics have perceived the problem early on. That delightful and tough-minded philosopher-theologian, Etienne Gilson, as usual, puts it best:

> *In our own lifetime the man-made artifacts inspired by the creative imagination of artists have progressively assumed more and more unfamiliar appearances, and still, on more protracted and closer acquaintance, they have finally succeeded in revealing their meaning to us. Since their apprehension was becoming a source of pleasure for us, their authors had certainly discovered the structure of possible objects, unknown to nature, but whose ultimate justification was to provide man with perfect objects of apprehension. No wonder that so many modern painters feel tempted to use anything rather than oils in their compositions. Oils are a perfect medium for a maker of images, but if the artist is ambitious to produce a real being, then his best chance is to attempt what A. Reth aptly calls a* Harmonie de matières—*that is, not an image made of colors, but a thing made of things.*[6]

Clearly an important part of critically accepted avant-garde art today is dedicated to the naming or description of things and, conversely, to the destruction of images. The parallel to iconoclasm in the Eastern Church (A.D. 730–842) is at hand and, within broad limits, apropos. Saint John of Damascus, speaking for the triumphant iconical group, reaffirmed that no veneration was due the icon as object, or thing, but only as image. And further, as Gervase Matthew shows,[7] the controversy was fundamentally a political one, not about icons as images, objects, veneration, and miracles, but about imperial and urban conservatism against military peasant freeholders. Perhaps we should examine the politics of the twentieth-century controversy between art and things.

We need not recount the imaginative achievements of artists since the Renaissance. They are well known and generally accepted except by a very few latter day pseudo-medievalists. What is not so widely recognized, except by scientific or Marxist historians, is the history of art as property, as both a source of various pleasures and an asset. While it may be somewhat exaggerated to say that the asset aspect is more dominant today than in the past of capitalism, certainly the period since World War II has witnessed increasingly blatant use of the work of art as a thing or a commodity subject to the assumed rules of the market. As early as 1947

the Amalgamated Bank of New York decided to "finance the purchase of paintings and sculpture by living artists." The Bank's president, Michael Nisselson, stated, "The buyer of art is as good a risk potentially as one who wants a loan for a small business or to pay other debts." The Artists' Professional League commented approvingly: "Like furniture, cars, radio and other such things, art is a vital part of the joy of life."[8] From this modest and somewhat ambivalent beginning, the concept of art as investment burgeoned to encompass various lunacies, not the least being a "Revolutionary Method for Buying Graphics" promulgated by Herbert Lust in 1969 in a pamphlet titled *A Dozen Principles for Art Investment*. In this system one multiplies the number of print subjects and the average number of imprints per subject, divides by the artist's rank in history on a scale of one to one hundred, and gets a "Number-Quality Ratio"—and now I quote: "For example by setting up a similar chart one can easily see why Seurat sells for much more per square inch than does Cézanne. The stunning point here is this: The lower the *Number-Quality ratio, the higher its investment status.*" In this never-never land, the only problem is the one of rating the importance of the artist! And here we have no material-thing criteria to help us in our hour of need.

Perhaps an even more telling example of the relationship of art to things under capitalism is the Dallas, Texas, auction of 26 June 1976 where Western-style paintings were auctioned with real cattle. While the highest price achieved by a painting was $14,500, a steer reached more than double that figure, $34,000. The businessmen present at that auction confirmed the judgment of most of their colleagues, past and present, that things are more valuable than works of art—in brief, they perceived the non-thingness of the paintings and their fundamental worthlessness. Art has no value in itself, and this is why some artists have not done as well as some businessmen in the past, leading to the semilegend of the starving artist. It is perhaps also true that some postwar artists have done well because they have convinced some people that they produce not art but things. The United States Congress and the Internal Revenue Service have cheerfully adopted this avant-garde position by denying to the artist any value for his work as a tax-exempt gift other than that of time and material.

The fantastic increase in the legal literature about art is further evidence of the firm perception of art as property—as well as a useless product of imagination. This dualism of attitude, called by some hypocrisy, is one of the saving graces of the capitalist attitude to art. It permits the artist to possess imagination and soul, to create functionally useless images, while encouraging market determination of the completed works. Perhaps the only freer aesthetic-social order was that of the old Chinese Empire where the scholar-official-artists painted their marvellous scrolls and albums, glorying in their uselessness, giving them away to friends who understood them, and abjuring the society of artisans who painted pictures to sell.

Now we have a new and certainly more just and equitable society in China and,

not unexpectedly, one of the great unsolved problems of this Marxist society is how to deal with art, particularly the art of the imperial or feudal past, and more particularly, with the great and still living tradition of Chinese painting. If we look first at this very specific question, it may give some light on a later consideration of things against art in Marxist analysis and criticism.

Aside from making the past serve the present, postulating the nonexistence of art for art's sake, insisting that art be for the workers, peasants, and soldiers, demanding that art be "cogs and wheels in the whole revolutionary machine," *The Quotations from Chairman Mao Tse-Tung*[9] pays relatively little attention to the arts—of 179 pages, but two and one half are devoted to the subject. However, a careful study of Chinese publications and activity in art and archaeology since 1948 is revealing and relevant to our search.

Archaeology, in contrast to painting, is certainly a perfect solution to the Marxist art problem. First, the results are achieved by hard, physical labor and extremely careful planning. Secondly, there is no outlay of capital for the works themselves. Thirdly, the overwhelming majority of the works excavated are artifacts and/or useful arts. Relatively few paintings have been excavated, and all but a very few of these have been by anonymous artists rather than by known "fine" artists. The one major exception, a scroll by Ch'ien Hsüan, has received more attention in the West than in China. In short, the works excavated are documents, things of material history and evidence for inevitable Marxist historical developments. Archaeology does serve the Revolution in theory and in practice.

The troublesome questions arise with art history, particularly of painting. While the National Palace Museum in Peking has an annual noble, if short-lived, display of their great early paintings in the fall and a continuing display of Ming and Ch'ing works, nearly all of the other major museums simply do not show their fine paintings—except by request. They keep them safe, they carefully repair and restore them, but they are an uneasy burden. The great exhibition of *Archaeological Finds of the People's Republic of China*, which toured Europe and then the United States from 1973 to 1975, had a particularly fine and official catalogue at the London showing in 1973 with a text by the eminent British scholar, William Watson. The sections on the Sung and Yüan Dynasties each contained substantial paragraphs on the painting of those periods, including the names of key masters, though no paintings were in the exhibition. By 8 August 1974, when the exhibition opened in Toronto, a new "official and authentic introduction and catalogue" had been prepared by the Chinese with numerous interesting and significant changes involving the place of Confucius and the Legalists in history, but of particular interest for our problem, with *no* mention of Sung and Yüan painting whatsoever. Such works, described by their painters as "useless play" or "random jottings," simply could not fit into a thing-oriented archaeological, material history grid.

This specific unease becomes an epidemic if we examine Western Marxist atti-

tudes, whether in the writers of the optimistic twenties or the more cautious but equally puzzled theorists of today.

Marx himself had great difficulty in dealing with works of art, whether within "bourgeois" society or within a projected socialist world. Since the value of a commodity was only a unit of "congealed labour-time" and since the alienation of a labor from production develops "as labour loses all its characteristics of art; as its particular skill becomes something more and more abstract and irrelevant . . . a purely mechanical activity," art becomes a model of anticapitalist activity. It stands outside of the critique of capitalism precisely because it does not fit commodity theory. But, on the other hand, Marx does not place art clearly within socialist activity. It remained for his followers to attempt what he either failed or never intended to do—to demystify art, make it into a commodity or thing and to put it at the service of the proletariat.

Thus Boris Kushner could write in *Art of the Commune* (*Iskusstuo Kommuny*) on 2 February 1919, beginning with "They used to think that art was beauty," and ending his manifesto with "To the socialist consciousness, a work of art is no more than an object, a thing." [10] While in April–May 1923, the journal *Lef* (*Levji front iskusstv*) published a "Declaration: Comrades, Organizers of Life!" including the following:

> We summon the 'leftists': *The revolutionary* futurists, *who have given the streets and squares their art; the* productivists, *who have squared accounts with inspiration by relying on the inspiration of factory dynamos; the* constructivists, *who have substituted the processing of material for the mysticism of creation.*

The avant-garde, or at least this part of such a category, has been in the same position for fifty years. The use of "socialist realism" under Stalin and continuing still in the People's Republic of China was and is a practical and political solution, equally unsupported by the idealistic theory of socialism and the pragmatic logic of capitalism.

The insecurity of the Marxist critics has most recently been displayed in a voluminous exchange of letters in *Art and Artists*[11] on this very subject where internecine attacks and defenses are finally capped by an intelligent letter from Michael Daley, who perceives that "Marx himself excluded art from his 'classical' theoretical structure," and hopes that art must somehow be placed within general socialist theory. In the course of this note he perceptively sees that "art objects acquire 'disproportionate' prices as the pursuit through art of a transcending and uniquely human experience becomes more urgent and desperate." The initial article by Peter Fuller which caused this continuing exchange contained one particularly poignant line: "It would be tempting to say with Oscar Wilde that since 'all art is quite useless,' it has no utility, and therefore it has no use-value either." But this momentary lapse

is sternly rejected by the flat and unsupported declamation, "But this is not the case."

If the identification of art with things is a major part of our two antithetical social systems, perhaps we can turn to quintessential matter for some enlightenment. I refer to rocks or stones and particularly to their place in the Western world as contrasted with that in traditional Chinese society.

While the diamond, ruby, and emerald are colloquially referred to by the vulgar as "rocks," their high market value has seldom been in dispute. But their aesthetic appeal is an apparently simple but really very complicated matter and one which I must confess never to have fathomed. Below this rarified crystalline layer we are on firmer ground, for the aesthetic appreciation of rocks in the West was largely limited to the curiosities of the Renaissance *Wunderkammer* until the influence of Chinese rock gardens on the English garden of the eighteenth century. The late development of mountain climbing and landscape painting in the West is further evidence of the low level of rock and mountain appreciation until modern times.

The overwhelming interest here has been in useful rocks, ore-bearing things producing rich economic returns. They also are documents or evidence for scientific investigations, and science, not satisfied with such rocks on Earth, has excavated and procured them from the moon and examined them by proxy on Mars. In the course of moon exploration the aesthetically rather nondescript specimens there have received an additional and quite unscientific aura. They have become fetishes, relics of a great human achievement, suitable for museum cases and gifts to especially high visiting dignitaries.

But business is not to be outdone by science. The average person in the United States has been persuaded, by an imaginative advertising campaign, to acquire for a small unit consideration, many "pet-rocks," carefully padded, encased, and endowed with presumed personal characteristics—even the ability to listen, if not to reply, to intimate personal remarks. The perversity of making a nonentity of a rock—the selection is rudimentary from an aesthetic or morphological viewpoint— into a substitute person has a fashionable touch of genius to it, but the fad is already past and the market has reached its proper rock bottom.

Still, the interest in a rock, any rock, as a non-thing reveals a yearning that may well go back to very early beliefs in magic rocks—and to the rock as an aesthetic object and stimulus to art.

Which brings us to rocks in the Far East. In China the magical use of rocks, as distinguished from carved stone or jade, goes back many thousands of years to at least neolithic times, but the use of interest to us here seems to develop in the T'ang Dynasty (618–907) and reaches full flower in the year 1133 when Tu Wan produced his *Stone Catalogue of Cloudy Forest (Yun lin shi p'u)*.[12] From this time on, the Chinese artist-scholar's passion for stones knew no bounds. Tu Wan catalogued one hundred and fourteen different types of rocks on the basis of their

geographic origin and, more importantly, as to their aesthetic and, only secondarily, their useful properties. Thus:

> *4. Stone of the Grand Lake in P'ing-chiang-fu (Tung t'ing lake S. Kiangsu). Huge specimens, up to fifty feet high, with a color range from white through pale blue to blue black, their surfaces textured in net-like relief, are hauled out of the lake. The most desirable have tortuous, rugged contours, and abundant hollows. Small surface cavities are called 'arbalest pellet nests' (T'an tzu wo); these are thought to have been made by wind and water. Reshaped specimens are aged by replacing them in the lake. Some are quite small, and are displayed on stands.*

Such various rocks were used by the Chinese scholar-officials in their gardens or with cleverly carved wood or ivory stands on their writing and display tables. The convoluted and penetrated surfaces were searched for relationships to landscape, especially mountain views, or less often to flora and fauna—thus the Lion Grove Garden (*Shi tzu lin*) of Suchou with its metamorphic rocks suggesting huge felines. Still, landscape thinking dominated the use of both large and small rocks, they being viewed as much as microcosms as were the landscape scrolls. Garden and table rocks occupied a place *between* nature and art—or as a fragment of nature made somehow more "natural" by the metamorphosis of art, either by manipulation or by the way they were seen by the beholder.

The relationship of these Chinese rocks to the "found objects" of the surrealists comes immediately to mind. There is some validity in this, but not much, for the *objet trouvé* is usually man-made and its merit lies in its complete transformation of purpose and/or meaning under the searching look of the artist who finds it. It is transformed, where the rock remains as a part of nature. The latter partakes of two worlds: the natural landscape of which it was a small thing-like part, and art, by which it becomes an image of the vastness of nature and its hidden principles.

The uselessness of Chinese rocks parallels the readily acknowledged uselessness of developed Chinese landscape painting. The recognition of this uselessness is a serious and positive note in Chinese criticism from the fourteenth century on, as written by artists and scholars, admittedly partially cloaked by ceremonial self-deprecation. Still, the force of the following is not to be denied:

> *What I call painting does not exceed the joy of careless sketching with the brush. I do not seek for formal likeness; I do it simply for my amusement . . . What a shame! But can one scold a eunuch for not growing a beard? {Ni Tsan}*

> *These few scribblings of a rough and clumsy brush can only be taken as an expression of a moment's interest painted for gratifying {my host's} graciousness. {Wang Hui}*

Or one of the finest titles of a painting in the history of art: Tao Chi's *Ten Thousand Ugly Ink Dots* of 1685.

To seek out and collect table and garden rocks, to understand their subsequent differentiation from things and their relationships to the vastness of nature as well as the embodiment of nature in painting through the study and appreciation of rocks, was a part of a personal adjustment to a "dusty world," the world of suffering as seen through Buddhist tradition. Like the art of the painter-calligrapher, the passion of the petro-maniac was an affirmation of useless art against the grain of this "dusty world." The famous and often quoted inscription by K'un-ts'an on his picture of an ancient Buddhist priest in a tree is still the best evocation of this attitude:

> *How to find peace in a world of suffering? You ask why I am here. I don't know. I am living high in a tree and look down. Here I rest free from all troubles like a bird on its nest. People call me a dangerous man, but I answer: "You are like devils."*

And so we are alone with our problem again—art against things. Today, within our own discipline, if one can use the word to encompass artist, art historian, art critic, iconographer, conservator, and—poor fellow—art administrator, we must find our place within the general social and cultural context. However, in doing this, some rudiments have to be spelled out to avoid serious misunderstandings. I shall be considering conservation and iconography, and, at the outset, let it be known that both are "good things," that each has made, and will continue to make, outstanding contributions to the preservation and understanding of art. Art simply cannot live without these two disciplines. But one mental set common to both conservation and iconography is only too easily and sympathetically understood by the interested layman. It will come as no surprise that this set is one that regards the work of art as a specimen or document—a thing to be analysed, preserved, and elucidated, employing the most current methods and equipment, or the most erudite resources of scholarship. And this is sympathetic to our good capitalists and Marxists. It brings art down to earth and, in the case of conservation, endows it with the indefinable glamour associated with the frontiers of scientific research. One cannot rationally be opposed to most of this. And yet, the preemption by such attitudes of possible other ways of understanding art is a clear and present danger to the survival and creation of art.

Only the summary of an exemplary report on Dirk Bouts' altar-piece of *The Last Supper* (Saint Peter's, Louvain) provides us with an attitude we have already observed in Robbe-Grillet and Andy Warhol—the elucidation of a thing.

> *The thickness of the ground varies from 350μ to 400μ, and is composed of chalk and animal glue. The ground is separated from the paint by a thin*

(5–10μ) unpigmented layer which appears to be a drying-oil film. The existence of minute fossil forms of marine algae of the family cocolitho-phoridae *has been observed in the chalk. These micro-organisms appear not to have been previously mentioned in connection with old paintings; their presence may be of significance in connection with the geographical origin of the chalk.*

The central panel (The Last Supper) *was transferred to a new support of oak in 1840.*

The thickness of the paint layer varies from about 30μ (for the greys and the flesh tones) to 110–130μ (for one of the dark reds): The design layers vary in hiding power; the layers that contain white lead are opaque, those that have coarse crystalline pigment like azurite are translucent, and the thin glaze layers are nearly transparent. The delimitation between the different underlayers is sufficiently distinct to permit of calling the painting technique one of 'superimposed layers' (Schichtenmalerei).

The composition and structure of the paint layers vary in accordance with the pictorial and chromatic effects desired by the artist. Nevertheless, it is possible to establish a series of typical structures each having a function in the pictorial composition.

It is possible to place the Altar of the Last Supper *in the category of oil paintings. There is no evidence of tempera even in the underpainting. No evidence was found either to support or to disprove the 'emulsion' hypothesis.* [13]

The generation of iconographers following the incomparable Erwin Panofsky have extended their searches far and wide. Examples of this mental set can be chosen almost at random—I say almost, for Marion Levy has quite properly reminded us that "Only God can make a random selection." The following is from a review by Larry Silver of a book by Dieter Koepplin on Cranach's portrait of Johannes Cuspinian of 1502 (Fig. 2):

The contextual reading of the Cuspinian portrait places it securely within the realm of Christian humanism, completely consistent with the biography of the sitter and Neoplatonic sources that gave rise to the Saturnine interpretation. Strengthening this positive, non-melancholic view is a detail in the corner behind Cuspinian's right shoulder that previously went unnoticed . . . Tiny, but identifiable by his lyre and bow, is the classical god, Apollo. As a nearly hidden figure, Apollo represents a personal symbol of Cuspinian himself, perhaps the combination of oracular poetic inspiration and medical arts. In the broadest sense, this is Apollo the diviner, corresponding to Cuspinian's own activity as doctor, poet, and humanist philosopher. This three-fold activity was expressed by Cuspinian's monogram CMP: Cuspinianus Medicus Poeta. The figure of Apollo serves to reinforce Koepplin's construction of the program and to argue against a notion of Cuspinian as a child of Saturn. In fact, the arms of the humanist, featured (in gravely damaged

condition) on the reverse of the portrait, include the god Hermes, or Mercury. Koepplin postulates that Hermes was a humanist equivalent to St John, name saint of Cuspinian; but Koepplin also points to the god's caduceus which could refer to the medical profession of the humanist. Apollo and Hermes, linked in myths, together could well represent the earthly activity of Cuspinian.[14]

What can one offer as a counter to the weight of these evidentially oriented approaches? Perhaps the critic or aesthetician should be bypassed here in favor of an obvious and usually committed source—the artist.

His approach to art was central to art museums and art criticism in the nineteenth century. Sir Charles Eastlake, a director of The National Gallery, was both a good painter and connoisseur. John Ruskin and Eugène Fromentin can lead the way as artist-critics of the mid-century. All of them looked at paintings both as process and embodiment, as a thing transformed by both vision and skill. I know, and agree with, the objections that immediately arise. Gilson cites the marvelous story of Gambetta's reply to Renoir's request that he be made curator of an art gallery: "My dear Renoir, ask me for a job as professor of Chinese or as inspector of historic

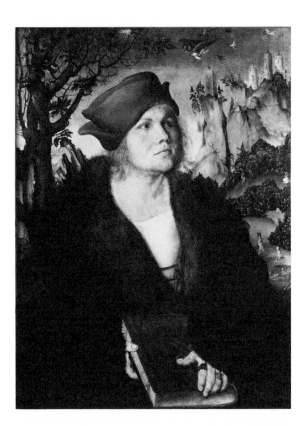

2 Lucas Cranach the Elder, *Portrait of Johannes Cuspinian.*

monuments, in short, for any job that is not related to your craft, and I shall help you; as to appointing a painter curator of an art gallery, everybody would laugh at us if I did." [15]

To justify Gambetta's irony we need only turn to the comments of great nineteenth-century masters on their own and earlier peers:

> *Rubens and Van Dyck may please the eye, but they deceive it; they are of a bad school of color. The school of the lie. {Ingres}*

> *I went to see the paintings by Courbet . . . What a subject! The commonness and the uselessness of the thought are abominable . . . Oh, Rossini! Oh, Mozart! Oh, geniuses inspired in all the arts . . . What would you say before the pictures? {Delacroix}*

> *The claim . . . for Michelangelo is that he has painted man above all, and I say that all he has painted is muscles and poses, in which even science . . . is by no means the dominant factor . . . He did not know a single one of the feelings of man, not one of his passions. {Delacroix}*

> *To my eye Rubens' colouring is most contemptible. His shadows are of a filthy brown somewhat of the colour of excrement . . . {Blake}* [16]

No, we do not ask of the artist that he necessarily be curator, professor, critic, or conservator. The specific record is sufficiently clear to make such assignments unsuitable in many cases. But what we do ask is that the artist's mental set, his approach to making and achieving art, be an integral part of the thinking and feeling of those others in the periphery of creativity. Do not ask the artist to pass judgment on the authenticity (and hence the market value) of a work, but do in examining and experiencing any work have the artist's means and ends as the center of the circle encompassing the different uses and abuses of art.

If we remember our technicians' and iconographers' words, let us turn to those of that nineteenth-century Romantic artist and critic, Eugène Fromentin, with particular reference to Rubens (Fig. 3), and, after reading, ask ourselves who understands Rubens's images, his means and ends, most deeply? Who makes us perceive the art of Rubens?

> *The fisherman with a Scandinavian head, his beard streaming in the wind, his yellow hair, his bright eyes in his fiery face, his great sea-boots, his red sailor's blouse, is overwhelming. And as is usual in Rubens's pictures, in which a very great deal of red is used to temper the rest, it is this fiery-looking man who does so in this case, acting on the eye and preparing it to see the green in the surrounding colours. Note, too, among the supernumerary figures, a lad, a ship's boy, standing in the second boat, resting on an oar, clad —no matter how—in grey trousers, and a vest of faded purple colour; unbut-*

toned, open on his naked breast.

What is really extraordinary about this picture—thanks to the circum-
stances which enabled me to examine it closely and to follow the workman-
ship, just as if Rubens were painting in front of me—is that it has the
appearance of surrendering all its secrets and yet surprises us almost as much
as if it had surrendered none of them.

Still more naturally in all secondary parts inserted for the general effect,
and to help out the whole, large expanses of moving air, accessories, ships,
waves, nets, and fish, his hand runs rapidly and does not stop to retouch
anything. A vast coating of the same brown, which is brown above and turns
to green below, looks warm where light is reflected, becomes golden in the
troughs of the sea, and stretches down from the ships to the bottom of the
frame. It is across this abundant and liquid material that the painter found
the true setting of each object, or as they say in the studios, "found his
setting". A few flashes, a few reflections laid on with a fine brush, and you
have the sea. The same with the net and its meshes, its supports and floats,
the same with the fish which flounder about in the oozy water, and which,
still streaming with the fresh colours of the sea, enforce an illusion of wet-
ness; the same with Christ's feet and the boots of the radiant sailor. {With
reference to The Miraculous Draught of Fishes *at Malines.}*[17]

What is striking about Fromentin's description is not only its absorbed interest
in vivid human detail but also its typical artist's vision of unusual relationships,
of equations that startle us and force our visual acuity. Thus "fish which flounder
about in oozy water . . . still streaming with the fresh colours of the sea," juxta-
posed with "Christ's feet," is for Rubens and Fromentin a far more revolutionary
comparison than Duchamp's rather simplistic urinal-equals-art equation. This art-
ist's vision of relationships, both aesthetic and human, lies at the heart of the
matter.

Again, Gombrich has clearly set forth the goal. If we remember Coreman's
scientific mind-set towards the Bouts altarpiece, then the following is particularly
relevant as a concept, regardless of its particular target—for in this case I believe
Gombrich still had in mind the controversy over the cleaning of the London Na-
tional Gallery pictures:

> *The objective validity of the methods used in the laboratories of our great*
> *galleries is as little in doubt as the good faith of those who apply them. But*
> *it may well be argued that restorers, in their difficult and responsible work,*
> *should take account not only of the chemistry of pigments but also of the*
> *psychology of perception—ours and that of the chicken. What we want of*
> *them is not to restore individual pigments to their pristine color, but some-*
> *thing infinitely more tricky and delicate—to preserve relationships.*[18]

You will have noticed that we have been finding out what not to do, what is not
art—negative, negative, negative. In this we find echoes of the old and universal

mystical approach to the definition of God—not this, not that—and such an approach is revealing in itself. We can know the properties of tungsten and that two and two is definable, not by what it is not, for this would require an infinite number of definitions, but by what it is. It is otherwise with art, and one must either take the uncertainty or leave it. A judgment and a choice are required if art is to be accorded the status it requires—that of Valéry's "privileged object."[19]

Such a solution may at first seem but wearisome and whining self-interest, but it does have at least two advantages. First it is practical, for it solves political questions neatly. Neither Marxism nor capitalism need account for the trying and annoying peculiarities of art within their theories. They need only endure art in practice, an accommodation possible to both but so far only partially achieved under capitalism. Secondly, the solution accommodates the facts and hence, may be even partially true. Since the art object is immovable and incapable of speech, it is useless to the world of entertainment. To show business the art object appears merely a prop, a thing. But another part of the market place recognizes that this curious object embodies a form or image given it by the artist removing it from a world of "real" things, that it has arbitrary rather than intrinsic or useful value. Neither fish nor fowl, its very ambiguity places it beyond the rules of the game.

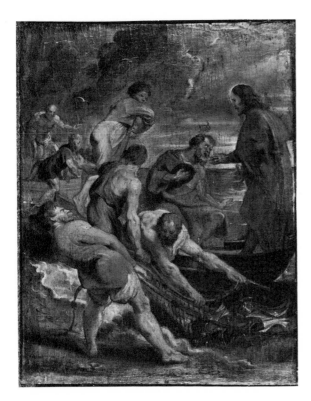

3 Peter Paul Rubens, *The Miraculous Draught of Fishes*.

Neither greedy possession nor frantic casuistry will assimilate art to marketplace or doctrine.

But we need art and artist— how we need him! Like love, art reminds us of our humanity and chides us when we forget. Art, visual art, shows us the infinite possibilities of human vision.

> *Long before painting achieved the means of illusion, man was aware of ambiguities in the visual field and had learned to describe them in language. Similes, metaphors, the stuff of poetry no less than of myth, testify to the powers of the creative mind to create and dissolve new classifications, it is the unpractical man, the dreamer whose response may be less rigid and less sure than that of his more efficient fellow, who taught us the possibility of seeing a rock as a bull and perhaps a bull as a rock.*[20]

Lascaux, Tu Wan's *Cloudy Forest*, Picasso's bicycle-bull sculpture, are integral components of this faculty of man, not stages in an evolution but inseparable parts of a humanistic configuration. "Objects don't stay up late at night to write books about man, neither do animals." (Niccolo Tucci)

Being wedded and then enslaved to things is bad enough, but to be dominated in thought and imagery by them is far worse than can be imagined. But who can imagine such hells except those very beings who are not so wedded, enslaved, and dominated, those whose unwanted creative thought and imagery go against domination by quantities and things. Gombrich wrote of "relationships," the ultimately indefinable and consciously placed bond *among* things that makes them meaningful. E. M. Forster appealed for us to "only connect" (*Howard's End*), referring particularly to individuals, but by clear extension to groups or cultures. These are the relationships and connections now endangered by growing antiscientific and antiartistic movements today. To these materialistic, political, economic, and social forces one must oppose creative, or so-called "pure," science and art, useless and essential, deep-structured in man but beyond the rules he makes. In this, science and art are one and C. P. Snow posed the wrong problem in his two-world construction —it is not art against science, but art against things.

Art Museums and Education

This essay appeared in Art International, *volume 21, no. 1 (1977). Lee began his museum career in the education department and worked for many years with Thomas Munro. He argues strongly for the right kind of education activities in the art museum.*

While the founders of our earliest major art museums in Boston and New York (1870) were firm believers in the educational values they embodied in the charters of their institutions, they did not conceive of these museums as primarily educational in function—educational responsibilities, yes, but educational institutions, no. While the latter concept grew with pragmatism and "progressive" education in the twenties and thirties, it never became a pressing consideration for museums until money pressures came to a climax with the Tax Reform Act of 1969. The difference in gift benefits for museums and "educational and charitable organizations" was sufficient to persuade the art museums and their spokesmen that they were, and should be considered as, educational institutions under the law. One can understand the reasons for the monolithic stance of museums in favor of this legal change; but, like so many postures illuminated by the hearings on the proposed tax laws, the reality behind the gesture, possibly ultimately harmful to art museums, was never examined for truth and consequences. This should be our first consideration.

The art museum is not primarily an "educational" institution in the current limited interpretation of the word. What and how it exhibits may well educate, but that is not its principal function—or rather it performs a kind of educational function presently unrecognized by legislators and even educators. In showing or juxtaposing visual images, the art museum provides an education unfamiliar to a word- and sound-oriented society. For the most part visually illiterate, our society defines education in logical sentences—acceptable words and sounds; thus, art museums may have an educational effect but one ancillary to visual delight. In the world of visual images, however, the museum is *the* primary source for education. Merely by existing—preserving and exhibiting works of art—it is educational in the broadest and best sense, though it never utters a sound or prints a word. Until such an approach is accepted within our social structure, art museums will continue to be second-class citizens in "educational" country. And until the original worth of visual images is reincorporated into a basic concept of education as the transmission of *all* knowledge, some of us must continue to deny that art museums are primarily "educational" institutions. The submission of vision to literacy is not a victory but a tragic defeat—and one we could see about us if we were truly more than literate and believed in a broader concept of education.

What then can the art museum do in such education after its primary functions of collecting, preserving, and displaying are well achieved? Its holdings are a part of both material culture and Matthew Arnold's "higher" culture. Too often the nature and monetary value of the museum's collections encourage a spurious cultural veneer to become a dominant goal. Trustees, staff, members, and public become primarily concerned with the "furnishings" of the art world—who said what, how much was it, a litany of names—all this meaning the use and abuse of art for mere entertainment and superficial social ends. Rather than accept the visual arts as furnishings of an alert but shallow material existence, we should insist that the art museum's first responsibility is to consider its holdings as an integral part of a creative and rational continuum comprising past and present, science and art—all that we can properly call knowledge and culture.

Education in the visual arts in art museums by verbal and literary means does have an important, but not crucial, role to play. If we accept this ordering, the museum educator should be in a more relaxed, flexible, "loose" position—freer to be both more creative and focused in his teaching. What is included in this kind of education for the museum teacher or administrator of teaching? Much can be included under the rubric "transmittal." First, there is still a vast amount of mere information to be handed on—in labels, catalogs, and special didactic exhibitions. This information, fundamentally factual, is essential to thought about art or art history as well as science. Too much art education assumes that feelings and attitudes need not be supported by accurate information. Yet this is a primary part of art education. Second, techniques must be transmitted. These can be looked upon as part of factual information; but the *doing* of them, or even just observing the doing, is fundamental to understanding and evaluating works of art. The separation of art history and art practice, of eye and hand, in departments of our colleges and universities has led not only to rivalry but to unfamiliarity by one faction with the information and techniques taken for granted by the other. Any educational endeavor that ignores the transmission of techniques can only become amateurish in the worst sense of the word—and, incidentally, that is one reason why the current fashion for various manifestations of folk art is a parallel to that for astrology in the popular hinterlands of science. Both are primitivistic rather than truly primitive or archaic. To indicate the subtleties and difficulties involved here, we should note that Dubuffet as well as the Chinese late Ming literati demonstrate that sophistication can be masked as naïveté—the result, however, being a far cry from folk art.

Still a third part of the transmittal aspect of education involves achievements of past and present as possible models for starting points or variations in the present. Of course this involves evaluation and selection. What models are to be singled out for more than usual attention? Here there is room for individual taste as well as for the cumulative verdict of history. Yet, unless transmission includes models,

configurations of fact and technique, the educational process becomes fragmented and immersed in detail. An atomistic view of history or education has its attractions, particularly when the imposition of patterns, models, or configurations becomes unreasonable and unsupported, or when it becomes dogma. The ebb and flow of movement among these three parts of educational transmittal—information, technique, and achievements as models—are essential and should be normal.

In addition to transmission, education should be concerned with innovation. Techniques can be a part of this, but facts should not be invented. Science and technology, individual imagination, or philosophic innovation can all provide the occasion or the means for quantum jumps in the arts. The invention of porcelain as well as that of abstract art are examples of innovations of major concern to art educators. The developments of Gestalt psychology in relation to visual images are yet another area of educational innovation, and they are still in process. The "Prints Teams" of the People's Republic of China produce work by cooperative means that should be of more than passing interest to the educator. Innovation is particularly important in the posing of problems and questions. A monotonous skepticism is usually counter-productive, but the new problems posed in painting by Picasso and Braque from 1907 to 1913 were as much questions of past assumptions as they were new discoveries. Innovation, whether in education, art, or science, does relate to the past, whether in constructing new models explaining history or in extracting from that history facts, techniques, or models that can be put in contemporary and different configurations. Education, particularly education in the visual arts, should know that the protean achievement of Picasso demonstrated that the past spurs modern innovations.

Before turning to specifics in art education and their relation to art museums, we should consider a fact, or is it a shibboleth, much discussed by intellectuals today—leisure and its concomitant, work, with particular relation to education and the arts. While it is true that many people have more leisure than before, many still continue to have little if any leisure. Those who do might well wish to spend some of their leisure being educated, enjoying art, or reading. But our consumer society has a particularly large industry dedicated to filling leisure by producing entertainment, and the distinctions between entertainment and enjoyment, or fun and experience, have become, at the least, somewhat blurred. We speak often of *popular* entertainment in music or theater and almost equally so of elitist or "highbrow" fare. And we all know what dominates entertainment for leisure time. I do not now or later advocate that art is necessarily good for one or that it is necessarily ennobling, nor that leisure should properly be filled with art or education. What does need clarification is the currently assumed dichotomy of nasty "elitism" and virtuous mass education in many disciplines.

Once again we are confronted with the importance of words and their meanings. If we speak of mass education favorably and then juxtapose as its opposite "elitism," we have made a choice harmful to understanding. Rather than elitist I would urge the word "aristocratic" in such a juxtaposition. Then our pejorative instincts will be well placed, for the assignment of merit by blood can only be appealing to those possessing it. But reason has properly denied that merit can be recognized by aristocratic right. The word "mass" is equally unilluminating, for it not only carries with it remnants of a discredited aristocratic snobbism, but it fails to recognize the humanity of man as an individual as well as a mere unit within a whole. Pride of lions, flight of ducks, mass of people—these may do for behaviorists, but for shared humanistic beliefs and assumptions, "mass" is simply inappropriate.

I suggest that we speak of democratic education and of the place of veritable elites within such a system. Bertolt Brecht's definition of democracy is relevant here. It is, he says, "to turn 'a small circle of the knowledgeable' into a large circle of the knowledgeable." No one winces when gifted dancers, creative writers, brilliant athletes, or wise committee members receive their justly deserved plaudits and respect. Such persons are members of an elite—a gifted, trained, and experienced set of persons preeminent within their chosen discipline. The sum of these elites is the glory of a democratic society. To denigrate the concept of an elite because of the abuses of hero worship and the star system is to look only at the rectifiable abuses of a fundamentally open system that makes possible the highest fulfillment of human capabilities. The problem is not how to destroy the concept of elites but rather how to broaden access to them and to cross-fertilize them, not by blood but by rational and emotional empathy. Other and radically different social orders, such as the People's Republic of China, consciously recognize the value of words and unconsciously admit the value of elitism when they substitute the term "responsible member" for chairman. Celebration and study of elites should be the order of the day in all areas of human endeavor—unless we have other and antidemocratic social *ends* in view.

If we can bear to accept elitism, then it has a creative function within the framework of a democratic culture and education. We speak of standards and goals; a currently fashionable word is paradigm. All of these imply a qualitative judgment of the standard and goal as worthy of emulation and effort—more worthy than other possible models discarded because they were not good enough. Behind all such judgments are knowledge, wisdom, experience, genius, dedication, and the many other extraordinary qualities that democratic elites bring to problems. Only the most obtuse totalitarian would find the combination "democratic elites" puzzling. The plural is essential to the meaning—not an elite, but many elites, as many as there are disciplines, games, studies, and arts in the complex mosaic of society.

* * * *

The visual arts are a part of this mosaic, and their place in the plan varies from culture to culture, geographically and chronologically. It is generally accepted now that art as experienced in any given culture, is unlike art in a different culture. But that different culture may see, experience, even incorporate, the first culture's art in its own way. Neither vision of art, the given original or the absorbed reflection, is "correct," though one may be considered preferable. These elementary propositions cause the frequent dissents between, say, artists and curators, connoisseurs and anthropologists.

Art is also but one of the numerous parts composing culture. It may *seem* universally important to an art historian or collector, but then so does music, dance, or chess to the true devotee. What is certainly true is that in our modern Western culture, and particularly in what we can call Anglo-American culture, the visual arts occupy a relatively minor and isolated position. Hence, our passion, anguish, and evangelism; hence, the failure of *any* weekly general magazine—whether *Time*, *Newsweek*, *The New Yorker*, *The Times Literary Supplement*, or the *Saturday Review*— to provide *regular* weekly columns on art. Literature, cinema, music, theater—yes; art —no.

We sense our loss of cohesion, our lack of visual literacy when we study Japanese culture, even in its present Western-influenced form. There the penetration of visual concern is to be found at all levels of society, as is easily demonstrated by an examination of the contents of department stores, fabric shops, or hardware stores, or by the enormous attendance figures at *all* exhibitions, whether of ancient or modern art. Even though one unsympathetically chooses to describe Japanese aestheticism as a mask, worn at home, or on vacation, or in temples, or on ceremonial occasions, in contrast to the implications of modern industrial sprawl in the urban areas of Tokyo, Nagoya, and Osaka, it nevertheless is an accepted mask used effectively by all, in contrast to our isolated and largely unattended efforts. Visual artistic competence is simply traditional, accepted, and integrated into the social and educational fabric of Japanese society.

This is so despite, or perhaps because of, the uselessness of art. Buddhist quietism in Japan may well encourage acceptance of useless aestheticism where the activist Protestant tradition in England and America occasionally attempts to legitimize art by making it useful (William Morris and John Ruskin), or worse, informational (art history and iconography are symptoms—though I do *not* in any way discard these disciplines as essential parts of artistic knowledge). The uselessness of art, its failure to provide useful information, lies at the root of its peripheral position in American education. Changing the nature of art, making it "fit" the curriculum, is not the answer to our problem of visual illiteracy. Changing the curriculum to make it "artistic" is equally futile. A place must be found for the visual arts as peers of other and different disciplines. Otherwise we shall, if we strive even harder, only increase an unhealthy and largely unrecognized tension.

Perhaps one entering wedge capable of redressing the educational balance in our society is to be found in the very complex and catholic nature of the visual arts. That taste varies, we know; the favorite cliché is that art is all things to all men. This widespread net may well be a saving grace for the visual arts, rather than a diffusion and weakening of particular strengths. Fritz Saxl's Warburg Institute in London taught us that the subject matter of art reaches deep into the philosophy, literature, mores, the very fabric of the culture of a time, reaching from that culture's present into a dim, even mythic, past. Psychologists and scientists exploring phenomena of light and color have revealed layers of visual complexity, largely unknown to even the cultivated connoisseur. Literary studies, particularly those related to seventeenth- and nineteenth-century art, have rehabilitated whole schools of narrative painting hitherto scorned by critics dedicated to "significant form."

These nonartistic disciplines, and many others, have discovered unexplored territories in the visual arts and in doing so have revealed the inherent capability of the visual arts to be all things to all disciplines—in short, it can well be argued that the study of art (art history, for want of a better term) is the most fruitful interdisciplinary study available to the academic world at all levels from elementary through graduate school. To understand a work of art fully requires much more ancillary knowledge than to understand a work of literature, music, science, or technology. Furthermore, the knowledge so acquired has in art a natural living focus rather than an artificial one. The history of art can be an organic mode of penetrating the culture of a given historical unit, whether chronological, geographic, or cultural, to a degree no other single discipline can achieve. Such a claim must inevitably draw resistance from other disciplines, but I find it persuasive and look forward to a day when art history becomes *the* catholic rather than *a* parochial member of those studies comprising the pregraduate curriculum.

What, then, is the place of the art museum in relation to art and the study of art? The haphazard accumulation of works of art within a structure dedicated to their display and preservation may well have no purpose beyond that of the accumulations of squirrels. But the effect of the holdings of art museums is, or should be, rational. Meaningful juxtapositions can be made as part of the museum's program or, where no such program exists, by the knowledgeable visitor who can mentally order the disparate exhibits. The essential thing is that these collections exist and that they are available year to year, decade to decade. As a resource not unlike a library, the museum's collections make it possible for each individual, group, or generation to arrive at its judgments and provide its insights about the past. But even more, these accumulations are meat for the present, the charnel grounds over which the living ride—as Blake and Cézanne,

among others, acknowledged. The art museum is both dead and living, but always a primary source for much of what is seemingly contemporary in our interpretation of what we see.

The extent to which works of art are placed in meaningful contexts, whether historical, material, technical, aesthetic, or other, represent the decisions of those responsible for the museum's policies and programs. However, one should realize that such contextual displays are arbitrary. Like a work of art or science, such contexts represent one ordering of data, and the effectiveness of the ordering is subject to exploration and evaluation. Still, one would probably not wish to apply the Dewey decimal system to the display of works of art. Retrieval for *all* of knowledge is not governed by the same assumptions as those required within a particular discipline. Specialized libraries use different systems, and art museums can present (retrieve) their works in contexts indebted to history, technique, media, subject matter, or aesthetic form—but these contexts must be consciously chosen and their components carefully organized. In short, the art museum has a responsibility to organize its primary sources, and in doing so it is performing a basic educational function.

However, there are different kinds of art institutions. A museum devoted to ceramics or art technology might well be expected to order its materials and its educational programs differently from those provided by a museum of fine arts, a museum of Christian art, or a museum devoted to contemporary art. Here we encounter a semantic problem, not only in terms of function but especially in terms of public and governmental acceptance. The word "museum" has, perhaps properly so, an aura of general acceptability. Accordingly, many other worthy activities, related but not by any means identical, are subsumed under the museum heading; the differing functions of these activities thus become commingled and result in a whole equal to less than the sum of its parts. We are in urgent need of an expanded vocabulary covering the often widely divergent needs and purposes of various individuals and groups devoted to the arts. In order to qualify for certain types of funding, the art museum tries to assume the role of elementary school; to qualify for other kinds of support, the cooperative art group may attempt to take on the role of the art museum. Furthermore, the art museum or the art center may even try to absorb all of these functions and many more. Such an undifferentiated organization runs the risk of becoming merely diffuse. Lack of differentiation may be very effective in a preliterate society, but it is usually ill-adapted to more complex, literate cultures. What we need is sharper differentiation, a more certain and precise perimeter within which we can effectively operate. The educational potentials of all art institutions, organizations, or groups are present and could be accounted for if only we knew where to look. A large part of that search is for identification. We need to know with precision whether we are looking at a museum, an art center, an artists' guild, an art school, or a center for the performing arts. There is

need and ample room for all these as well as for various kinds of art museums, but we need to define their functions. And, as the Bible warns us, their names are more important than we know.

All of this leads to the specific question of what is a real art museum and what are its educational responsibilities. It has already been indicated that the existence and availability of an art museum satisfies a large part of that responsibility. This massive, if passive, contribution should extend to the visual presentation of quality, always remembering that quality is most definable within given related types. Still, the dumb presentation of Botticelli with Jacopo del Sellaio is itself an education in the difference between the best and the good. If we extend this visual presentation to include the hundreds, thousands, or, in the case of a major institution, tens of thousands of objects, then the size of the educational impact becomes evident.

Evident it may be, even to the untutored but apt pupil; yet it would be the sheerest snobbism to hold that better results could not be achieved by doing more than just presenting works of art, no matter how cunningly they may be arranged. The question then becomes, what kinds of educational efforts will be useful to the fundamental purposes of the institution and the needs of its publics—not only as stated by them but also by their critics?

Most critics could agree that a lack of visual perceptiveness is a major failing of people educated in our literary and auditory society. Aesthetic education would then seem to be a unique and all-important activity for an art museum. Before considering that primary task, however, what of other educational approaches that may be both good in themselves and of assistance in the fundamental aim of aesthetic education?

We have already urged the utility of art history as a particularly suitable vessel for "interdisciplinary studies." The historical context, symbolic content, literary background, and technological fabric of the work of art cut across many humanistic disciplines and a few scientific ones. If the work is studied, examined, interpreted, and experienced by enlightened and profound means, it can be seen to contain a concentrate of the culture of a place in time and to be capable of stimulating reactions within the student's mind involving *his* culture.

The art museum and the teacher of art should use history, not only as a general screen behind the observed work, but as a specific and detailed part of that work. Frederick Antal's analyses of Florentine painting and the sources of its economic and social support, taken together with Millard Meiss's study of the religious confraternities and their impact on Florentine art, provide a profound reading of history as well as of art. If ancient, medieval, and renaissance history are now rarely taught in secondary schools, perhaps art history could remedy at least a part of that loss.

And what of early undergraduate exposure to the humanities? Is this not a proper and potentially fruitful opportunity for the study of art history, especially by non-majors in that discipline?

Emphasis upon "aesthetic form" in the first half of the twentieth century played havoc with literary painting and the literary "reading" of subject matter in art. While one would not substitute art history for literature, full exposure to the complexity of art history by secondary school and early college nonmajors in art, might profitably stimulate longer, deeper, and more imaginative readings of the subject matter of art and of its sources. The very process of transforming literary description or narrative into visual imagery, for example, is an intriguing and necessary human activity enlightening to those with unspecialized interests. One thing seems clear to me as a teacher: the competent student of art history understands more of the Vulgate and King James Bible than most of his high school and college peers. Well-explicated comparisons of Rembrandt's and Guido's Biblical subjects are effective means for understanding the Reformation and Counter-Reformation in the seventeenth century —and, of course, they provide other intellectual and affective benefits as well.

On the other hand, it is a commonplace that students of art history are seldom aware of the material and physical properties of the works about which they so freely extemporize stylistic and iconographic essays. Measurement, the chemistry of pigments and grounds, the physical properties of metal or stone, all have existence in themselves and as determinants of the final aesthetic shape of the work of art. Scientific theories have their reflections, sometimes dim but still discernible, in the artistic set of mind. Theories of indeterminacy, the Copernican "revolution," and Chinese prescientific cosmogony, are a legitimate part of the history of art, and exposure to such phenomena would be salutary for students, particularly those who customarily avoid the sciences.

These aspects of art history are concerned with more advanced education. This need not be totally so, but it seems likely that such complexities embodied by the artist in his works are more accessible to secondary school and college students than to those in the lower grades.

Here we must take up a primary educational task of the art museum and the schools—especially the latter. Most people can read (even if they do not) and can understand written or verbal exposition because they were taught to do so. Our compulsory mass educational system teaches students to recognize and to make meaningful combinations of visible and auditory symbols. They may not fully comprehend difficult texts, but f-i-s-h is elementary. Not so with visual forms (as distinct from linguistic symbols). The color wheel, the concepts of values, saturation of hues, the simultaneity of negative and positive shapes, the mathemat-

ical structuring of pictorial composition, and all such elements of visual vocabulary and syntax are not a regular part of the early school curriculum. There is simply no time in the school day for the visual arts, and the proof, if any were needed, is the unseemly haste with which art teachers are released when school budgets are reduced. One need say nothing of the kind of teaching, the quality of the teachers, or of their preparatory institutions. The evident fact is that the visual arts are a poor last in the educational order and that as a nation we are indeed visually illiterate.

We got here through the public school system, aided by long traditions of grassroots neglect of the arts. I assume that visual literacy can only be achieved by reversing matters. In terms of quantity the art museum can be only a minor part of the process. The mass educational system will need to be changed by pressures from without and within before any large-scale amelioration of the situation can occur. What then should the art museum do about mass education in the visual arts?

If we consider the numbers of public school students within cities or counties that contain adequate art museums and then add the number of those students in areas beyond easy reach of such art museums but who could use the museum's facilities, the physical impossibility of the museum's meeting this mass educational charge becomes crushingly evident. Recommendations that art museums should attempt to perform this task surely stem from ignorance. One-shot class tours are still the bread-and-butter effort of the museum for mass education, and in some cases they are at least a palliative. However, on balance (particularly considering how long they have been practiced), such tours have had no visible impact on the mass improvement of visual literacy.

The concentrated program involving lengthy and continuous exposure of the student to the art museum's environment and concerns, has proven effective. If such a program cannot be physically provided at a major museum for all schools, it can at least offer a model for the schools themselves to use if they will. This kind of influence, achieved through models, pilot projects, teacher training, and special classes for those who *will* to have them, seems to me to be reasonable, effective, and attainable for the art museum with adequate professional educational staff and facilities. More could and will be done with older high school students. The cooperation of museums and colleges or universities is growing and should lead to more and better exposure of the college student, even the nonart major, to the visual arts. These programs can be correlated or integrated with adult education efforts on the part of both museums and institutions of higher and extended learning. Still, if these future efforts are to succeed, they will have to be made within the perimeters of a reasonable and just estimate of what art is and what it can and cannot do. I have tried to indicate that these boundaries do not contain the notion of universal admiration for and need of the visual arts; nor do they include that therapeutic area where art is somehow "good" for anyone. Mutual respect among various

disciplines, sports, and amusements may be more useful in the long run than anything else we could accomplish.

What I plead for is a pragmatic and realistic approach to the broader, larger considerations—and paradoxically, for high idealism in and dedication to details. This method of operation for the art museum, and particularly for its educational program, may not save the world, but it can help us to provide the most perfectly calculated displays of works, accurate and intelligent catalogs, well thought out and persuasively taught seminars or workshops, carefully conserved works of art, truth in labeling, recognition and use of the concept of quality, an almost infinite number of particulars. However, let us not deceive ourselves on too-perfect, all-embracing aims and purposes—just enough at a time to make the mark, always remembering the overriding need for the contents of the art museum to be visible now and in the future. The burning of books in China under the first universal emperor Shih Huang Ti, in Alexandria by some know-nothing Christians, in Germany within our memory, are concrete examples of man's willful destructions of his own accumulated wisdom and knowledge. The very possible atrophy of the art museum by misuse would be an even worse tragedy, for it shall not have been willed but accomplished by a lethal combination of good intentions and default.

As marginal institutions, suppliants to the private and public purse, art museums (meaning of course all those who staff them and make their policies) are understandably sensitive to reasonably objective study, let alone criticism. Tearing to tatters may be commonplace in the criticism associated with literature, music, and drama, but positive thinking and the maintenance of a solid, if mute, defensive front are standard good form in education and the visual arts—especially with regard to art museums. Critical (in the best sense of the word) studies and attitudes are uncommon in this area for a variety of reasons—penury, servitude, sloth, good manners, and not many others. The proof of the pudding is to be found in the literature associated with art museums (seldom, if ever, passionately for or against anything) and in the simple fact that most of the gifted talents in the field of art history and criticism gravitate at graduation to the colleges and universities. The complaint of many museum recruiters is not that nobody is available but that no person can be found. The intellectual stimuli symbolized by the healthy give-and-take of responsible criticism are largely absent from the "universe" of the art museum. In this field we all need help, whether proffered in positive or negative form. Boosterism has no place in institutions claiming a rightful place in the intellectual community. And if art museums are not a part of that community and do not subscribe to what should be its tough standards, then they are indeed unworthy of the kind of unqualified support they request and urgently need.

Life, Liberty, and the Pursuit of . . . What?

This is an edited version of the convocation address for the annual meeting of the College Art Association, given at The Metropolitan Museum of Art, 27 January 1978, as subsequently published in College Art Journal, *volume 37, no. 4 (Summer 1978).*

The Declaration of Independence was the first effective such document in modern times. Though not part of the Constitution nor formally adopted as national law after the Constitution, it has been imbedded in the law through tradition as well as numerous court decisions. The phrase chosen as our subject is probably the most basic and famous one in the Declaration, and it has evoked a massive body of comment in court decisions and in critical literature. While life and liberty have been largely accepted as given then and continuously ratified from the French Revolution onward, the "pursuit of happiness" has occasioned both discussion and argument.

Happiness may be an ambiguous word now—"happy as a clam"—but its general meaning then was more pointed and specific. Thus Spenser writes, "Like beast [that] hath no hope of happiness or bliss" (*Ruines of Time*, 357, O.E.D.). Howard Mumford Jones[1] notes that the colonial rebels, well grounded in classics, agreed with Epicureans, Stoics, Aristotelians, and Platonists that happiness was some form of virtuous activity. The ancients distinguished between enjoyment, appropriate, for example, to cattle, and happiness, involving contemplation and hence appropriate to humankind. Thus Seneca in *De Vita Beata*:

> *A happy life, therefore, is one which is in accordance with its own nature, and cannot be brought about unless in the first place the mind be sound and remains so without interruption . . . It must also set due value upon all the things which adorn our lives, without over estimating any one of them, and must be able to enjoy the bounty of Fortune without becoming her slave.*[2]

The problematical, subjective, and elusive quality of happiness as virtue was subtly expressed in Gibbon's last sentence of Part I of *The Decline and Fall of the Roman Empire*.

> *We may therefore acquiesce in the pleasing conclusion that every age of the world has increased and still increases the real wealth, the happiness, the knowledge, and perhaps the virtue of the human race.*

If wealth and knowledge could be seen as being cumulative and progressive, con-

trariwise the virtue and goodness implicit in the ancient concept of happiness could be expanded to include concepts less and less subject to quantitative analysis. Consequently there were studious efforts on the part of many affluent Americans to identify happiness with material accumulation, or even to replace the ambiguous and potentially dangerous word with another of more weighty and temporal import —*property*. Thus, until 1902, while seventeen states incorporated "pursuit of happiness" in their constitutions, at least seven states substituted the words "acquiring, possessing, and protecting property and reputation."[3] The conflict and difficulty were clearly recognized by the Wisconsin Supreme Court in 1906 when it opined:

> *It is relatively easy to define "life and liberty" but it is apparent that the term "pursuit of happiness" is a very comprehensive expression that covers a broad field.*[4]

and went on to identify the principle with the right to bequeath property. Perhaps they should have made reference to the specific if broader definition of John Locke, who wrote on this very problem.

> *Not what I own, but the faculty to make use of my own, the liberty to employ my faculties to ends I have myself determined. This is the higher meaning of* property.[5]

"To ends I have myself determined" is indeed good, hardheaded empiricism displaying a new self-will unhampered by the psychological or mystical problems inherent in the concept of true happiness—and even more, in that other word bound to happiness—*pursuit*.

This word in the Declaration has received less attention than its object. At the most visible level, pursuit implies that the goal of happiness is perhaps—but not necessarily—attainable and further, that pursuit itself may well be a part of a process encompassing happiness. One has life and liberty in order to pursue what is good and true. Pursuit is a means to an end and is bound to the other word in an indivisible activity. On a deeper level the word pursuit has a special flavor, more profound and meaningful than merely a chase. English usage makes this clear. The *Oxford English Dictionary* confirms that one pursues truth (Wood), love (Addison), passions (Hobbes), to which one can add the proverbial pursuit of knowledge, excellence, perfection, and all those other virtues or principles so dear to commencement and convocation speakers. Behind the cliché lurks the uncomfortable truth that though we may chase rabbits, we pursue truth. Pursuit is a serious, even mystical, conception; at the very least it consumed the pursuer. But in a perceptive mystical reversal the burden is often shifted from the quarry onto the pursuer. Mystical literature is rich in this notion and Francis Thompson's *Hound of Heaven* may stand for them all, where man becomes the object of God's pursuit.

I fled Him, down the nights and down the days;
I fled Him, down the arches of the years . . .

Now of that long pursuit
Comes on at hand the bruit;
That Voice is round me like a bursting sea:

In short, whatever is worthy of pursuit has the capacity to become the pursuer. Man pursues happiness, the good, love, knowledge, truth—or art, but is in turn pursued or obsessed by them. He may expect something of them; but they demand something of him—not just barely enough truth or knowledge or art to get by, but as much as is humanly possible, and sometimes, it seems, even more. The unattainable but necessary goal is not just "good enough," but perfection. Accepting this fate, the artist, scholar, philosopher, historian, athlete, whatever creative person you will, recognizes excellence and its concomitant, elitism.

The dreadful word has become increasingly contentious, misappropriated by politicians and mischiefmakers, and misunderstood by the ignorant as a synonym for snob, with its associations with superficial society and arrogant wealth. *Elite, elitist, elitism,* carrying their true associations with choice or the best, are words that deserve respect and allegiance, particularly from those in hot pursuit of excellence. The attack on elitism is cant, pure and simple, as Stuart Hampshire forcefully puts it:

> *. . . because everyone, including the mythical man in the street, admires, studies and imitates the few supreme practitioners, and also the competent critics, in any pursuit that he takes seriously, whether it is an art, a craft, a game, a sport. No one thinks that local connections, earnest endeavours, and goodwill are any substitutes for genius and talent in any pursuit in which they are really interested. But it is convenient for politicians to ingratiate themselves with this 'man of the people' style.*[6]

The accusation of elitism inevitably carries with it elements of condescension. If excellence is the curse of the chosen, then mediocrity is the presumably assigned lot of the remainder. The good is too good for those beyond the pale. This perverse logic is characteristic of various pseudodemocratic movements, from the "Know Nothings" of late nineteenth-century American politics to the populists of today. Folk humor quickly recognized this inconsistency with its aborigine replying to the condescending missionary in perfect English, or a Northwest Indian in a current television commercial identifying a plane overhead to a slick trader as "a B-747, you dummy." The antielitists in the long run underestimate the capacities of the various publics. Nineteenth- and twentieth-century communications are a two-edged sword and one should not be surprised at the often sophisticated aspirations of the disadvantaged. One of the best of many current indications of this is to be

found in Kenneth Koch's teaching of poetry to the very young (and later, to the very old) as recorded in his *Rose, Where Did You Get that Red? Teaching Great Poetry to Children.*

> *The usual criteria for choosing poems to teach children are mistaken. . . . These criteria are total understandability, which stunts childrens' poetic education by giving them nothing to understand they have not already understood; "childlikeness" of theme and treatment, which condescends to their feelings and to their intelligence; and "familiarity" which obliges them to go on reading the same inappropriate poems their parents and grandparents had to read.*

In short, it is more and more apparent that the confusion implicit in the now wildly fashionable demand for relevance and a "nonelitist" approach cloaks a parallel confusion and failure in the subject matter and methods of education. Some scholars, thoroughly grounded in both art and social thought, have got it right. Arnold Hauser points out that "good taste is not the root, but the fruit of aesthetic culture," and that "public taste is not a primary datum; it is what it has become."[7] That is, public taste and its foundation, knowledge, is determined by what is offered —a conclusion so sensible and objective that it should command the assent of all reasonable persons.

Before continuing to both pernicious and constructive means of offering knowledge of art to the various publics perhaps we should recognize at least two levels of elitism without whose offerings we should all be much poorer. One is at the highest level of individual creativity, the other at the level of codifying and organizing both the achievements of, and the potential indicated by, such individuals.

The following words of J. Robert Oppenheimer are a moving expression by an elitist of what it means to be one and of the harrowing problems accompanying high achievement.

> *We also know how little of the deep new knowledge which has altered the face of the world, which has changed . . . man's view of the world, resulted in a quest for practical ends or an interest in exercising the power that knowledge gives. For most of us, in most of those moments when we were most freed of corruption, it has been the beauty of the world of nature, and the strange and compelling harmony of its order, that has sustained, inspired, and led us. That also is as it should be and if the forms in which society provides and exercises its patronage leave these incentives strong and secure, new knowledge will never stop as long as there are men.*[8]

The close relationship of scientific creativity to that of art is clearly expressed here, as well as forebodings of corruption by the ancillary misuse of what has been created.

At least a part of the protection necessary for discovered "truths" has traditionally

been provided by the now much-maligned academy, an institution that can also be identified as an association (The College Art Association) or a society (The American Philosophical Society). At its best the academy, in the words of Charles Fried,

> . . . *stands behind the idea that knowledge may be pursued for its own sake and the idea that a criterion for that pursuit of knowledge for its own sake is generality, depth, power; but these notions of power and depth should not be allowed to loop back into utility.*[9]

Both Oppenheimer and Fried reveal a deep-seated fear of "corruption" and "utility," something that should not surprise an observer of elitism. Pursued by their art, jealous for its creative capacity to enlarge the perception and knowledge of man, their happiness lies in the pursuit, and in the transmittal, of their discoveries. Corruption begins when utilitarian modes, whether collectivist or capitalist, preempt the understanding of science and art for ulterior purposes that immediately diminish or pervert the intellectual and social climate making such achievements possible. If we can smile at the alchemist attempting to make gold from copper, we should at least appear puzzled if he essayed the reverse.

Such perverse alchemy is currently attempted, if still unsuccessfully, under both socialism and capitalism. The Cultural Revolution in the People's Republic of China now seems a repudiated effort, at least in the realms of art and science. The depiction of happy peasants, whether by professional artists dragooned into the activity or by talented peasants supervised by the professionals, is no longer enough. The carefully proper and defensive attitude of Chinese art historians in 1973 has been modified to a point where even such an elitist artistic endeavor as traditional Chinese painting can be discussed with Westerners. The cultural aspects of the social experiment in Sweden have been recently devalued by the Minister of Culture of that country.

> *Within the workers' movement we believed for a long time that increased welfare for the broad mass of people would automatically bring a growing culture need and a rise in the level of culture. Today we are not so sure—one is rather more inclined to believe that no such connection exists . . . What is worrying is that mass culture's products flood over us in such a steady deluge.*[10]

But we live in the United States and the problems I am now concerned with exist here and nowhere else. They concern the relationships existing between business and the arts, the latter a phrase very much at the center of contemporary exhortations. What follows does not deny the value of money and disinterested support, but does attempt to suggest that there are clear and present dangers in a necessarily uneasy relationship. Why uneasy?

The seats of unease were proposed as early as 1838 by James Fenimore Cooper.

> *Commerce is entitled to a complete and efficient protection in all its legal rights, but the moment it presumes to control a country, or to substitute its fluctuating expedients for the high principles of natural justice that ought to lie at the root of every political system, it should be frowned on, and rebuked.* [11]

If we substitute for "fluctuating expedients," "good enough," that is, utility, then we find the nineteenth-century quandary to be a twentieth-century one. There should be no misunderstanding at this point; "good enough" is indeed good enough in the production and supply of staples essential to the health and physical well being of all the people. Mass production of materials good enough for these purposes is the only satisfactory means known to us for today's numbers—and with it come concepts of utility and reasonable cost. But these requirements are at total variance with what I take to be the essentials of art—uselessness, perfection, and often, unreasonable cost. This opposition of utility and happiness or delectation is common in both the collectivist and the capitalist state, but in the latter the peculiar needs of art are tolerated, sometimes encouraged, while in the former the few early harbingers of creativity were effectively suppressed.

The situation is no different in science, ultimately congruent with art. Under ancient aristocratic patronage and its ensuing conservative or radical successors, scientific research was accepted as a gamble. But today neither government nor business prefers such gambling. Businesslike arrangements are preferred and the more predictable such an arrangement the better. As Charles McCutchen puts it, "Business itself dreads uncertainty, and business methods are designed to eliminate it." [12] The same can usually be said of the monies appropriated by the various legislatures for support of either the sciences or the arts. The old capitalist adage "money doesn't stink" really only applies to free money, money without unnecessary strings. Beyond this an argument has been made by Stuart Hampshire which I find compelling as an extreme case.

> *Private enterprise in the market for entertainment, the leisure industries, will always have an overriding interest in promoting the greatest possible uniformity of taste in the public. . . . It will organize a mass market for safe and familiar products, and it will neglect and deride experiments and minorities, with the reliable support of the press.*
>
> *. . . a public corporation has been able to act on the contrary view: that the public, taken as a whole, consists of a number of overlapping minorities, and should be treated as such, with a view to reinforcing tendencies to variety, and to experiment already in being. To treat people as if they already know what they want and as if they ought to know what they want, in matters of taste and imagination, is to treat them as less than human.* [13]

We can scarcely be surprised, in the present state of forced accommodation or confusion if the boundaries between art and commerce have been obliterated. Thus business, with its legitimate utilitarian mission of supplying as much as is needed, useful, and economical, with academic support becomes a teachable art and "management by objectives" acquires a bogus status as mystique, or even an art. Indeed, bureaucracy, whether in business or in government, ceases to be a means to an end but an art or skill to be practiced as an end in itself. Contrariwise, a real artist, Christo, creates a fence whose million-plus cost represents a compromise with business methods in being only the best fence he could make within the utilitarian limits of available money and existing law. In this situation, the now questioned easel painting at least falls outside such limitations and the perfection achievable here is limited only by the capacity of the artist. Hence, too, the confusion of the Congress and the I.R.S. in allowing only the cost of materials as a base for the artist's evaluation in making a gift within the limits of the applicable tax laws. In Japan, at least, they sometimes recognize the worth of the art in the artist by registering him rather than his work as an Important Cultural Property. This echoes an earlier Chinese tradition of "spirit-resonance" (*Ch'i-yün*), the sine qua non of painting, as residing in the artist and the beholder, with the work of art being simply a means of transmitting the essential element of art.

One can study and criticize this general process of infiltration from one realm into a different one, but what is one to make of the hearty endorsement given business methods by art museums? Some art museums have adopted an organization having an administrator with business and/or bureaucratic experience as the chief executive director; but this practice, officially disapproved of by the Association of Art Museum Directors, is still a minority one and its fundamental lack of logic or principle need not concern us here. A more pressing problem is set by the entry of many museums into the realm of business marketing, not of original works of art —which might be a defensible maneuver—but of replicas, reproductions, copies, or adaptations of original works of art. Both the theory and practice of this development are worth critical examination.

I think few would deny the research and educational worth of reasonably accurate photographs, slides, postcards, or printed color reproductions of works of art. They may well have become too easily available and heavily used—hence the ironic description of art history as the history of slides—but they have made possible considerable advances in attribution, iconological studies and, not least, simple awareness of an enormous body of hitherto unknown works in remote or obscure locations—whether Liao-ning or in storage at major museums. Again, we are not concerned here with these, for they clearly do not really claim to be anything like originals. For proof of this we need only note that they are not the subject of major sales advertising campaigns for the general public. Everyone knows what they are—and what they are not. Our concern, for there are many others who question

the practice we now consider, is for those replicas and adaptations, largely three-dimensional, that can be proposed, however remote the justification, as actual substitutes for an original work of art.

These questionable replicas are produced in quantity, whether in actual or supposedly limited editions, or in frankly unlimited numbers. They are mass produced copies of handmade originals whose very nature involved variety, adaptability, improvisation, and accident. Such qualities are precisely opposite to those inherent in mass production. Arnold Hauser notes, "By contrast, the rules according to which mass art has to be produced are strict, rigid, and inexorable," following the "well-worn lines whose popularity has already been proved." [14] A work is chosen for reproduction, not because of its place within an educational context, or because of its intrinsic aesthetic worth, but because of its marketability. Usually the choice is made, not by a curator or educator but by persons on a sales staff. Arguments are piously made that the process aids the appreciation of art, and more pragmatically that the sales provide income for scholarly or educational uses. The first argument is effectively parodied by Etienne Gilson:

> *The cycle is then complete. Art appreciation is being taught on the basis of industrial products imitated from works of art, which are not works of art.* [15]

We must agree with Hauser that the reproduction is a commodity with no individual value. As a substitute it is aesthetically worthless. [16] In this it differs from original photographs and film which consist of nothing *but* copies. Parenthetically, one wonders why museums in financial need do not exploit the sale or use of original photographs and film since these are replicable aesthetic objects or events and can enhance knowledge and provide enjoyment. One thing is certain, the questionable replica bears little relationship to its original when a direct comparison is made; while the adaptations simply corrupt the integrity of the original and are properly in the world of fashion rather than that of style.

But the replicas, in themselves, are not the most corrupt part of the whole transaction after all; most of them will be lost, strayed, or stolen. They are usually marked so that future confusion can be avoided. They will simply add more to the accumulated detritus of modern culture. The best they can hope for is to become part of that catchall of the pseudoantique market—the collectible.

The more dangerous part of this commercial transaction lies in its ambience. Scientists are necessarily aware of and on guard against the environment inevitably accompanying any experiment. Writers, not publicists, are acutely aware of the precision of language necessary to convey either meaningful exposition or literary delight. Psychology teaches of the invariable connection between stimuli and responses. Art museum and commercial replica sales operations are not exempt from these considerations of cause and effect. When a label in the permanent col-

lection or a lecturer in the educational department of an art museum expounds
on the integrity of material in Egyptian stone sculpture, how can the interested
layman be reconciled to the more widely dispersed and more persuasively phrased
legend in a sales catalogue from the same institution which claims for a facsimile of
an archaic Egyptian lion that "after two years of research we have been able to
create in polymer the marvelous glitter and translucent surface of quartzite rock"?
How can one maintain the concept of integrity of scale in the comprehension of
a work of art when a major sales advertisement celebrates the reduction of a life-size
gold mask to a miniature "small original sculpture"—to say nothing of the claim
that other reproductions are "exact duplicates of jewelry and sculpture," or "(Limited
edition of 5,000 copies. Each with numbered certificate)"?

What we witness here is the intrusion of commercial advertising language and
thinking into the communications of art and educational institutions dedicated
to truth on the gallery label but to, at best, exaggeration in their sales copy. The
language is indistinguishable from that of the Franklin Mint, whose most recent
and presumably successful endeavor, endorsed by four prominent art historian
members of this Association, is "an extraordinary collection of one hundred beauti-
fully sculptured art medals portraying the greatest masterpieces from the world's
most famous museums." Further, "This strictly limited Mint Edition is available by
subscription only." The copy then goes on to explain that each subscriber is limited
to only one set, but omits mention of any limitation of the size of the edition!
This advertisement is a two-page spread in today's most successfully marketed mu-
seum publication, *Smithsonian* (October 1977). There appears to be no advertising
disclaimer on the title page, though appropriately the editorial offices are listed
in Washington while the advertising offices are on Lexington Avenue in New York.
Ironically, the editorial in this issue wonders:

> *If we cannot make the museum profession attractive to highly qualified
> professionals and bring them into the ranks of curators, we will have failed
> our public as well as ourselves. Without them we are in danger of turning
> into that stereotype I described. . . . All crumbling away for lack of enthu-
> siasm, dedication and sheer love that go into the creation of a museum
> professional.*

The wild discrepancies between what the art museum may do in its collections or
educational programs and in its marketing of products recall only too well the
bitter inventions of George Orwell, "Newspeak" and "Double-think."

I believe one can have little if any quarrel with a carefully thought out museum
store program that recognizes the need to provide patronage for the living creative
artist or for mass-produced objects that fulfill well studied standards of creativity
and design. One thinks of the better part of the Museum of Modern Art's activities in
its store, even now being subjected to yet another careful review, and there are others.

Still, the problem will not go away. Why should business and commercial concepts and methods be all-embracing? Why does the introduction to *The Shopper's Guide to Museum Stores* present the following passage with not a thought to its implications?

> *A museum's association with a product has become an important attribute at a time when consumers are often skeptical about quality and workmanship. Coincidentally, the museum going public has reached a point at which its appetite and enthusiasm for aesthetics, history and science extends beyond the ownership of non-utilitarian replicas . . . to useful adaptations. Recognition of these two marketing factors was not simultaneously or quickly comprehended by museum store management or by those manufacturers, distributors, and department stores party to the development of museum-related products. Nonetheless, although the catalyst varies, more and more companies with little or no prior commercial contact with museums are becoming involved in the development of useful adaptations of works in museum collections.* [17]

In other words, the initiative for the current fashionable making and marketing of replicas and adaptations came from the business sector. We were chosen and have learned to love the product. Again as Orwell has it:

> *We are not content . . . even with the most abject submission. When finally you surrender to us, it must be of your own free will. We do not destroy the heretic because he resists us; so long as he resists us we never destroy him. We convert him . . . we reshape him.* [18]

Now, things are not yet as bad as all that, but the warnings are there and the increasingly complex fabric of interdependency among art, science, business, politics, etc., means that seemingly unimportant details and broad general principles are related and that both need careful study and purposeful action. What should the artist, art historian, and art museum professional do? If colleges and universities continue to demand excellence why shouldn't it be demanded of museums? And by excellence one can also mean excellent *haut vulgarisation* (or, as we say, popular education) in adult education as well as primary and secondary schools. Why cannot museums be included under the umbrella of academic defense of intellectuality against current tendencies to the contrary? Why can't the art historians fully accept the curator whose bread and butter is the object rather than the document? Distinguished historians such as Peter Gay can say,

> *Art, once again, enjoys no special status in historical analysis: its casual texture is as rich, as variegated, and ultimately as unpredictable as the texture of diplomatic or military events.* [19]

A work of art is as much a fact of history as any other thing, idea, or event, and we should be as concerned with the corruption of these particular facts as we are with the falsification of documents, misquotation, or quotation out of context. Academic instruction at all levels must make greater, not less, use of original material in teaching. Especially within this College Art Association, more attention should be given to closer relationships between art museums, artists, and art historians, and to a positive use and defense of the art museum as a part of the general virtue that Seneca, Gibbon, and Jefferson knew and that we know to be the principal part of happiness.

PART II: East and West

4 Charles Demuth, *Strolling*, 1912. 5 Charles Demuth, *At Marshall's.*

The Illustrative and Landscape
Watercolors of Charles Demuth

This article first appeared in the Art Quarterly, *volume 5, no. 2 (Spring 1942). It grew out of Lee's dissertation on American watercolorists and was written while he was working under Wilhelm Valentiner at the Detroit Institute of Arts.*

Like any Jamesian character,
They learn to draw the careful line,
Develop, understand, define.

W. H. Auden, *The Double Man*

Demuth is one of the two great modern American water-colorists. Whereas Marin presents the appearance of a romantic extrovert, Demuth suggests the introversion of the extremely sophisticated and sensitive person. Like Proust and James, with whom he had a sympathetic understanding, Demuth's art is the subtle, civilized art of perfected suggestion by indirection. It is of no use to discard him as overdelicate or too feminine, for behind his delicacies lies the strength of a great master. To the casual observer the flower pictures are Demuth's most representative works. More extended consideration reveals the strength of construction in his landscapes and still lifes, the strength of suggested emotion and setting in his great illustrations. Behind these qualities is a sure sense of materials, and an ability to organize aesthetic components in a complete and finished manner. Marin's work has been called sketchy; Demuth's could never be called that.[1]

Unlike other American artists, Demuth would have been the first to acknowledge his indebtedness to the movements of painting in modern Europe, particularly France. While in Paris from 1912 to 1914, Demuth was associated with Les Jeunes and the others around Marcel Duchamp. Cubism obviously fascinated him, particularly in still life and landscape. Watercolors by Marin and photographs by Man Ray were to be found in his Lancaster, Pennsylvania home. His awareness of the modern movements made him sensitive to the folk art of the Pennsylvania Germans as well as to other types in this country.[2] Like Marin he never imitated in a futile, derivative sense, but made the attitudes and techniques his own, to be integrated with his subject matter and his desires. His continued acquaintance with Sheeler, Marin, Man Ray, William Carlos Williams, and Stieglitz allowed him to keep up thoroughly with the mind of the day. After his two European trips of 1904 and 1912–1914, his traveling was confined to this country and Bermuda, but in gen-

eral Lancaster was his continued home.

Demuth's death in 1935 was the result of a long illness, an ailment that had always been with him and was one of the determinants in his choice of career. This sickness, diabetes, certainly must have affected his attitude and his art. It is, perhaps, too simple to say that the surface fragility of his work was the result of his affliction. But the fact remains that his boldest work was produced early in life, and that after he had embarked on the quieter still lifes he once answered, "I simply haven't the strength," when asked why he did no more figure pieces. Certainly this would indicate that his health had much to do with the turn of his work after 1920.

The earliest Demuths of interest to us were executed in 1912 on his second trip to Paris. In these works the illustrative qualities are preeminent. The handling of the medium is extremely simple, so simple as to approach the category of the tinted drawing. The delicate pencil line is continuous and flowing, the wash is even, wet and very transparent. These sketches have a simple, intimate air that is most appropriate to the handling. In *Strolling* (Fig. 4) we see the beginnings of that effective pencil work under the wash that does so much to enliven and strengthen even areas of color. Backgrounds are undeveloped in these early works, all interest being concentrated on the figures. The drawing, as in all of Demuth's illustrational work, is free flowing and not tied too tightly to the intricacies of the form beneath. Concentration is upon the momentary impression of pose and attitude, the hunch of a shoulder, the bend of a knee. I cannot escape the impression that these early works are parallel to some of Bonnard's drawings and prints. The intimate quality, the suggestive line and the delicate color seem vaguely common to both. These works can be considered as slight sketches but they definitely indicate the illustrational development of Demuth's next years.

During this second European trip, Demuth executed a few landscapes that are of passing interest because of their unusual flavor. The color in these is unusually complex with a full range of light Impressionist color.[3] Calligraphic squiggles of the brush give a nervous movement to the sea and landscape. The color is more sensuous, more full and saturated than usual, reminiscent of Signac in type. The strokes blend in with one another in a manner analogous to Renoir's late landscapes. The broad sweep of the distance in the landscape is also unusual, for Demuth characteristically uses enclosed and shallow space, well defined. These light, airy landscapes, sensuous and atmospheric rather than austere and organized, are sharp contrasts to the later pictures in a more abstract, constructive manner.

The year 1915 produced works that are diametrically opposed to these last mentioned pictures. In the *Flowers* of that year (Addison Gallery, Andover) the flowers are laid in a kind of allover pattern against a flat, close background of dark browns, maroons, and blues. The flowers, loosely drawn in pencil, are light against this area. The background is varied by pooling the color in the hollows and

wrinkles of the smooth paper, a method found in Pennsylvania German frakturs. This mottled texture advances and recedes, while the evenly washed flowers mark the forward limit of the apparent movement. These pictures are most sensuous in color and pattern. It almost seems as if Demuth tried his new technique out in an abstract manner before applying it to the illustrational scenes. In these flower pieces, however, there is little pencil work beneath the washes, and none of the sharp blotting effects which he used later.

In 1916 we begin to get the flood of illustrative watercolors that continued until 1920. At first these works carry on the methods seen in the 1915 flower pieces. *Angel Fish*[4] is mainly of decorative interest, like the flower pictures, but there is now the new element of human representation. The complete statement of the new form can be seen in the remarkable watercolors illustrating scenes of night life. In this respect they can be considered as a late manifestation of the fin-de-siècle concern with night clubs and places of amusement, as in Toulouse-Lautrec or Picasso. But these have a more vigorous air, less languorous and decadent than the mordant work of the Frenchmen. They are, I believe, our only pictorial documents of the prewar jazz age. The mottled and blurred backgrounds are familiar but handled with more control and more use of smoky, flamelike sections of paper. The colors are dark and hot, in keeping with the quality of the scene. The exaggerated whites of the blacks' eyes, the cramped gesture of the dancers and the gloomy, smoky atmosphere are all recorded with equal sensitivity. The loose pencil drawing, suggesting rapid movement into space in the lower part of the paper and becoming most nervous and flat above, contributes its share of the burden. This manner of working can be seen in the watercolor *At Marshall's* (Fig. 5). The integration of decorative with illustrational units makes for a very powerful effect. The immediacy of the response and the somber, deeply felt nature of the scene, make this a watercolor that holds up as well as Expressionist works by Nolde or Schmidt-Rottluf. The amazing delineation of macabre facial types in the right distance lends a grotesque note to the scene. The exaggerated pose of the tapdancer, as the arms swing up and the feet cross, is remarkably immediate in its evocation. This spontaneity is characteristic of the Expressionist aspect of Demuth's work as contrasted with the more intellectual and measured response in later watercolors. The mask-like quality of the face is emphasized, another macabre element which adds to the implied grotesqueness of the scene. Here the pencil work is fully subordinated to the washes of color with a blurred method predominating. The device of vistas seen through the arms and legs of the performer is unusual and is a well-known phenomenon to frequenters of night clubs. It is unfortunate that this work, and the others in Merion, are so effectually hidden from view. The color must be a lurid addition to the other elements of the paper.

It is a relatively short step from these pictures of the demimonde to illustrations for Zola's *Nana*. These pictures are the first of a series of illustrations for books of

6 Charles Demuth, *Nana, Seated Left, and Satin at Laura's Restaurant,* 1916.

varied types.[5] It is unfortunate that none of these has been used for publication, for
they are remarkable insights into the meaning of the works, as well as decorative
units of intrinsic interest.

The *Nana* series[6] uses the dark grape, maroon, brown, and black of the nightclub
scenes but adds a vigorous loose pencil hatching beneath the wash which adds to
the agitation of the representative and organizational elements. Zola's militant
realism is paralleled by Demuth's desire to comment and to project an intense
emotion into the illustration. In this sense, as well as in the resonance of the color,
these illustrations can be profitably compared with the Expressionist watercolors.
Ta Nana is the most powerful of the *Nana* pictures I have seen. The heavy pencil
drawing and scribbled hatching gives a rich, agitated texture. The movement
of color and shape is swirling, never resting in the blurs of background or in the
lines searching out the significant poses of the figures. The cheap-looking gold
mirror is an aesthetic and psychological element in the picture. From a narrative
point of view the picture shows a nude courtesan (Nana) before a mirror, her clothes
hastily thrown on a chair at the left. A man in underclothes (Count Muffat) de-

spairingly kneels before a crucifix on the floor. In the mirror is reflected the death's head features of the woman. We are presented with the naked emotion of the count as he despairingly identifies Nana with the evils destroying his society, and the woman herself oblivious to all but her body. All this is not obviously set forth, the representation of detail being subordinated to the general effect of the picture, a device common in Expressionist painting. The hot color, the agitated shapes, the narrative, all combine to produce a truly direct and immediate expression of material depravity, emotional despair and a sense of unceasing conflict and restlessness.

A second picture in the series[7] (Fig. 6), is less intense an expression, more akin to the previous night-life works. Here the boredom of the prostitute (Nana and her companion, Satin) waiting in a cheap dive, is the illustrational concern of the work. The savage pencil textures, indicating directions of movement, as well as fan-shaped texture units, are unusually prominent. This picture more than any other Demuth recalls Lautrec. The tilted perspective of tabletop and floor, as well as the distribution of objects on the table, in coherence with the location of figures on the floor, is perhaps more consciously arranged than in the spontaneous outburst of *Ta Nana*. But the communication of "blue" looks and a sour atmosphere with adequate aesthetic means mark this as another significant illustration. The more definite use of blotting in the upper right foreshadows the organized use of this method in later illustrations and circus pictures.

A series of watercolors (i.e. *Eight O'Clock*, The Museum of Modern Art, New York) executed in 1917 are an interlude between the Zola and the James illustrations. The subject, young men arising and dressing in a disordered interior, is common to these pictures. The general air of decadence and nervousness is again to be noticed. But there is an important expansion of Demuth's technique. The pencil hatching is still present, as are the fluid, blurred areas of color. But there is an added means of variation by a methodical and complicated system of blotting. The effect can be termed crystalline in appearance, as if a sharp point, covered with cloth, had been pressed on the almost dry color in a series of regular patterned points. This pebbly, crystalline texture can then be controlled within areas, long and striated, round and indefinite, depending upon the area involved. Combined with the use of pencil and blur this represents a development towards greater complexity and diversification. The use of this blotting in large areas leads to a more delicate and fragile effect, strikingly different from the bold treatment of 1916 and 1917.

In 1918 Demuth began the illustrations for *The Turn of the Screw*. These are the best known of his illustrations and the union of artist and author seems to be especially happy. I have seen only two of the six. Four are in the collection of Frank C. Osborn, Esq. These are reproduced in Gallatin. The fifth illustration, not listed before, is on the New York art market. A sixth illustration, the first in point of time, has hitherto been unpublished: *At a House on Harley Street* in the Museum of

Modern Art. It was listed in the Whitney catalog as a separate work, but the picture tallies in title with a section of a line on p. 11 of the Adelphi edition of *The Turn of the Screw*. The room in the picture agrees with the last lines on this page: "a big house filled with the spoils of travel and the trophies of the chase." The woman can be recognized as the governess, the man as her employer. The picture is earlier than the others for it is of the same heavy pencil style as *Ta Nana* and *Eight O'Clock*. The later works are lighter and more delicate, with a thinner pencil line and more crystalline blotting.

The early technique is well suited to the Harley Street atmosphere of the first scene with its air of splendor in the setting, and solicitude and interest in the figures. The deliberately fussy line adds to the overstuffed air of the interior. Significant details such as the stuffed birds under glass and the owlish moose heads add to this sensation. The placement of the two figures in the very close foreground serves to catch our eye while the accumulation of detail gradually creeps up on us. This subtle method is similar to the method of James in building up his air of suspense by the accumulation of sensitive psychological detail, a method which Proust used in France for his long novels of sensation, response, and introspection. The early works of Demuth have none of this supercivilized reticence and introversion, but under the spell of the novel the illustrations become more and more delicate, fragmentary, and reticent. This can be seen in the picture *She had picked up a small flat piece of wood* (Fig. 7). Much more of the paper is blank and the pencil is not heavily used, but lightly with a lacy effect. Especially well caught, in the spirit of the book, is the willful sullenness of Flora as she ignores the vision which appears to the startled governess. Only the three blurs in the upper right betray the presence of the ghostly figure.

Another of the pictures brings the four protagonists together, extremely well characterized; the bulky housekeeper, the sensitive governess, and the two children acting out their parts as creatures of sweetness and light. The crystalline blotting is used a great deal here to procure a mottled as well as a striated texture. The sudden vista, leading to significant detail, is present in this work as well as in the other illustrational pictures. This picture is also noteworthy for its development of rising motifs in the figures and landscapes, which add a sense of unrest to the surface calmness of the scene.

The climax of the story, the scene between the governess and Miles, is presented in a more simple manner with a suppressed background of vertical angular motifs in contrast to the more closely knit arrangement of the two figures, the anguished woman and the uncertain boy, torn by the conflicting desires of loyalty and degeneracy. Here the sensitivity seems to me too delicate, too remote for the great moment in the story. The earlier of these illustrations seem to be more effective. These are not obviously ghostlike illustrations, nor do they carry the direct impact of the *Nana* series. They are immensely subtle illustrations in a twisted, tortured

manner that parallels the style of the novel. Hints are dropped, nothing is demonstrated.

Demuth's liking for James's novels led to a second series of three pictures to illustrate *The Beast in the Jungle*.[8] In these, even more than in *The Turn of the Screw*, Demuth relies on the indirect glance, the momentary pause and subsequent embarrassment. The pictures are more simple and direct than the story, which is so reticent as to be almost without tangible meaning. The heavy use of pencil and color is revived and the blotting areas are decreased in size and number. Demuth found a contemporaneous outlet for this technique in other pictures of the time, for he was turning more and more away from narrative. The scene *Don't you know now* probes with piercing acuteness into the depiction of the embarrassed man and the uncertain woman. The dark units of the picture are confined so as to add to the "pale cast of thought"; one is more conscious of the light areas with the quavering uncertain edges of dark against light. The furniture is purposely more strong and forceful than the two humans. The final picture, the man prostrate on the woman's

7 Charles Demuth, *She had picked up a small flat piece of wood (Flora and the Governess)*.

8 Charles Demuth, *Marcher Receives his Revelation at May Barthram's Tomb*.

grave (Fig. 8), is a masterpiece in the integration of the coldly impersonal decorative treatment of the tombstones and trees as a foil for the misshapen and contorted figure of the man. The writhing character of the edges and the pathetic strung-out arrangement of hat, gloves, handkerchief, and cane, is most noticeable. The utter darkness of the figure against the pale areas is directly expressive of the mood and meaning of the final part of the story. The success of these James illustrations might have been carried on in the kindred spirit of illustrations for Proust's *A la recherche du temps perdu*, but these were never begun. Demuth's choice of books to be illustrated was particularly fortunate.

It should be remembered that these illustrations were not plucked from the written narrative only, but were built up out of many slight sketches from direct experience. In these, the flowing pencil line of 1912 is continued as is the pale wash of color.[9] These instruments are buttressed by a greater use of the blur and the blot. The picture in question, like most of the work of this time, is subtly suggestive in its design and representation. This is not obvious eroticism, but rather the type which becomes so veiled and meaningful in the hands of a James or a

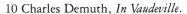

9 Charles Demuth, *Acrobats*, 1919.

10 Charles Demuth, *In Vaudeville*.

Proust. Demuth would probably never have illustrated the lusty exuberance
of Joyce.

During these years Demuth had applied his developed technique to a series of
watercolors concerned with circus and vaudeville scenes. On the whole these pic-
tures, in contrast to the illustrations, are primarily of interest for their qualities of
formal organization rather than for any illustrational or psychological significance.
They tend to be more rigidly organized with a more systematic and arbitrary
employment of blotting and pooling. In those that I have seen the heavy pencil
work is not so evident as in the pictures just considered. Here stresses and strains,
repetitions, contrasts, and plane recessions make up the structure of the picture.
In this sense they are more abstract than the others, and hence lead directly to the
cubist period of Demuth's work.[10]

As early as 1916 Demuth was interested in the design opportunities offered by
the sharp silhouettes of performers in the spotlight before a curtain. The movement
and quivering of the spotlight is well defined by the crinkly and nervous edge in
Demuth's pencil drawing. The movement into shallow space is often accompanied

by recessive elliptical planes, a method that he carries over in his later still lifes. The tensile strength of the figures in their strained actions is achieved by both a sinuous edge and a systematic system of blotting that add a subtle buttress to the other elements. One never finds an obvious strength in this man's work; but the power is there, achieved by deliberate understatement. *Acrobats* (Fig. 9) is a lighter, more delicate version of this theme. The division of the picture into circular, elliptical, and indeterminate vistas of varying opacity is especially noteworthy. The crinkled, blotted edges function as designations of the transitional penumbra between shadow and light. This nervous, quivering movement is continued throughout the picture, particularly on the edges of arcs and ellipses that go to make up most of the form of the work.

Others of this group develop the blotting technique until it becomes a major factor in the organization of the picture. By varying the weight and complexity of the striated texture, Demuth is able to make the tilted ground planes undulate and move in a nonstatic manner appropriate to the sweeping movements of the climactic unit. The illustrational power is still present.

In Vaudeville, in the Barnes Collection (Fig. 10) which I have not seen, is important as a static composition of great strength and weight combined with an indication of soaring movement. In the former respect it is akin, in a less substantial way, to the *Bather* pictures of Cézanne. Elliptical planes and shapes are prominent here, but they are interlocked and buttressed by angular and rectangular forms. These more solid shapes are picked up in the figures, giving them the same static effect. This is the function of the seemingly artificial pose of the man on the right. The general symmetry of the organization is an aid to the effect of the picture. The space is shallow and enclosed, but made less so by the variations induced through patterned and shaped blotting in a manner related to the "swirling form"[11] of Castagno's enclosed space.

Coincidental with the illustrations and the circus pictures (1918–1919) we have a large number of landscapes and flower pictures by Demuth. These works, in general, move from more curvilinear, organic forms towards more abstract and geometric types. This development can be attributed to his growing interest in cubism and more abstract statements of pictorial form. Like Marin, however, Demuth never loses contact with his representational elements. In these works the same thin washes, from dark raspberry to light tan, the same crystalline blotting, and the same swirling movement that we have seen before can be found.

A very close parallel, however direct or indirect, exists between Demuth's nature abstractions and the plant photographs by Blossfeldt. Demuth seems to move from these organic abstractions of nature towards more arbitrary man-made abstract forms. As early as 1916 Demuth painted a landscape which uses these rolling, interweaving planes.[12] These interlock in moderately shallow space to form trees and branches. Curved areas are repeated in an arbitrary symbolization of shallow

space. The solid forms of the picture are concentrated in the center of the paper and the farther the distance from the center, the more blank paper is to be found. This creates a single form in the picture composed of many interweaving parts. These organic, interlocking forms, defined by color as well as line, are carried over into the early flower pictures.[13] The strength and organization of this type is directly comparable to that of the landscapes. The later flower pictures may be considered more delicate, more naturalistic and less ordered. In the *Flowers* of 1918 in the Metropolitan Museum we notice a new element, unusual in Demuth's work. By means of color and tone he tilts four separate sections of the picture into separate vistas which recall Marin's more obvious "enclosure forms." Demuth, always more of an introvert than Marin, naturally turns to less direct methods.

Coincidental with arbitrary, rather flat, cubistic paintings in oil and tempera, 1917 produced aquarelle works from Bermuda, Provincetown, and Lancaster that have a more balanced proportion of organic and geometric shapes. In these we find a range from the complex, crowded forms to the spare, austere organization of *Landscape* (Private collection, Detroit). These pictures are characterized by a generally similar organization; angular building shapes seen through and in relation to curving, volumetric tree forms in the foreground. Space is shallow and is bound at the rear by the delicate planes of the sky. Linear and flat shapes predominate in the latter picture. The crystalline blots are used to a great extent, but more for the purpose of shading for volume in the foreground, and plane placement behind. The whole method of balanced planes and volumes indicated by washes of color is analogous to the late watercolors of Cézanne, but the latter's work is more vigorous in stress and tension, more sure in placement, and less prim or even "fussy" in handling.

A similar handling of planes and volumes (but more slight), can be seen in one of the great early flower pieces, *Daisies* of 1918 (Whitney Museum).[14] Here the placement is even more delicate with an unusually fine treatment of vague background planes in varying depths. The edges of the picture, as in some of the earlier landscapes, are less definite and appear to go deeper into space.

At the end of 1917 and in 1918 the angular forms begin to predominate in the landscapes. These shapes are broken up even more than usual by continuing lines and angles. This development can be seen in extreme form in the oil and tempera pictures. *Red Chimneys* in the Phillips Memorial Gallery (Fig. 11) shows this trend in unusually clear terms. The curvilinear foliage shapes are present in pencil form but they have not been defined by color. The result is a preponderance of angular-textured roof forms and chimneys. The angular inner frame for the lower part of the picture acts as a large angular unit in the whole picture, an effect to be seen in some of Marin's ship pictures.

These landscapes, with the narrative and circus pictures, are of immense importance in any critical estimation of Demuth's worth. In them we see an ordered,

94

11 Charles Demuth, *Red Chimneys*.

classical concept of nature, less vigorous and tense than Cézanne's but certainly
comparable. They are austere products of the intellect, fortified by the sensuous
element of color. As such they are of great importance in modern art, and should be
considered equally with the work of men such as Braque, Gris, Ozenfant, Feinin-
ger, Klee, and Picasso.

The logical end of this search for geometric organizations of nature and architec-
ture would be in the modern mechanical forms of industry and architecture. Shee-
ler has continued in this direction. Demuth essayed it many times in oil and
tempera, but seldom in watercolor. The few works that we do have in the medium
seem to me to be of superior quality and interest than the less complex and techni-
cally limited works in the other mediums. Those executed in watercolor seem to
have been done mostly in 1920 and 1921.

The industrial scene[15] is handled with the straightedge and the compass. The
representative forms are simplified and projected into a world of pure, simple planes
and shapes. Crystalline blotting is used only in the crisply curved smoke forms.
As in many of Demuth's earlier works the vistas are very important: vertical shapes
in the foreground through which are seen the smaller receding planes in moderate
space. The delicacy and variation inherent in the medium are subordinated to
the shape organization of the picture. Color is used as a fill for bounded areas. On

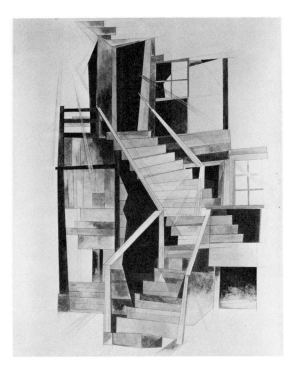

12 Charles Demuth, *Stairs, Provincetown*, 1920.

the whole this picture relates more definitely with the stylized work of Sheeler rather than a constructed abstraction of mechanical forms as in Léger.

A second picture (Fig. 12) is more successful in this respect. Early American staircases are splendid beginnings for the study of shifting and twisting directions made up of geometric shapes, as Sheeler has so well demonstrated in his oils. The use of the ruler for this type of work is common to both men. Here the planes progressively twist into new directions, while cut by the geometric extensions of bannister and window units. Color and blotting are limited to filling-in roles, though the blotting serves for recession and for the statement of intermediate transactions from dark to light. The general organization is based on an irregular twisting projection of the geometric staircase into space from the relatively flat background of boards, windows and shadow. Demuth again relates this unit to the edge and plane of the paper by a gradual fade-off of activity towards the edges of the picture. This device becomes practically constant from now on.

In 1930, after a decade of still-life and flower pictures, Demuth returned to figures and incorporated the crisp, blank paper technique of this decade with the newly revived subject matter. With this return to illustration and figures we find a regression to an extended use of the pencil; hatching, scribbling, etc., but in a more controlled and restrained way than in 1916–1919. Striated blotting, giving

96

13 Charles Demuth, *Distinguished Air.*

a tiger stripe effect also returns in one instance. The pictures, especially the Provincetown beach scenes, seem more rigidly and statically organized than the early Expressionist papers. This fact makes these late works of interest as developed examples of Demuth's more obvious organizational capacities, as seen in the late still-life and flower pictures, applied to figurative subject matter. They are his last pictures; the labor involved in producing them must have been tremendous for a sick man. In contrast to the bulk of his previous output, these pictures do not "breathe easily."

The one illustrative watercolor (Fig. 13) is a prime example of Demuth's ability to hold a heavily asymmetric composition together. This is accomplished principally by the curve of the Brancusi statue, the binding horizontal of the dado, the large blank area in the upper right, and the comparatively complex representational development of the woman's figure. The horizontal striations are another unit in the total form. Representationally, the old quality is there but in a harder, more careful conformation. The strong, supple drawing of the sailor and the more broken, effeminate and slighter delineation of the fop is carefully differentiated. The casual downward glance of the other man is a fine bit, perhaps loaded with meaning if we knew the text. But on the whole this work, despite particular regressions, takes its place with the aesthetically developed pictures of the late 1920s. Texture, weight, shallow space, and shape organization are of principal

interest in this primarily architectural and reasoned style.

This becomes more apparent in the bathing scenes. Where Prendergast saw receding flats of mosaiclike color in a rich and sensuous way, Demuth saw interesting organic shapes, reinforced by color and tone against the distant horizontal sea or against well-marked recessions on pier or dock. These things are arranged, not in Prendergast's classical system, but in startling asymmetric arrangements. This tendency, apparent in 1930, continued even to the extent of loss in representational significance. Thus we find figures drawn in pencil, but left blank of color in order to fulfill the asymmetric functions of the form (*Bathers on a Dock*, Private collection, Detroit).[16] The saturated oranges and blue blacks of the picture add decidedly to the plastic effect. This is also carried out in the drawing by emphasis on the big rounded masses of the woman's buttocks, legs, and shoulders.

Demuth's watercolors are of great importance in modern art history. Like Marin, Demuth devoted most of his efforts to the watercolor medium, and in that method he produced works that take their place with the architectonic watercolors of Cézanne, the abstract works of Braque and Ozenfant, and the Expressionist figure pieces of Nolde, or the early Toulouse-Lautrec. Like Marin, Demuth has demonstrated the importance and seriousness of the aquarelle medium for significant work outside the more prominent and crowded field of reporting and recording of light and visual appearance.

Demuth's early contribution lay in his ability to invest the vibrant color and outward forms of Expressionism with the tortured subtleties of a sensitive and sophisticated mind. Tentative outlines, ever searching for the final delineation, seem to express the gropings of his mind towards his selected goal; while the vibrant color attests to the certainty of his emotion. With maturity his mind gains the upper hand and one feels the change in the severity of the outlines and in the chastened color. The gropings are replaced by a serene, delicate, and subtle sense of the shapes and placements of nature's forms. This later approach is perhaps best described by Wordsworth's particular definition of poetry ". . . emotion recollected in tranquility."

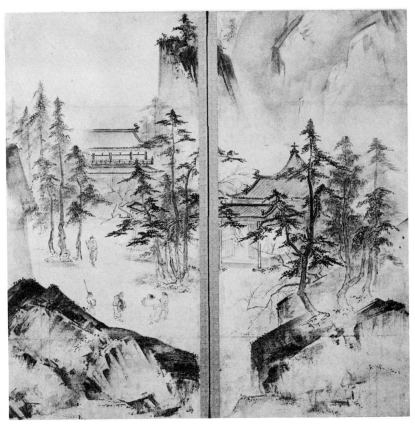

14 Shūbun, *Winter and Spring,* Japanese, Muromachi Period.

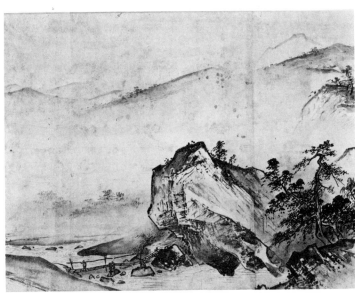

15 Hsia Kuei, *Pure and Remote View of Streams and Mountains*, Chinese, Sung Dynasty.

Contrasts in Chinese and Japanese Art

This article first appeared in Journal of Aesthetics and Art Criticism, *volume 21, no. 1 (Fall 1962).*

Art historians and art critics are spinners of webs. Often we are guilty of torturing material to fit a concept we find particularly exciting or illuminating. Within reasonable limits this is a valid thing to do if one remembers that the materials are temporarily deformed by this activity and that after one has explored the pattern, the material is suitable for yet another pattern, for another spinner to find something perhaps similar or even quite different.

One of the questions asked most often about Chinese and Japanese art is: What is the difference between Chinese and Japanese art? How does one tell a Chinese painting from a Japanese painting? Or, as the question is more often put: Isn't it true that Japanese art is but a pale and weak imitation of Chinese art, the only difference being one of quality?

There are periods in Japanese art where the artist is either copying, or is heavily influenced by, Chinese art. At such times it can be said that Japanese art is a strong reflection of Chinese art. But other works show the most original contributions of the island culture. In these we see the small differences magnified to such an extent that they become fully developed and original styles.

At the outset we must remember, and admit, that the substance of this essay is intended to apply only to the most prevalent and characteristic modes of Chinese or Japanese art. It would be easy to find works, even periods, of Japanese art that are more like dominant Chinese styles than other Japanese examples. There are secondary styles or fashions in Chinese art that are quite at variance with the main stream. The appearance and occasional revival of a Western-influenced technique of modelling painted figures in light and shade would be one case in point. There are others. But in general, and for the most typical art styles of China and Japan, I think these comparisons are meaningful.

A colossal head and torso of a Buddhist deity, the *Eleven-faced Kuan-yin* dating from about 820,[1] can be compared with a small Japanese wood sculpture of a seated *Shakyamuni*[2] dating from about the same time. The style of the head is one that developed in China in the eighth and ninth centuries and is characterized by a fleshy but elegant, rather sensuous attitude. The style goes back for its inspiration ultimately to India, and was transmitted to Japan by Chinese sculptors, sculptures, and copy books, where it became the fundamental style for Buddhist sculpture in the Jogan period. This period and the Chinese mid-T'ang style produced works which are roughly comparable: large, rotund facial types; emphasis upon the geometric and even curves of the chin, throat, and eyebrows. There is a definite

emphasis on representational mass even to the point of corpulence, like that found in the West in the works of Rubens, Jordaens, or even Michelangelo. The representation of a large figure is the simplest method of conveying the impression of weight and mass. Such appearances may not appeal to our local traditions of beauty but they evidently do to others.

The general point to be observed in the first thread of this particular web is that the Japanese artist tends to exaggerate the style or technique of the Chinese artist, even where he follows it most closely. He emphasizes the corpulence of the figure even more. He heightens the rather geometric character of the drapery. Such exaggeration, often expressed in almost wild variations at extremes, seems to most sociologists and anthropologists rather characteristic of Japanese culture. One remembers the restrained grace and elegance of the tea ceremony and the uninhibited wild and noisy activities of some festivals; or the ritual "politesse" of domestic entertainment and the thoughtless rudeness evidenced in public transportation. On the other hand, we think of the golden mean when we recall the philosophy of Confucius and of the Neo-Confucian tradition. I would, then, call attention to exaggeration as being typically Japanese and moderation as being characteristically Chinese.

Numerous works illustrate this point within seemingly identical styles. A detail of a handscroll by the great Southern Sung artist of the thirteenth century, Hsia Kuei, in the Palace Collection, can be put beside two panels of a screen by the great fifteenth-century Japanese monochrome master, Shūbun, and reveal that on certain occasions it is virtually impossible to put one's finger on the precise difference between a Chinese work and a Japanese work in the same style (Figs. 14, 15). In these rare cases, the individual Japanese artist will so effectively recreate, so completely convince himself of the validity of the Chinese style and so absorb it into himself, that he will produce a work which is a re-creation of the work of the Chinese master of an earlier time. This is seen most strongly in the work of Shūbun, one of the founders of the monochrome school of painting in Japan. There may be a trace of exaggeration in the brushwork of the rocks in the lower left foreground of the screen; there may be also a trifling exaggeration in the compositional display of these great mountain heights, reaching up beyond the edge of the border of the painting; but fundamentally this is a faithful and creative re-creation of the earlier style.

However, if we look at the same detail of the painting by Hsia Kuei and at a detail of a handscroll by the pupil of Shūbun, the more famous Sesshū, we see, within the same stylistic framework, two fundamental differences. One is this matter of exaggeration: the axelike brush strokes that form the rock of the painting by Hsia Kuei on the upper right or the staccato accents of brushwork that make the bridge and the man walking on it are exaggerated in the scroll by Sesshū to a point where the brush strokes are no longer really functional in a representational

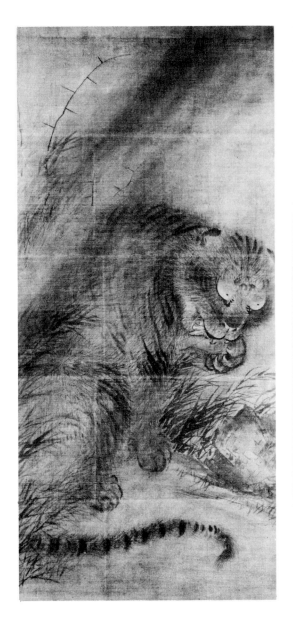

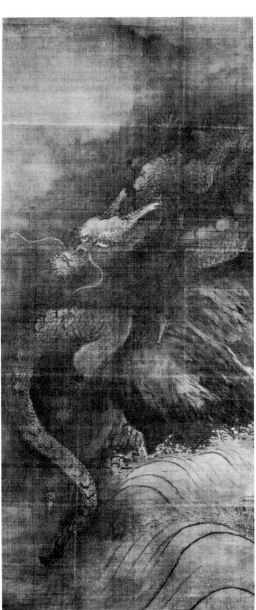

16 Attributed to Mu Ch'i, *Tiger*, Chinese, Southern Sung Dynasty.

17 Attributed to Mu Ch'i, *Dragon*, Chinese, Southern Sung Dynasty.

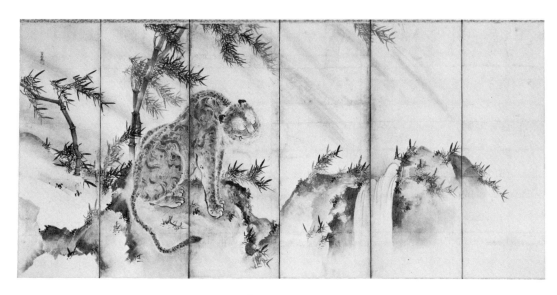

18 Sesson, *Tiger*, Japanese, Muromachi Period.

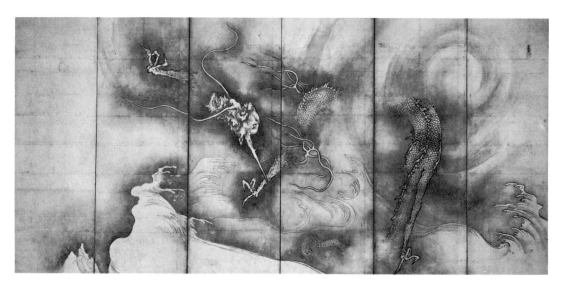

19 Sesson, *Dragon*, Japanese, Muromachi Period.

sense. The brush strokes in the painting by Hsia Kuei seem to be a part of the representation. The brushwork and rock are identified and exist together. In the work by Sesshū certain elements of the brushwork have become an end in themselves. He has exaggerated the importance of the brushwork to a point where it becomes an aesthetic good somewhat divorced from its ends, and this, in a Chinese evaluation of this particular style, is a violation of the unity that must exist between representation and brushwork. This analysis does not say that the Chinese work is, in itself, greater, merely that there is a difference between them. It can also be pointed out that the space in the Japanese work tends to be more sharply divided: there is much more contrast between near and far, where in the Chinese work subtle gradations define the recession of space. Once again, then, in two rather similar works there is a contrast between exaggeration and moderation, and a Japanese emphasis upon the decorative development of brushwork—of great significance for the future.

Other comparisons may be in order. Another work by Sesshū,[3] the Japanese master who died in 1506, compared with a painting in Japan by the great Chinese artist Li T'ang, which can be dated effectively to 1135 or 1137,[4] confirms all that has been said before. If one looks at the massive rocklike structure behind the two small men, one is hardly aware of the differentiation of brushwork and representation, while in the Sesshū representation is clearly separate and there is a concurrent play with the brush which becomes a kinetic and aesthetic end in itself.

Now let us examine two particularly Oriental beasts—first, two tigers in the Cleveland Museum. The one is attributed to the Late Sung Chinese artist Mu Ch'i and was once in the collection of the fifteenth-century Japanese Ashikaga shōguns Yōshimitsu and Yōshimasa. The other is from a pair of screens by Sesson, the follower of Sesshū (Figs. 16, 18). Again we sense the difference between the representation of the Chinese tiger in rain from that of the Japanese work. The brushwork is assimilated into the structure of the tiger; the fur presents the baggy, shapeless character that the tiger presents when relaxed, with the folds of skin literally hanging from its frame. This keen observation is combined with brushwork which supports it, while the Japanese work presents a more playful handling. The same distinctions are true of the psychology of representation. The Chinese tiger gives the impression of reality, of power, of a presence that seems to emanate from the representation. Sesson's tiger exhibits a certain playfulness, passing almost into caricature, and this is of considerable significance for some facets of other Japanese works as we will see.

The other of the paintings by Mu Ch'i represents a dragon and it is matched by Sesson's other screen (Figs. 17, 19). The Chinese dragon rests quietly but with an inner breathing power; he throbs with capability. The Japanese dragon by Sesson moves with great rapidity—strides, thrusts, turns, twists his way through the air. The waves in the Chinese painting occupy a subsidiary position and operate primar-

ily as representations of water with foam. In the Japanese painting these have become a strong and decorative pattern, a major counterpart to the representation. Now it is entirely possible that Sesson, who made a catalog of the collection of the great Ashikaga shōgun Yoshimitsu, saw these paintings and we may be witnessing a true case of direct influence. If one looks at details, these opposing qualities become clearer. The brushwork representing the stripes of Sesson's tiger are curling and playful. The expression of the beast—one fang protruding, bulging eyes, rather sharp and exaggerated delineation of the nose—is in contrast to the Chinese representation, where the dominant quality is not of humor or exaggeration but of restraint and quiet power. Even the brushwork in the reeds and the bamboo, shows less of the exaggerated, almost self-conscious art of Sesson. Details of the dragons reveal these qualities both in terms of brushwork and the psychology of representation.

A final comparison of two works of a rather similar nature will precede our examination of more striking contrasts between Chinese and Japanese art. One is a painting of *Two Peacocks* by the fifteenth-century academic Chinese master Lin Liang;[5] the other is one of the famous sliding screens by Kano Motonobu[6] in the Reiun-in in Kyoto. Certainly the Chinese considered the peacock painting a decorative painting, and it is decorative, rather in the sense of a French eighteenth-century tapestry—the artist tends to fill most of the space achieving an allover pattern. Beware the old cliché that the essence of Chinese painting is to be found in a large expanse of silk with a small tree or figure in the corner. The great majority of Chinese pictures show a quite different pattern: the artist attempts to fill the space, to achieve a complex and rational arrangement. The decorative pattern in the Lin Liang *Peacocks* is carefully organized and rather formal, supported by an X which crosses in the center of the picture. The relatively balanced composition includes the presentation of bamboo against the other peacock, bamboo against bamboo, and the peacock's tail balanced against the long sprig of bamboo in the upper left. The other example, a painting by Motonobu, is in the Chinese style of the fifteenth century but was executed in the sixteenth century, and shows one of the typical Japanese approaches to decoration. This is a tendency to force large blank areas against complex areas which usually include complex silhouettes, in this case the crane and the pine tree against the open space behind. The effect of this mode of decoration is allied to that often to be found in Braque, Matisse, or in other contemporary painters, founded on asymmetrical pattern, and depending upon a dynamic tension between nothing and something.

Some of these differences that exist in nuances on a very small scale, take on a far more exaggerated character in more independent and creative works of Japanese art. One of these differences is that between an idealist approach, reconciling opposites, more or less to be equated with China, and a Japanese tendency to oscillate between either a decorative style and one which is realistic, even to the point of

20 Imperial plate, Chinese, Ch'ing Dynasty, Reign of Ch'ien Lung.

21 Kutani ware plate, with phoenix, Japanese, Edo Period.

caricature. The portrait by Chang Wu-chun of a Zen Priest[7] is one of the most beautiful of Chinese Sung portraits; while equally masterful is the contemporary portrait of Priest Jugen, kept at Todaiji in Nara, and dating from about 1210–1220.[8] The Chinese concept of portraiture makes us aware of a noble individual. But despite the fact the two men have similar facial structures, we are aware of the Chinese individual in a sympathetic but slightly removed way, as an ideal portrait. While he does not possess all the paraphernalia of old age, he gives the impression of ancient wisdom. The Japanese work emphasizes precisely those things that the Chinese artist de-emphasizes—the wrinkles of the face, the set of the jaw, the vast cavern of the ear, the sunken sockets of the eyes. Almost to the point of caricature it mercilessly exposes the realistic detail that marks both the character and the appearance of the individual.

These same divergent qualities are to be seen in the narrative scrolls which were painted both in China and Japan. In general, the narrative scroll in China was a secondary category. There were scrolls showing famous historical or literary events of the past, but usually the narrative content was restrained; and an interest in narration is one aspect of realism. On the other hand, the Japanese absorbed the handscroll format and made of it a great narrative tool in the late twelfth and thirteenth centuries. A Chinese painting of the twelfth or thirteenth century now in the museum in Peking, represents the various activities in a Chinese town on a river during the spring festival.[9] Another, even more famous, but Japanese handscroll in the Boston Museum represents *The Burning of the Sanjo Palace*, the first roll of three from the story of the Heiji uprising.[10] In the Chinese scroll, despite the

bustling activity to be inferred from the numerous figures represented before the shop-fronts, the little servant boys, the bails being unloaded, the little boy pointing out the way to a stranger, an ideal environment dominates. All this, and more, is present but it is not obtrusive. The emphasis is rather upon the figures as a part of the whole setting of nature, including civilization.

In the Japanese work, on the other hand, despite its roughly comparable scale, we are aware of violent activity. As a spinner of webs I must admit the juxtaposition is a purposely exaggerated one. One could show numerous other Japanese hand-scrolls where the representation is more comparable to that on the Chinese painting —a village scene with local activity—but you would still find the exaggeration which we see to a magnified degree in the Heiji Monogatari. When the Japanese represent a village there is almost always a repeated mise-en-scène: a gnarled and bent old woman staggering along the street, a boy fighting with another boy, an exaggerated caricature of a diseased and ugly person. There is a tremendous interest in a coldly rational, even satirical, realism, represented by the movement, the vigor and strife of this Heiji scroll. One must repeat that the Chinese work emphasizes rationality—everything in its place and nothing to excess. In this sense much of Chinese painting shares the serene and noble quality that we find in most Greek work before Hellenistic times.

Contrariwise, the Japanese work has a strong emotional quality. A revealing experience happened when I went to the cinema with some friends who had not been to Japan. They saw for the first time the Japanese work *Rashomon*, now a recognized classic of film art, and were horrified at the expression of emotion, the wildly exaggerated movements of the bandit, his snarling face, his spitting, and all the significant detail we remember so well. They were equally horrified by the music derived from Ravel, somehow so "unoriental"—not quiet and calm with a thin piping reed. But this wild, emotional quality is a basic part of much Japanese art. These people vacillate between the extremes of repression, or, if you will, self-control, and wild emotional release. This latter is the quality that makes their narrative handscrolls one of the greatest contributions to Far Eastern painting.

Even with two plates, the one a Chinese Imperial porcelain in the Tokyo National Museum made for the Ch'ien Lung Emperor some time about 1750–60, the other a Japanese plate from the Kutani kilns and dating perhaps a half century earlier, one finds a perfect "unloaded" example on the widest possible scale of these essential differences (Figs. 20, 21). The Chinese is interested in rationality and restraint combined with the observation of nature, the welding of brushwork to nature, and a strong interest in the written word combined with these things. The other and larger plate is one of the boldest and most original of all Japanese porcelains, a work in which I think we can use the term caricature in the best sense of the word. The phoenix struts, his enormous tail flung up, his head tilted, pushing to proud and masculine extremes quite in contrast to the Chinese style of porcelain decora-

tion. One of the reasons that the old Kutani pieces have reached such astronomical prices is that the Japanese fully realize that these are their most original and creative porcelains of the later periods.

Even when one considers a Chinese expression of deep emotion, the comparative Japanese expression will "tear a passion to tatters, to very rags." The fragments of a handscroll in the Boston Museum tell the story of Wên-chi's captivity in China (Fig. 22). One scene is of the highest emotional significance. These figures holding their sleeved hands to their eyes and noses are weeping because Wên-chi, a captive who has lived long years of exile in Mongolia, must now be returned to China and so must leave her adopted Mongolian family. The situation contains deep elements of tragedy, yet the figures of the drama stand quietly, even stiffly erect and are subordinated to the setting. The whole has the effect of a *tableau vivant*, the figures frozen in space. The other detail is a scene from one of the greatest of all narrative paintings, *Ban Dainagon Ekotoba* (Sakai Tadahiro collection, Tokyo). It tells a story of intrigue and rebellion leading to a fire in the palace, with an accompanying "crowd scene." Wildly writhing and turning, the crowd is made up of faces with their wide-open mouths expressing extremes of panic and fear. The profiles of the various plebes are represented with terribly exaggerated jaws and noses; there is great distortion in the size of the heads in relation to the body. The whole is a wildly throbbing and dramatic presentation of a dramatic moment; contrariwise the Wên-chi fragment is a quiet representation recalling Wordsworth's "emotion recollected in tranquility."

Even in the later scholarly painting of China and Japan, where painters painted for other painters, for only the gentleman-scholar was considered to be an original

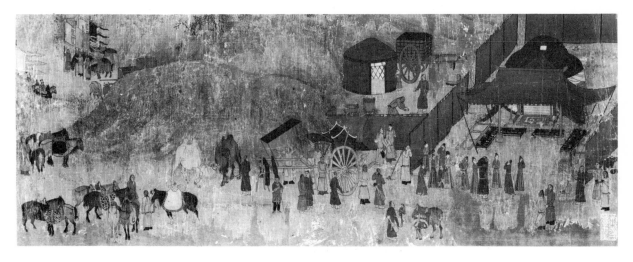

22 *Wên-chi Parting from her Husband and Children*, (No. 3 of a set of 4 paintings of *Wên-chi's Captivity in Mongolia and Her Return to China*), Chinese, Sung Dynasty.

and creative artist, the same quality of idealism versus exaggeration is to be found; witness a painting by a great seventeenth-century individualist in China, Tao-chi,[11] and an eighteenth-century Japanese man much influenced by what Tao-chi represented, Ike-no-Taiga.[12] In Tao-chi's album leaf there is a wonderful play upon the idea of a beard: a bearded old man and his attendant are half hidden in the mist under a cave with beardlike hanging reeds and grasses, while above that is a waterfall, a magnified and fluid representation of a beard. The opportunity is presented to make a smashing belly-laugh; instead a quiet, restrained private joke is gently urged. In Taiga's album leaf the representation involves another visual pun: a man looks like a mountain. Which is the mountain, which is the man? And here the pun is presented with force, exaggeration, and evident humor. One seldom laughs at Chinese painting, but in Japanese painting numerous representations are humorous in the best sense of the word.

Another major contrast in the arts of the mainland and the islands is that between Chinese rationality and the intuitive quality of Japanese art with particular regard to the domination of, or surrender to, nature. One of the few hanging scrolls by, or close to, an eleventh-century master, Chu-jan, is a monumental landscape in Cleveland where the Chinese artist has expressed perfectly the concept of rational principle in nature, or as the Chinese term it, *li.*[13] In this hanging scroll we find a unified combination of rationality and observation which is neither a surrender to the material, nature, nor a domination of it. A Japanese painting, *Kumano Mandala: The Three Famous Temples*, also in the Cleveland Museum,[14] dates from the thirteenth century, and in its overall organization can be contrasted to the Chinese painting as an evident domination of nature. The geometric pattern of the temples, in plan view, is superimposed on nature so that one is more conscious of design than of nature. But when one looks at a detail of each painting, no matter how far into the Chinese painting one goes, one finds again a balance, a measured representation of principle by means of the brush, which is not only brushwork but also representation; while in the Japanese painting we sense a surrender to the loveliness of nature's forms—the seductive colors of blossoming nature, of pear and prunus, of moss and lichen. These different representations, rather than the brushwork, comprise the detail of the painting and produce a lovely and decorative effect quite removed from the consistent rationality of the Chinese painting.

Another side of the domination of, and surrender to, nature on the part of the Japanese, and of the middle position of the Chinese is to be found in ceramic art. The Chinese combine an effective representation with a sure realization of technique and of the material. A seated figurine of the Han Dynasty, perhaps of the third century,[15] can be juxtaposed with a Haniwa in the National Museum in Tokyo.[16] The Japanese representation of the sixth century is dominated by its material, a dominance expressed in its name—Haniwa, circle of clay. The artist leaves it rough and uses the circular form to produce an almost abstract symbol for a figure.

23 Mortuary horse, Chinese, "Six Dynasties" Period, 6th century A.D.

24 Haniwa horse, Japanese, 4th–6th century A.D.

Before the rise of Abstract Expressionism, Haniwa were the proverbial dime a dozen. But now the demand exceeds the genuine supply, with predictable results. In the Chinese figurine, the artist allowed the representation to meet the material halfway and the result is a representationally satisfactory substitute for reality. The same with the representation of horses in these burial figurines. The Chinese horse of the sixth century, and the Japanese Haniwa horse are contemporaneous (Figs. 23, 24). True to its name, a circle of clay, the legs of the Japanese sculpture are simply cylinders of clay; the body is almost a cylinder; the head is clearly based on a cylinder. These given shapes are combined to produce an equation, 3c equals horse. The Chinese burial substitute is the very living spirit of the horse expressed with attention to observed detail, yet with complete control of the clay medium.

These contrasts are even more evident in useful ceramics. In general, the Chinese pot is a cunning blend of material, body and glaze, with a logical near-geometric shape, usually a circle or a near-perfect circle, a cone, or ovoid shape. The Japanese bowl, later in time to be sure, developed from an art appealing particularly to recent modern taste, a style emphasizing asymmetry and which paradoxically dominates the material to a point where it makes the material look more natural. The English phrase, "studied nonchalance," perhaps expresses most nearly in Western terms what the Japanese tea-taste aims for, by indirection naturally. In the Chinese wares, there is little self-consciousness, no studied nonchalance. Rather one finds a devil-may-care directness in folk or peasant wares, or the utmost of rational and sensuous sophistication in the Imperial wares. One of these latter, one of sixteen Sung Imperial pieces in Cleveland displays a complex development of crackle deriving from an almost magical, if experimental, control of glaze enabling the kiln

master to produce this perfect deep crackle, deep color, regulation of surface and of the flow of the glaze. There is an added fillip of an intellectual content implying a historical, even archaeological, interest: the use of archaistic shapes (Fig. 94). The Lu incense burner type reaches back over a thousand years, and yet it was consciously revived in the thirteenth century as homage to the past, an historical footnote. On the other hand, one of the most beautiful of Japanese tea-ceremony pieces, a Shino waterpot in a private collection in Japan, is a prime example of beautifully studied nonchalance—asymmetric treatment of the seemingly barely formed shape, no perfect circle, no perfect straight line, rather a subtly rough and ready, natural-looking piece eminently appropriate for use in the tea ceremony (Fig. 25).

In one medium the roles assigned by the web-spinner seem reversed. The garden art of China seems visually extreme and grotesque when compared with the quiet serenity and naturalness of the usual Japanese garden. And yet this may be the result of the contrasts we have assumed. The Chinese travel far to select the ancient and remarkable elements for the garden; but their respect for *li* in nature may prevent them from controlling the untidy tendencies of untended nature. Thus one of the gardens in the Summer Palace outside Peking, when compared with perhaps the most famous of all Japanese gardens, the tiny jewel within the Daisen-in in Kyoto, brings out one part of the Chinese character which the Japanese also possess but seem able to control. Here, at least, the Chinese lets himself go—his love for old forms, for the spirit of antiquity, old rocks, especially twisted, gnarled, and perforated rocks, things that express the grandeur of old age. This basically Confucian idea of wise old age, is most prominent in the gardens of the ancient mainland. The Japanese garden, like the tea-ceremony wares, takes the forms of nature and, with studied nonchalance, places them about in space so that they seem to create a painting. This is a reversal of the painting process. The Chinese painter takes a brush, looks at other paintings, observes nature, and paints a landscape. The Japanese garden designer, often a famous landscape painter, observes paintings, looks at nature, takes its elements, and makes them look like a painting.

Our last selection of contrasting works is selected to demonstrate the difference between the logical and descriptive style of most Chinese painting, even Chinese decoration, and the more intuitive and boldly decorative qualities of Japanese decorative style. One of the most interesting comparisons is that between the Chinese painting of the *Night Banquet of Han Hsi-tsai*, a handscroll now in Shanghai,[17] and a scene from one section of a Japanese scroll, illustrating the famous *Tale of Genji*,[18] readily available in the enchanting translation by Arthur Waley. The *Night Banquet of Han Hsi-tsai* illustrates a particularly, as Chinese taste goes, wild party. The scroll is supposed to have been painted by Ku Hung-chung at the demand of an Emperor of the Southern T'ang Dynasty so that he might vicariously experience one of the reportedly licentious parties given by one of his ministers, Han Hsi-tsai. As Emperor he couldn't possibly attend and so he requested the

25 Shino ware water jar, with flowers and grasses, Japanese, Momoyama Period.

painter to bring back the party alive. It is a masterpiece of logical organization, of space-setting in the Chinese system of perspective, of a rational representation of a group of men and women drinking, conversing, and listening to music on the lute. Only the most subtle hints of impropriety are to be found—rumpled bed-clothes, indiscreet glances. In the scene from the *Genji Monogatari*, as in the novel, everything is said by indirection. The human figure is a decorative unit with a tiny head protruding from a pile of drapery. The interior is a cunning grid of lines that make a decorative pattern, and a space broken by large planes, almost in the manner of a contemporary painter dividing his picture space. In contrast to the rationality of the space in the Chinese painting is the irrational and intuitive quality of the Japanese space; and in contrast to the sober and descriptive quality of the Chinese painting is the arbitrarily asymmetrical, decorative quality of the Japanese painting.

Even the arbitrary and decorative fan shape provides evidence for these differences of style, as in a fan by Wen Cheng-ming painted in the mid-sixteenth century, and a fan painting from a group by the seventeenth-century Japanese decorative master, Sotatsu. The Japanese painting shows a completely arbitrary division of the fan shape with direct implications of objects in space continuing off the edge of the fan. But the Chinese painter has carefully bent his landscape, as Columbus crushed the egg, to logically fit the given format. He has allowed very little to project beyond the frame, which in turn contains the landscape. This is a combina-

tion of logic and description, while the Japanese artist has implied more, has intuitively placed his things in a balance that is asymmetrical and dynamic, and has, in a sense, denied the shape of the fan or, at least, used it for something more than the frame provides.

Or compare the Chinese fan of an *Early Spring Landscape* by the seventeenth-century master, Yun Shou-p'ing,[19] and a pair of fans by Sotatsu.[20] Again in the Chinese painting, nature is made to conform to the shape of the fan. We find the same type of composition in both Chinese and Japanese works—water, a point of land with a pavilion which reaches out into a bay fed by a stream. The Japanese painter makes his water and land conform to a decorative pattern emphasizing the rhythmical repetition of the larger but similar shapes of the spit of land. Above all, the composition is dominated by heavy layers of pure color: malachite green, azurite blue, and silver. Worse still, from a Chinese point of view, is what the Japanese artist did with the fan. To the Chinese, a fan was a personal gift, a token, a memento which one artist painted and gave to a friend. To the Japanese, the fan became a part of a gorgeous pair of screens in which the fans were distributed over a gold surface to produce an asymmetric, overall pattern. The fans are twisted and turned alternately, sometimes slightly overlapped, as in the two on the far right and far left. Thus we have a double decorative play, an overall pattern on a larger scale and daring variations within the smaller fan shapes.

When a Chinese did make a screen, as in the well-known Coromandel types,[21] they emphasized the frame with a border, even a series of borders, being careful to see that the whole scene was contained. Then he produced a logical and balanced development: one spray of flowers or leaves to each panel. The landscape is largely descriptive. A Japanese master such as Kōrin also had to contend with a border in his screens of red and white plum,[22] but the plum branch comes from outside the picture, reaches in past the low point, then sweeps up and out of the picture. The stream of water fixed on the surface by rhythmically repeated ripple whorls flows in from the outside right and reaches across the ground. The asymmetrical organization is achieved by balancing a large area of gold, controlled by the silhouette placed upon it, against a more dominant but smaller area of black made interesting by the patterning of the waves. If one looks at a detail of the Coromandel screen and at the second screen by Kōrin, there is the same contrast of descriptive quality with a rather simple use of color against the Japanese patterning of water and branch, perhaps even more prominent and even more decorative in this member of the pair.

These same differential qualities are to be found in porcelain. Made at almost the same time in the seventeenth century, the Imperial Kang Hsi bowl[23] and the Kutani plate[24] are images from different worlds. For the Chinese the decorative quest was to find a way to use the peonies in three different colors, and to contain them, carefully balanced, within the circle of the bowl, while maintaining perfec-

tion of technique and purity of color. The designer and potter of the Lord of Kaga made a daring use of a string of mere eggplants on a rope diagonally across the center of the large plate, with a background of waves and whorls not unlike that motif in the Kōrin screens. There is no difference of aesthetic quality here, only one of style.

Or consider the Chinese lacquer, an Imperial example of Middle Ming in the sixteenth century,[25] and a remarkable Japanese writing box of the early seventeenth century owned by the Seattle Art Museum.[26] The Chinese lacquer has the same qualities already studied in the Coromandel screen; the border is self-contained; the representation is of a fairly naturalistic landscape; the presented image is rational and descriptive. For the box designed by Kōrin one finds the same style as that in his screens: overall decorative patterning in an asymmetrical way; tensions, suggestions of movements beyond the surface; de-emphasis of the frame to imply continuity beyond. All of this is part of the Japanese decorative taste including the ability and imagination to use exotic or mundane materials in a decorative way. The gold lacquer is familiar, but some of the other cranes are done in two different metals, pewter and lead, and the textures of these different metals subtly differentiate the birds from an aesthetic viewpoint. Of course the Chinese have used pewter and lead, but seldom if ever in so sophisticated a context, or juxtaposed with precious gold.

Finally, observe two almost exactly contemporaneous paintings, the one a landscape after the great Northern Sung master, Kuo Chung-shu, by the seventeenth-century individualist priest-painter, Chu Ta,[27] the other a hanging scroll by the Japanese scholar-painter Gyokudo.[28] Chu Ta's construction, though based upon a style like that of the monumental landscape by Chu-jan which we saw much earlier, is a personal re-creation by an individualist of the seventeenth century; but wild as they were we are aware of something here that can be sensed only in general terms —a certain rational remove. The landscape seems to be distant from the spectator, he views it from afar. The use of cold, blue-black ink heightens the quality of icy rationality. The way the mountain twists while leading the eye up to the mist that suddenly appears and separates the viewer from the higher peak, this whole construction is one of a strong will but an equally strong mind. On the contrary, while the Japanese painter is equally willful—notice the way he has turned many of the rocks and points of land into little round "pancakes" tilted up toward the spectator —still this landscape seems to come toward you, somehow you seem a direct participant in the landscape, you are intuitively involved. Despite the exaggeration of the Japanese style—the little pancakes, the fluffy trees, the overall warmth of the mist, the softness of the whole—it is all part of an intuitive and decorative approach which plays counterpoint to the logical and descriptive approach of the Chinese artist.

One could pursue these webs endlessly. Japan has long been famous for the

wealth of its collections of Chinese art. But what did they collect? To the Chinese they are equally notorious for their usual selection of just those products of the Chinese artist which fail to meet general acceptance among artists and critics of the mainland—the asymmetric compositions of the Southern Sung Painting Academy, T'ang realistic pottery figurines, the rough tea bowls of Fukien, the wild and humorous blue and white wares of South China in the Late Ming period, or the products of that aberrant form of Buddhism, Ch'an or Zen.

Such is the web I have tried to spin. In general many of the principles hold true and may serve as a useful framework to understand something of the differences of style between Japanese and Chinese art.

The First *Calabazas* by Velasquez

This was first given as a talk at the annual meeting of the College Art Association in New York, 29 January 1966. The painting, which had been heavily overpainted, was controversial at the time, but is now universally accepted as a Velasquez.

After 1638 Velasquez painted four moderately small pictures (40 × 30 inches) of court fools and dwarfs. All are depicted as sitting or kneeling, thus making them seem even smaller than in nature, and all, with the possible exception of the scribe "El Primo," are characterized with an acuteness that leaves no one in doubt as to their pathetic condition and, in one case at least, reveals an expression of tragic frustration and despair (Fig. 26). All are painted in a free and broad "optical" manner with a subtle use of what Delacroix called "this firm yet melting impasto" combined with areas of canvas barely covered with thin, liquid films of paint. All four have been much admired, especially now when their psychological nausea and sheer physical existence appeals to our contemporary existentialist tastes. But this direct, modern appeal has its dangers. If Skira can title a series on the art of the past "The Taste of our Time," he inadvertently suggests that such an orientation is temporary; and this is not the best tool by which to judge

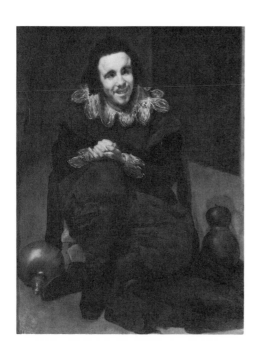

26 Velasquez, *Jester, Calabacillas.*

116

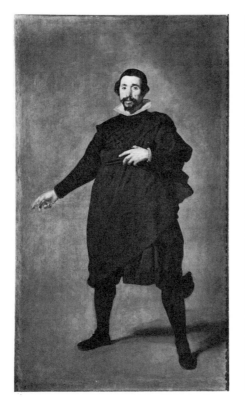 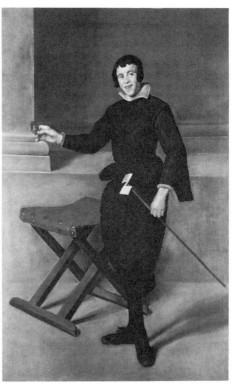

27 Velasquez, *Jester, Pablo de Valladolid.*　　28 Velasquez, *Jester, Calabazas.*

the painting of any century before the twentieth—and especially the seventeenth century.

There are four other portraits by Velasquez of court buffoons, which were more to the taste of a previous century of tastemakers, the nineteenth. These are four full-length standing portraits, varying slightly in size but roughly conforming to the precept of life-size imitation. These four are unified by a more extroverted, less psychological concept involving a demonstration to an audience assumed to be observing the canvas. They, in a very real sense, perform for us, where the smaller, and later, pictures seem meant for the eyes of a solitary viewer, even an interloper. To Manet, writing in Madrid in 1865, the *Pablo de Valladolid* (Fig. 27) is:

> *The most astonishing piece of this whole splendid oeuvre, and perhaps the most astonishing piece of painting that has ever been done. . . . The portrait of a celebrated actor {sic} of the time of Philip IV. The background disappears, air surrounds the man, dressed all in black, and alive.*

while to Fromentin, writing in 1876, the same kind of Velasquez called forth the following:

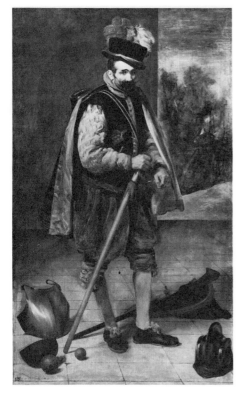

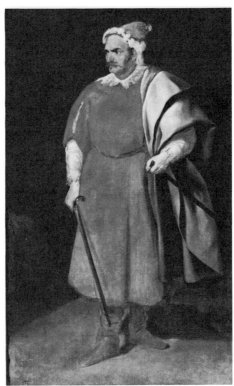

29 Velasquez, *Jester, Don Juan of Austria*. 30 Velasquez, *Jester, Pernia*.

There are men . . . who colour marvelously with the most disheartening of colours. Black, grey, brown, white tinted with bitumen—what masterpieces has he not executed with these dull tones.

If the *Pablo de Valladolid* (and how revealing of the extroversion of the painting is Manet's mistaken identification of him as an actor) is the most famous of the full-length jesters, the first and formative picture of the series is the *Juan Calabazas* formerly in the Cook Collection and now in Cleveland (Fig. 28).

While a very few full-length single figures of court fools had been done before, and one of them, the *Pejeron* (ca. 1560–70), Jester to the Duke of Alba, by Antonio Moro, was familiar to Velasquez since it was in the Alcazar by 1600 (Fig. 31), one cannot say that these pictures represented anything more than the fool as a single piece of still life—indeed, even as a somewhat grotesque aristocrat. There is little about the pose or the arrangement that differs from other portraits. When Velasquez set about painting the *Calabazas* he had no creative tradition to follow. Being an inventive and intelligent painter, he could not follow such an immediate cardboard prototype as the *Soplillo with Philip IV* by Villandrando (Fig. 32) painted

only a few years before. Velasquez had already evolved a telling formula for a noble or royal portrait basically derived from Titian's *Portrait of Philip II* of 1551 (Fig. 33), well known to him from its presence in the Alcazar from 1600 on, and it seems most likely that this commanding Venetian portrait dominated his thinking when he began the *Calabazas*. In a sense he partially bypassed his own royal and noble portraits of Philip and Don Carlos to go back once again to his source, the Titian *Philip II*. The cast shadows of the legs, the use of an architectural setting of pilaster or pillar, the furniture accompaniment, the thin rodlike sword as a linear development in depth, the outstretched arm—all are part of the solution of a new problem for Velasquez—a full-length secular portrait—and of a fool at that. How to transform the noble character of Titian's and his own portraits was Velasquez' task.

The still tentative solution in the *Calabazas* was a psychologically and aesthetically difficult one for the royal painter—the *informal* disposition of a figure with a suggestion of human *activity* rather than royal hauteur, coupled with a *physical* concept of abnormality rather than, as the x-ray views of Velasquez' first portrait of Philip reveal, idealized yet recognizable features.

Calabazas is seen attired in a black velvet costume with white collar and cuffs. In his left hand he awkwardly holds a stick with a two-bladed toy paper windmill, while with his right hand he holds out for our inspection a framed "portrait" miniature. His fool's grin accompanies his animated visage with its slightly swollen temples and the badly crossed right eye. This disconcerting face is topped by deep chestnut-colored hair, light and fluffy in texture, a poignant touch of loveliness against the malformed visage. The pipestem legs with the crippled and dangling left foot are an insubstantial support for the body and, again, make a poignant contrast with the firmly realized "still-life" wooden legs of the folding stool with its rich yellow-brown leather seat fastened to the stretchers with brass-headed nails. The figure and the accompanying stool stand in a space swimming with light and air and marked by three solid geometric division markers—the warm gray of the floor and the cooler grays of the ledge and more distant wall with its base molding. To the left, rising from the ledge, is a deep rectangular pilaster, another firm accent contrasting with infirmities. The counterpoint of angling lines, both in surface pattern and in depth, assists in fixing the body in space, as do, for example, the severer schematic frameworks used today by that painter of ambiguous demonism, Francis Bacon.

We are led by the master into a deliberate ambiguity; all is not what it seems—a type of secrecy that was to culminate in the still familiar difficulty of literally interpreting *Las Meninas* (or *The Royal Family*). Calabazas is apparently well favored, but on inspection is not. The looming stool reduces his size and materiality. The holding of the miniature, appropriate to a courtier, is belied by the toy windmill. The *Calabazas* can be seen, then, as an ironic essay on the fool as courtier; just as *The Topers* and *The Forge of Vulcan* have their ironic elements. The *Calabazas'* still

somewhat elegant character was recognized by the presumably nineteenth-century restorer who heightened the effect by fleshing out the legs and removing the cast of the right eye. If this ironic reference to elegance can be accepted then, a character, even a program, for the four full-length portraits, Calabazas, Pablo, Don Juan, and Pernia (Figs. 27–30) can be proposed—Pablo being the jester as actor, Don Juan, the fool as an almost quixotic warrior, and Pernia, the fool as a fierce exotic, a Corsair —even the Grand Turk as in Lope de Vega's *Locos de Valencia.*

The *Calabazas* becomes, then, the logical first part of a general developmental sequence peculiar to Velasquez' eight pictures of fools, dwarfs, and jesters. What of the style and technique of the painting? We must first realize that the picture *was* considerably and vitally overpainted as it was known before September 1965. The right eye had been uncrossed and its character and placement in the head diminished. The legs had been overpainted to flesh them out, to make them more normal. Many of the areas in the background revealing the red bolus ground beneath had been overpainted and the liveliness of the gray destroyed. Finally, the heavy yellow varnish had made the warm and cool grays a uniform greenish gray, destroying the source of light, air, and space in the picture. All this was recovered in the cleaning—and the x-ray indications that the portrait miniature and background were original were confirmed—contrary to several previous opinions. The miniature itself, incidentally, is framed in a manner typical of about 1600, with four curlicue decorations at the four quarters of the oval frame. The painting of

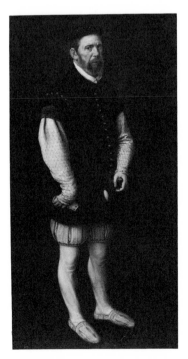

31 Antonio Moro, *Pejeron, Jester
to the Duke of Alba.*

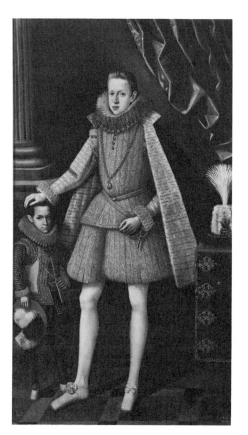

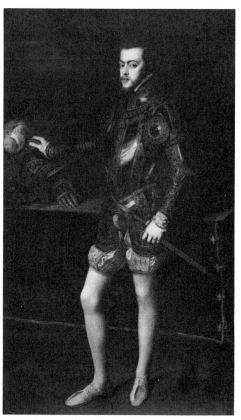

32 Roderigo de Villandrando, *Dwarf,*
Soplillo with Philip IV.

33 Titian, *Portrait of Philip II.*

Calabazas as we see it now is all of a piece, by one hand, and shows in the details
of its handling of paint the peculiarly individual touch of Velasquez. The blacks in
particular are characteristically varied, rich, and wetly painted, with two particu-
larly telling details. First, the wet blacks where the edges of shapes meet the gray
background are often pulled, even flicked into the still tacky gray, producing a
homogeneous and integrated effect. Second, within the blacks, where the dark
strokes do indicate the cut velvet pattern, these are often very wet indeed, with a
peculiar vermiculate or wormlike movement, a quality we find more and more
in the pictures from 1634 on, as in the manes of the horses, and the strokes on the
white costume in the *Surrender at Breda,* the horse's mane in the *Philip IV on Horse-*
back, and even in the draperies of the *Mars.* These touches find no counterpart in
the brushwork of Velasquez' contemporaries. One must also pay particular attention
to the edges where the painter wished to vary a contour from hard and sharp to
soft and lost. Here, in the stool, as in the still-life details of hafts and wooden rods

in the *Forge of Vulcan* of 1630, the artist works a special magic. He loads his brush with the darkest tone at that edge of the bristles with which he intends to form the outer edge of the profile. By beginning with slight pressure and increasing it at the desired moment, he can force a dark line that is not drawn in but which appears wetly and magically, only to disappear again as the pressure is decreased. These are the painterly methods which so endeared Velasquez to Manet, and by which a part of his particular visual truth is achieved, and alongside which the more pedestrian touch of a Cano or the surface bravura of a Mazo stands confounded. Perhaps the painting of the shoes with their ties and the cast shadow beside them are as brilliantly executed as any part of the painting, combining hardness and softness, and suggesting the difference between the bulging surface of the slipper containing the supporting right foot, and the more slack and helpless surface of the hanging left foot.

The date of the *Calabazas* is difficult to determine despite its clear position at the beginning of the court dwarf-jester-fool series. It has been dated as early as 1626 (Mayer and Salazar) well before the first Italian trip, and as late as 1632–33 by Gomez-Moreno and Aznar, largely because of the court record of the gift of a velvet costume to Calabazas on 9 November 1632. The general type of composition is indeed closely related to the royal portrait of 1626–28, the *Don Carlos* of 1626–28 and the *Olivares* of 1625. Trapier and Soria, with regard to other pictures than this, cite the red bolus ground as characteristic of work before the Italian journey of 1629–30; but the Boston portrait of the Prince Baltasar Carlos with a dwarf of 1631 has a red bolus ground. Certain details of brushwork in the *Calabazas*, particularly the previously mentioned fluid, vermiculate strokes in the blacks of the costume seem to point ahead to details in the *Surrender of Breda* (1634–35). Then, too, Calabazas entered the service of the King from that of Don Fernande the Cardinal-Infante in 1632 and if the picture belongs, as I believe, with the other three full-length royal zanies, then 1632 seems the earliest likely date.

There is hitherto unconsidered medical evidence to support a date after Velasquez' return from Italy. The identity of the fool shown in the Cleveland and Prado pictures (Figs. 26, 28) has not been questioned and has been easily confirmed by medical specialists. The heads of the two versions show the same slightly swelling temples, grimace-like smiles of similar construction, and above all, the same cast in the right eye. Calabazas died before October 1639 and Dr. K. M. Laurence of the Welsh National School of Medicine (Penarth, Wales), a specialist in hydrocephalism, and Dr. Ralph Fried, a pediatrician on the staff of Mount Sinai Hospital and St. Luke's Hospital, Cleveland, estimate his age in the Prado picture at about twenty-four to twenty-five years. The age of Calabazas in the Cleveland full length is estimated at seventeen to eighteen years—taking into account the recent findings of Dr. J. M. Tanner on the relative ages of puberty in past centuries. Since the painting could not have been painted in Italy and since 1628 or earlier would make

the age discrepancy far too much, we seem to be on fairly safe ground in dating the picture to about 1632, a date which accords well with the various other considerations previously discussed.

Medical opinion is divided on the precise nature of the crippling disease which afflicted Calabazas. Dr. Laurence diagnoses mild hydrocephalism with spina bifida, a lesion of the spinal cord causing pescavus, the toe pointing to the ground and incapable of supporting weight. Dr. Fried considers the most likely cause to be cerebral palsy, accounting for the strabismus and deformities of the extremities; another more remote possibility being poliomyelitis. In any case the condition of the left foot accounts for the curious entry in Moreno-Villa that Calabazas used twelve pairs of shoes in his last ten months. These could only be accounted for by the dragging foot and consequently the unusual wear on both feet.

We now leave the primary sources, original paintings, to deal with secondary materials, particularly the history of the *Calabazas* of 1632. The picture first appeared in modern times in 1863 in the collection of the Duc de Persigny, though it is "reported" to have come there from northern England. It was sold on 4 April 1872 at auction to Maurice Cottier, Paris, then to Sir George Donaldson, London, then to Herbert Cook of Doughty House where it remained in the Cook Collection, except for wartime service at the Fitzwilliam and a postwar sojourn on Jersey, until the Christie's auction of 19 March 1965, when Cleveland purchased it. With the possible exception of Trapier (1948), all scholars have accepted it, with reservations only for assumed repainting of right hand, miniature, and background—precisely where we have already seen that no repainting exists. [Justi (1903), Beruete (1909), Moreno-Villa (1920, 1939), Mayer (1936), Lafuente (1943), Sanchez-Canton (1953, 1963), Gaya Nuno (1953), Pantorba (1955), Soria (1959), and Aznar (1964)] Let it be added that Moreno-Villa's careful study of the royal inventories for evidence about fools, dwarfs, etc., found twelve portraits, extant and lost; of these subjects between 1620 and 1650, and that of the twelve, all but one were by Velasquez. The sole exception was the *Soplillo with Philip IV* by Rodrigo de Villandrando and, as we have seen, one can well understand the royal preference for Velasquez.

Such statistical citations, like inventories, are subject to various kinds of error—mental lapses, verbal confusions, laziness, carelessness, and manipulation. The description of a *Calabazas* by Velasquez in the 1701 inventory of the Buen Retiro is cited by Trapier as proof positive that the picture listed there cannot be the Cleveland one. First, let it be said that the inventory has never been correctly transcribed and citations from the beginning are incorrect in detail and arrangement.

Folio 720 of the *Testamentaria of Charles II* begins with the *Pablo de Valladolid*, continues with the *Pernia* as Corsair, the *Don Juan of Austria*, all these valued at twenty-five doubloons, then *Ochoa, Porter of the Court*, the same shape, author, and frame as *the one before last (penúltimo)* at twenty-five doubloons, then carrying over

to folio 721, "another of the same shape, and character of Calabacillas with a portrait in the hand and a letter (paper) in the other valued at *20* (not 25 as hitherto recorded) doubloons." All of this is simply to show that in the inventory the *Calabazas* was associated with the three other full lengths now in the Prado, through the medium of a lost picture of the porter Ochoa—perhaps dimly reflected in the picture of the same name in a private collection, Madrid, and in an etching by Goya.

The valuation of twenty doubloons indicates a slightly smaller picture than the three in the Prado, as is in fact true of the Cleveland *Calabazas*. The inventory gives 2½ × 1⅓ *varas* for Pablo and Don Juan, 2 × 1½ for Pernia, and "the same" for Calabazas. Since the *vara* varied enormously from region to region, and time to time, and since its sloppy application is only too customary in inventories such as those of the Palace and the *Torre de la Parada*, we can only say that none of the pictures really work out to the inventory measurements.

The *villete* is more serious, but not fatal. Verbal confusion is always a possibility. One can imagine the clerks of 1701, certainly neither experts in painting or iconography, listening to their colleagues and not always getting it right—did you say *villete*? or was it *molinillo de juguete* (toy windmill)? or *molineta* (little mill)? or was it *rodete* (a small wheel)? After all, the small *Calabazas* of the Prado was misnamed *Bobo de Corls* in the inventory of 1794 and the name stuck until the 20th century. Fortunately, a very recent article by Professor Lopez-Rey, incorporating research and discovery in the archives of the Royal Palace in Madrid, dispels all doubts about the documentary evidence. An inventory of the Buen Retiro Palace completed on 7 September 1789 lists as no. 178 "Another (painting) by Velasquez: Portrait of Velasquillo, the buffoon, which the old inventory says is of Calabacillas, holding a portrait and a pinwheel in his hands." Then on 5 July 1808, the picture is listed in a royal chamber, then allocated to the Inspector General of the French armies in Spain. The painting then disappears until its appearance in Paris in 1860 in the collection of the Duke of Persigny. This comedy of errors, changing the description of the windmill, then correcting this mistake while making another, the misnaming of the buffoon, is proof enough of the unstable nature of inventories, catalogs or lists, ancient or modern—as unstable as the nature of their makers, man himself.

Today we understand Velasquez as an intellectual, that many of his paintings, notably *The Fable of Arachne* (also called *The Tapestry Weavers*), contain elaborate intellectual programs, particularly delightful to the modern iconographer. The first *Calabazas* displays such a program; but it is not fully revealed. Velasquez' library at his death contained two works on symbolism, one by a certain Peregrino (Andreas Schott?), not yet identified, and the well-known woodblock illustrated edition of Cesare Ripa's *Iconologia*. This cookbook of iconography contains, as Soria recognized, the basic elements of Velasquez' presentation of Calabazas.

Pazzia (Madness): a man of virile age; a full-length costume of black color. A laughing appearance, riding a cane as a horse. In the right hand holding a paper pin-wheel. . . .

Velasquez has shifted the pinwheel to the left or sinister hand, and has added to the performance a miniature held in the right or auspicious hand. The miniature, not an addition, and not a mirror as in common "fool" iconography, is evidently significant, but the bust representation upon it is so generalized, or better, idealized, as to make a positive identification quite hypothetical. Trapier's "a later addition because of the costume," is a case of hearing the grass grow. The idealization of the costume approaches that used by Velasquez in such classical representations as that of Arachne in the background of *The Fable*; but the head itself could almost as well be male as female. Still, the high-dressed hair seems to be that of a woman. One can speculate endlessly: Beauty and the beast? or, ironically, the courtier as a gallant holding the image of his beloved? The contrast between dexter and sinister seems to be significant. The pinwheel is definitely the unstable attribute of madness; why is not the miniature the opposite personification of wisdom and stability? —perhaps Minerva? Is there a precedent for such a hesitant identification? Garzoni's famous *L'Ospedale de' Pazzi Incurabili*, Ferrara, 1586, a source for some of the literary use of madness images in Spanish and Italian drama, gives the following (as cited by M. Foucault in *Madness and Civilization*):

> *Here each form of madness finds its proper place, its distinguishing mark and its tutelary divinity; frenzied and ranting madness symbolized by a fool astride a chair, struggles beneath Minerva's gaze. . .*

And what of the solidly painted, almost magically real folding stool in the *Calabazas*? I have searched at considerable length among Spanish and Italian portraits of the seventeenth century, and the folding stool is not by any means common. Though it was an ordinary item of furniture, I have found *no* examples of its use as staffage in a portrait. Its selection should be significant; and at least is so in being a less noble seat appropriate to a lower member of the royal court. But it may well have another and more hidden meaning. It is not a fixed seat, being deliberately collapsible and portable—unstable. Unlike the two-bladed pinwheel held by Calabazas, Ripa's paper windmill has four blades. And in the iconography of that favorite of the Spanish court, Hieronimus Bosch (el Bosco) in the Lisbon *Temptation of St. Anthony* (at the Escorial during the seventeenth century), as well as on both sides of *The Carrying of the Cross* in Vienna (whose provenance is unknown), the two-bladed paper pinwheel is used as the attribute of the divine or secular fool, and of the stupid onlookers, twice it is accompanied by portable three- and four-legged supports used for infants, cripples, and fools. The specific derivation from Bosch to Velasquez is almost certainly unprovable; but meaningful reverberations of the past are surely present in the Spaniard's subtle and many-layered depiction of *Calabazas*.

The Water and the Moon in Chinese and Modern Painting

This article was first published in Art International, *volume 14, no. 1 (20 January 1970). Lee is able to make broad cross-cultural comparisons, integrating here two areas at first glance totally dissimilar.*

"But", I asked him, "do you understand the water and the moon? The former passes by, but has never gone. The latter waxes and wanes, but does not really increase or diminish. For, if we regard this question as one of impermanence, then the universe cannot last for a twinkling of an eye. If, on the other hand, we consider it from the aspect of permanence, then you and I, together with all matter, are imperishable." [1]

The kinds of conclusions one can draw from such comparisons, and whatever insights may be apparent here, are of a limited and general nature. They belong more in the realm of the critical essay than that of the scientific paper. Surely, you may say, the cultural environment of the Chinese painter of premodern times is so far removed from that of the modern Western artist as to be incapable of comparison at all. The Chinese lived in a traditional and pre- or unscientific society, heavily centralized in its political and economic controls, family— and ancestor—oriented in its social outlook, whether the family was that of the sons of Han, the nonbarbarians, or that of the Imperial dynasty, or the strong regional prejudice for the province as "family," or the basic social unit held together by ties of blood or adoption. An intellectual elite largely based upon a complex and successive official examination system, but partly and practically based upon an aristocracy of traditionally "official" families, was above all well practiced, even phenomenally so, in an ancient literature common to all through hard discipline in memory and calligraphy. The latter discipline, however, was much more to the Chinese scholar than to his Western counterpart. Calligraphy was not merely a means of expression, it was expression itself; and the intimacy of the Chinese scholar with brush, ink, and paper was easily and customarily transferred from literature to painting, from verbal to visual imagery. But even more, calligraphy was to the Chinese what analysis is to the Freudian, the revealer of character, of the innermost morality of the man. The careers of these scholars were not limited to one discipline, as is usual in the West, but embraced literature, painting, statecraft, philosophy, and religion. Their energies were directed to these disciplines, usually in equal degrees. To be a professional painter or politician in the Western sense was unthinkable, except for artisans or barbarians.

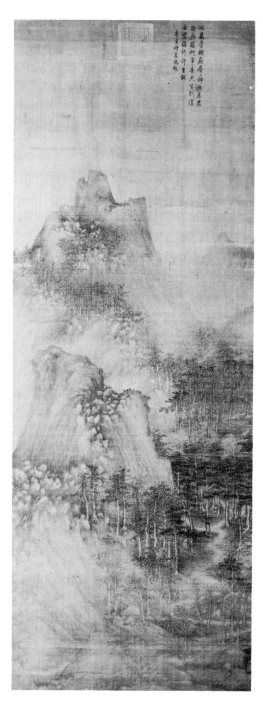

34 Chu-jan, *The Receding Peaks and Groves of Trees*, Chinese, Northern Sung Dynasty.

35 Tung Ch'i-ch'ang, *In Shade of Summer Trees*, Chinese, Ming Dynasty.

In contrast, the mobility of modern Western society, its combination of pragmatism, idealism, and science, its professional specialization, its cult of individualism and originality, and above all its search for hitherto unthinkable questions, seems to reveal a more dynamic, constantly expanding, if not progressing, social order, where art and particularly painting is, if not beside the point, not very close to the centers of power and creativity. One can boldly describe the Chinese painter as a member of a closed society, and his modern Western counterpart as the inhabitant of an open society.

But having admitted all this, one is left with history, that great corrective of science and art; and in history one finds some significant developments that may have some meaning for one interested in the arts in general and in certain strange shapes and images of later Chinese painting in particular.

If we Westerners confront two Chinese landscape paintings widely separated by time, the one of the tenth century, the other of the early seventeenth century (Figs. 34, 35), we may be pardoned, but not exonerated, for our failure to distinguish the vast artistic gulf that lies between them. Such a failure of communication is but one more in a long series well known to comparative anthropologists. How can one be so blind? But conditioning and habit make us so. Hence the need for revolutions. Such revolutions occurred within the history of Chinese painting and usually during a "time of troubles," a period of social instability when the traditional Chinese artistic response was introspective but still searching for and desirous of change. Who could believe that only a century separates the toy- and fairy-land of the ninth-century *Journey of the Emperor Ming Huang to Shu* from the towering, knowing, majestic monumentality of Fan K'uan's *Travelers Among Mountains and Streams* (Figs. 36, 37)? With one leap the Five Dynasties artists went from miniature rocks to awesome crags; their painterly means caught up with what they had written and said as poets long before. Inhibited by the figural power of Buddhism and by the celebration of the worldly pleasures of an all-powerful Imperial Court, they found themselves in a new and troubled world without a social or political anchor. Their answer was to provide the foundations of the first great monumental landscape art in the world's history.

The thirteenth and fourteenth centuries provided a comparable intellectual climate, this time in terms of real or assumed repression by foreign barbarians, the Tartars and the Mongols. Radically new styles of landscape flourished—fragmental and poetic responses to nature with a new freedom of brush and ink—if still clearly derived from the earlier monumental landscapes. This aesthetic response failed to be enough, for the very professional painter classes that experienced it were considered too deeply involved with Chinese disgrace and Mongol triumph to provide the artistic leadership and morality demanded by Confucian social theory. Thus there arose the "gentleman-painter's" (*wen-jen*) revolution, the assumption by a class, an in-group of scholar gentlemen, of the role of true artistic leadership. The *wen-jen* knew very well the revolutionary nature of an art for art's and morality's sake,

despite their reverence for and study of the masters of earlier monumental landscape painting. The purity and extremism of their art was also marked by wilfully personal styles, as in the two extremes here of Ni Tsan and Wang Meng (Figs. 38, 39), painting at almost identical times—the 1360s. Such individual expressions of the literary man's style, refined and in some cases amalgamated into a more universal mode, remained the standard for creative Chinese painting for more than two hundred years.

The troubled times of the late Ming Dynasty—one might "Timese" them into the "turbulent 1600s"—evoked the most violent aesthetic reactions in the history of Chinese painting. The works of this period are the ones that particularly concern us here. The nature of the response can be symbolized first by its intellectual crystallization in the frozen but monumental forms produced by Tung Ch'i-ch'ang (Fig. 40) in his single-handed effort to rebuild the old monumentality, large scale, and pictorial integrity. This fierce purposefulness, disregarding all effects of mere charm and skill, was not enough. Aloof, even coldly intellectual, Tung's art lacked the intuitive and emotional elements of revolt. These elements were supplied by the late Ming and early Ch'ing individualists, perhaps the most famous of them being Tao-chi (Shih-t'ao). If we compare his *Waterfall of Mount Lu* (Sumitomo collection, Japan) with the earlier work *Lofty Mount Lu* (1467) of Shen Chou (National Palace Museum, Taiwan), the character of the new attitude becomes clear. It is best expressed in the words of Tao-chi himself:

> *I am always myself and must naturally be present (in my work). The beards and eyebrows of the old masters cannot grow on my face. The lungs and bowels (thoughts and feelings) of the old masters cannot be transferred into my stomach (mind). I express my own lungs and bowels and show my own beard and eyebrows. If it happens that my work approaches that of some old painter it is he who comes close to me, not I who am imitating him. I have got it by nature (genius), and there is no one among the old masters whom I cannot follow and transform.*

Within the thinkable rules of the game, such thoughts and their pictorial expression constitute as violent and revolutionary a response as was possible.

Such changes, or revolutions, are well known in different contexts in Western art. Since I have named three in China, it is only fair that I name an equal number in the West. The change from Byzantine understanding of the subject of Christ in the Garden of Olives to Giotto's presentation of the final scene in the same setting in the Arena Chapel, separated by less than twenty-five years, is one from a purely conceptual never-never land to a stage where purposeful and sculptural figures act their parts in a real tragedy, not a symbolic mystery play. The sequence of paintings from the Arena Chapel to Raphael and Michelangelo is so familiar to you that one can pardon your calm acceptance of the successive violent changes involved.

All is clear sailing, within reasonable limits, until one comes to Cézanne. Revolution, already a political reality after 1848, became visually acute when the picture frame became more than a window—when it became a boundary for architectonic struggles whose prototypes existed in some previous relics of European painting, but never so nakedly and never so disrespectful of the primary concerns of tradition. When Cézanne talked respectfully of Poussin he had Nature, or better his sensations of nature, uppermost in his mind. In a sense his attitude was Romantic for he conceived of a return, beyond Poussin, into nature. Such an Eternal Return finds its first principal modern spokesman in Jean-Jacques Rousseau—never speak of painters leading intellectual revolutions.

The third change followed even harder upon the second. Abstract painting, historically the "invention" of the most unartistic of artists, Kandinsky, is too well known to require illustration. Its protests and demands will form a large part of the following discussion. And, as we shall see, within its very loose rules of the game, it offers some interesting parallels with the more confined Chinese tradition.

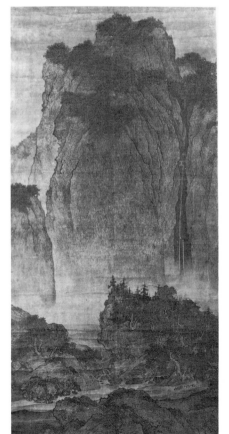

37 Fan K'uan, *Travelers Among Mountains and Streams*, Northern Sung Dynasty.

36 *Journey of the Emperor Ming Huang to Shu*, Chinese, T'ang Dynasty.

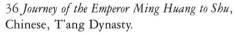

We have twice alluded to "Rules of the Game." Rules are given from various alleged sources; these sources all variously spell tradition. To the Chinese individualist, tradition loomed like the substance of the labors of Sisyphus. Throwing off half the rock was better than bearing the whole—and just as courageous, or more so, as Duchamp's drawing a moustache on the Mona Lisa, an automatic action preceded by innumerable less gifted lavatory geniuses. Tao-chi puts the Chinese position as strongly as possible.

> *The works of the old masters are instruments of knowledge. Transformations mean to understand {these instruments}, but not to be as they. I never saw a painter who being like the old still could transform them, and I have often regretted the {conventional} manner of adhering to them which causes no transformations. This depends on a limited understanding and on adhering simply to the outward likeness. When the superior man borrows from the old masters, he does it in order to open a new road. It has also been said: "The perfect man has no method", which does not mean that he is without method. The method which consists in not following any method (of the ancients) is the perfect method.*

One needs little wit to recognize this source of Ad Reinhardt's negative strictures on the nature of true art.

And Cézanne, the next-to-the-last spokesman within the then existing Western tradition, feels his position almost as a Chinese. Writing at Aix on 12 May 1904, he says:

> *The Louvre is a good book to consult but it must only be an intermediary. The real and immense study that must be taken up is the manifold picture of nature.*

And on 23 January the following year,

> *To my mind one should not substitute oneself for the past, one has merely to add a new link.*

I said next to the last, for Picasso is the last. His comment is, typically, pictorial— *The Women of Algiers after Delacroix.* The link to Cézanne is not unsupported, for before that very picture in the Louvre, Cézanne remarked to Gasquet, "We are all there, in that Delacroix."

The succeeding generations have witnessed a growing impatience with the rules of the game. No more striking or touching example can be cited than the words of Frank Stella and Donald Judd as recorded by their straight-woman Lucy Lippard in *Art News*, September 1966:

> Question: *Are you implying that you are trying to destroy painting?*
> Stella: *It's just that you can't go back. It's not a question of destroying*

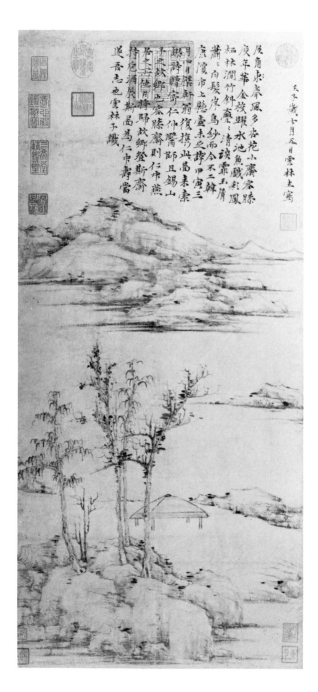

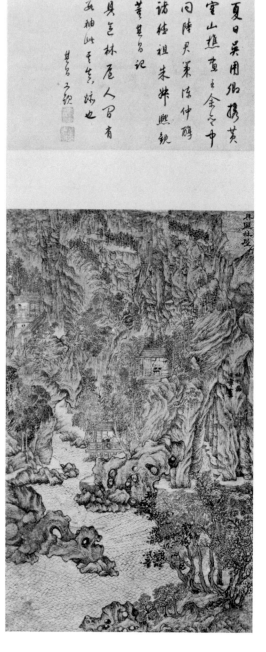

38 Ni Tsan, *Jung-hsi Studio*,
Chinese, Yüan Dynasty.

39 Wang Meng, *Retreat at Chu-
ch'u*, Chinese, Yüan Dynasty.

anything. If something's used up, something's done, something's over with,
what's the point of getting involved with it?
Judd: *Root, hog, or die.*

In practice the Chinese revolt had to take place within the boundaries of subject matter. A consciously conceived abstract painting was inconceivable. Thus landscape and figure could be reduced to extraordinarily free brushwork, not eliminated but almost hidden. Or the subjects could be manipulated or interchanged—man could look like tree and vice versa. This was quite a consistent and purposeful effort as is evident in two paintings by Chin Nung (private collection, Japan), aesthetically quite different, but equally showing a determination to reduce the subjects to equality, and by indirection to nullity. The direct response of the Western artist was to eliminate subject matter altogether.

The Chinese revolt included inversions and perversions of technique and medium. Old techniques of brushwork were broadened and pushed to extremes. The techniques of blowing ink from a bamboo tube or splattering it from a stiff hog-bristle brush were already at hand. Tao-chi speaks of "establishing the divine essence *in the sea of ink,*" but then reverts to "the point of the brush." J. Pollock, Yves Klein, and kindergartners were by no means the first to use the hands in painting. Kao Ch'i-pei and Kao Feng-han were eighteenth-century masters of "finger-painting," a means more restricted than that allowed by the brush, but now evidently more satisfying, i.e., antitraditional.

One final violation of the rules in both East and West can be cited. This was a basic revolt achieved by denial of a format. The handscroll, that long pictorial development on narrow paper through time, was one of the greatest of all Chinese contributions to pictorial art. It maintained its fascination through the seventeenth century, and even beyond in the hands of more traditional masters of later times. But, aside from isolated and usually youthful efforts, the later individualists preferred the hanging scroll and especially the more intimate album formats. In the twentieth-century West we have witnessed the repeated death, by decades, of easel painting, first by satire and irony, and more recently by the environmental scale of paintings by Pollock and other modern masters of the avant-garde. Even more recent explorations of the "Thingness" of squared canvas have further limited and finally destroyed the concept of the framed picture space. To achieve a proper revolution, "each man kills the things he loves."

Fine art has always, willy-nilly, been for an in-group, an elite. The throngs that accompanied Duccio's *Maesta* through the streets of Siena were surely largely motivated by nonaesthetic thoughts and emotions. Still, one of the most characteristic features of modern painting has been its in-group character. Popularity is the death-knell of a movement. This has been especially true of Chinese painting, and never more so than with the works produced by the *wen-jen*—the literary gentlemen—since the fourteenth century. It was a matter of pride that scrolls were not sold but

given away—and to friends, not to those in the out-group. The close geographic and familial ties of the Chinese *wen-jen* painters are a matter of record. Their Western counterparts were and are less class-bound, more an in-group of individuals with shared standards.

Such standards, as we shall see at the end, were primarily moral and ethical, rather than shared styles, as was true to a comfortable degree for the impressionists and the cubists.

Now, by in-group we mean friends, sharing what friends share. When Lo P'ing paints his friend I-an in 1798 he shows him almost as grotesque as the rock behind him (Ching Yüan Chai collection). And such rocks, twisted and gnarled, pierced and broken, were analogs of the character revealed by the thoughts and actions of humans. The Chinese scholar-painter collected rocks; he valued them as he valued an upright nature. By similarity, but more by contrast, Vlaminck and Derain portrayed each other in 1906, bound together as much by style as by friendship, but still characters, more than mere passing faces in an unknown crowd.

The Chinese and modern Western in-groups shared their interests. Words and sketches passed back and forth from Kirchner to Fritz Bleyl on postcards. For the Chinese it would be an album of sketches—memories of the Ch'in Huai River dedicated to a friend (Fig. 41).

One curious parallel, even ludicrous, springs to mind—Kokoschka and Ming scholar painters cheek by jowl, with Alma Mahler as the intermediary. Shades of Lehrer's Gustav, Walter, and Franz! Between 1912 and 1914, Kokoschka enjoyed a tumultuous affair with Alma, and painted some "souvenir" fans—on swan skin (Fig. 42)! These were remarkable echoes of the Ming and Ch'ing painters' habit of bestowing informally painted fans upon friends as parting or commemorative gifts. Slight as works of art, they still mirror the most transient thoughts and aes-

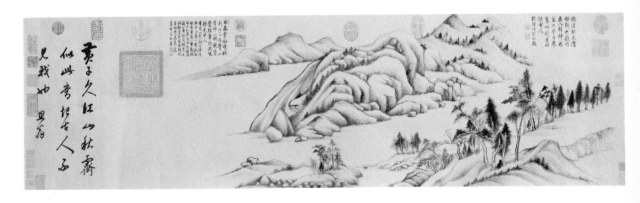

40 Tung Ch'i-ch'ang, *Mountains on a Clear Autumn Day*, Chinese, Ming Dynasty.

thetic modes of these gifted literati. Kokoschka embraces Alma forever; but Li Po contemplates a waterfall to eternity (Fig. 43). Here the rules of the game pose freedoms and restrictions that symbolize in a most concrete way the gulf, however comparable these groups may be, between the Chinese literati and the Western intellectuals.

All the products of art can be characterized as themes and variations. But for the modern artist and for the later Chinese painter, theme and variation, to a very specific and limited degree, became a way of painting, a way of limiting the aesthetic problems to be faced. At the same time this liberated intensity of feeling, providing a concentration of forces impossible of achievement within the relatively broad scope of traditional subject matter and style. The conscious series is a commonplace in modern painting. Motherwell's *Elegies to the Spanish Republic* now number in the sixties. All are fresh approaches to pictorial and philosophical problems of tension, pressure, release, blackness, and death, made more poignant and moving by their economy of means, their insistence on a new resolution each time of a simple but compelling problem (Fig. 44). While, far removed in mood from these dark thoughts, Mei Ch'ing's terraced forests (Fig. 45) are directly comparable efforts to produce a maximum impact from a deliberately limited representational and aesthetic means. The rhythmical repetition of limited shapes, almost rococo in their light and delicate nuances, achieves a personal and unmistakable style—a limited theme with infinite variations. And such an achievement need not be confined to the traditionally most popular subject matter of later Chinese painting—landscape. Chu Ta's fish (Fig. 46) and birds are justly remembered for their human qualities. Personified as whimsical, furious, or frustrated, these fish are part of an assault on the extreme possibilities of the traditional album painting format and traditional subject matter. To place the smallest fish on the largest expanse of paper is a gesture of defiance as great within its limits as the more daring possibilities available to the modern Western individualist.

To be sure the theme and variation idea was built into later Chinese painting with the almost ritual composition of album sequences of eight to twenty-four leaves displaying landscapes painted "in the manner of" classic early masters (Figs. 47, 48). Here the artist genuflected lightly in the direction of his various ghostly mentors and indulged in his own touch or manner as a counterpoint to that of the earlier prototype. In a sense it was a using of tradition for liberation, an acceptance of chains in order to be free. Such contradictions are more inherent to a traditional society than to what we call an "open society." The current Western vogue for the strikingly antithetical but coupled ideas of Zen Buddhism poses questions about the intellectual freedom of our complacently accepted free society.

Finally, to persuade by reduction to absurdity, the theme and variation comparison between Chinese and modern Western art can be capped by alluding to the most extraordinary example of the type known to me. The late Ming individualist

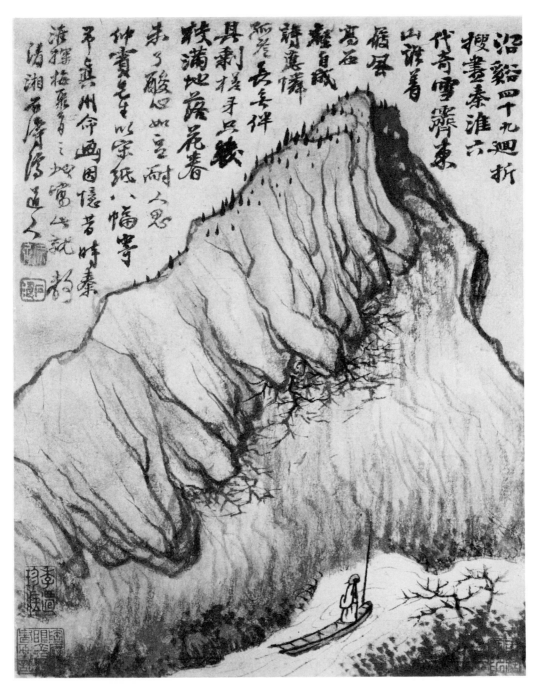

41 Tao-chi, *Reminiscences of the Ch'in-Huai River*, Chinese, Ch'ing Dynasty.

42 Oskar Kokoschka, *Self Portrait with Alma Mahler.*

Ch'eng Cheng-kuei set out to paint, in handscroll format, five hundred versions of landscape entitled *Dream Journeys Among Rivers and Mountains* (Fig. 49). At least three hundred are known to have been painted, all carefully numbered and all bearing the same title. The key word is *dream*. How else to free the mind during the fall of a dynasty and the triumph of the foreign Manchus than to dream the same thing, again and again?

Certainly one of the most characteristic modes of modern painting is that of protest, whether violent or quietly subversive. Without the late Goya some angry critics would find the early nineteenth century unbearable. With the Industrial Revolution, and most particularly in the twentieth century, large-scale protest, whether savage and specific, or a vague kind of weltschmerz—the ancestor of current nausea—became a part of the avant-garde. We have seen Duchamp's moustachioed Mona Lisa, but it pales beside the *Guernica* or the abstract images of Motherwell. Protest is often ugly and it had only a sporadic use in China. The unusual quality of direct observation and comment visible in Chou Ch'en's *Street Beggars* (Fig. 50) is almost unique in Chinese art. These poor, miserable creatures were, by the evidence of the artist's own colophon, directly observed from nature. Further, they were intended as a comment upon the disturbed social conditions of the day, as is made explicit by the appended comments of a contemporary annotator who cites the pitiable conditions in a previous dynasty as a cloaked criticism of the rulers under which he and Chou Ch'en live. Such protest was forbidden and hence the subversive literary cloak; but the pictorial evidence is clear enough for those with eyes to see.

However the traditional means of protest was the retreat into the hermit-scholar's life. Simply by withdrawing from society the artist's protest was made

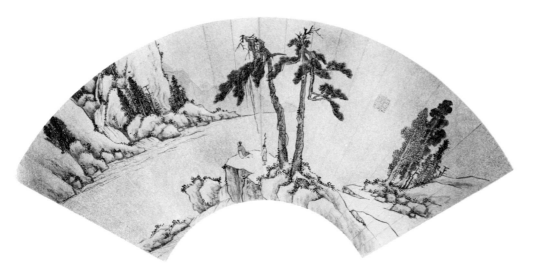

43 Wen Cheng-Ming, *Li T'ai-po watching a Waterfall*, Chinese, Ming Dynasty.

clear. For under Confucian morality the ideal situation was to be found in the family, and in office at the service of the good ruler. Simply withdrawing became, for the Chinese, a devastating comment not lost on those against whom the artist thus revolted. The classic pictorial expression of such a retreat was in remote landscapes where the single figure sat, his back to the world (Fig. 51). Literary and historical aid is necessary to fully complete the equation. The grotesque rendering of the Wu mountains with the small, rocklike figure lost in the wilderness, was a direct visual expression of retreat and it was further pointed up by the deliberately anti-traditional brushwork of this then youthful artist of twenty-seven, a descendant of the Imperial family condemned to futility by the gathering powers and ultimate triumph of the foreign Manchus. Such a crabbed and original picture speaks volumes by indirection.

But it was not even enough to be indirectly in revolt at this time. By Chinese and even Western standards the expression of revolt and disillusionment in the mid-seventeenth century reached a considerable extreme in the person of K'un-ts'an, an individualist turned Buddhist monk. In a most remarkable combination of poetic and pictorial protest, K'un-ts'an expressed sentiments of a most modern revolutionary nature.

> *The question is how to find peace in a world of suffering. You ask why I came hither; I cannot tell the reason. I am living high up in a tree and looking down. Here I can rest free from all troubles like a bird in its nest. People call me a dangerous man but I answer: "You are like devils."*

His subject is not just himself, but derived from tradition—a Ch'an (or Zen) monk, Priest Tao-lin (better known as Niao-kuo or Choka, monk in the bird nest), who

138

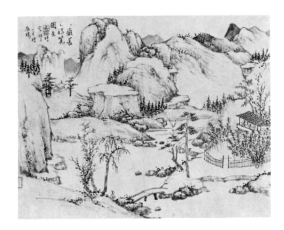

47 Ch'a Shih-piao, *Landscape after Ni Tsan*,
Chinese, Ch'ing Dynasty.

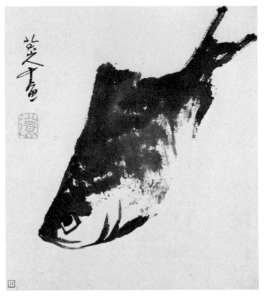

46 Chu Ta, *Album of Flowers, Birds, Insects
and Fish*, Chinese, Ch'ing Dynasty.

44 Robert Motherwell, *Elegy to the
Spanish Republic No. LV.*

45 Mei Ch'ing, *Landscape Album of Ten
Paintings*, Chinese, Ch'ing Dynasty.

lived in a tree, a Buddhist Saint Simeon Stylites if you will. Yet the force of K'un-ts'an's statement can be sensed if one compares it with an almost exactly contempo-rary rendering of the same subject by a great Japanese painter, Sotatsu (Fig. 52). Now we are in a moderately disciplined, prosperous, and contented milieu, the time of the rise of the Japanese middle class, of mercantile prosperity, and delight in joyful decorative painting.

Some of K'un-ts'an's landscapes display the same turbulent nature expressed more concretely in the semi-autobiographical painting (former T. Yamamoto col-lection, Tokyo). Such a panoramic cataclysm is not unique at this time and other individuals of the seventeenth century, such as Kung Hsien (C. Drenowatz collec-tion, Zürich), seem to radiate the same spirit. In Kung's case the emotion of revolt is buttressed by a reliance on effects of light and shade quite foreign to Chinese tradition and probably attributable to the influence of Western art through the medium of engravings and etchings imported by such foreign intruders as the Jesuits.

We are familiar with these forceful expressions of artistic protest in the West in forms as antitraditional as possible—notably in the exploitation of children's draw-ing. This deliberate espousal of awkwardness, of undisciplined haptic modes of representation, is an obvious protest against slickness, too much knowledge, and adult untrustworthiness. This particular mode is directly paralleled in China by the *wen-jen* cult of "blandness," a kind of deliberately awkward and amateurish way of drawing things, particularly people and buildings (Fig. 53), since these were the special skills of the despised professional artisan-painters. To judge a literary man's or individualist's painting by the skill shown in figures or buildings is to fall into the trap he has so artfully prepared for you. If you discard him, he has the last laugh; he has managed to lose you, an encumbering clod who cannot reach through the artifice to the heart of the matter. How subtly avant-garde can one expect a Chinese scholar to be?

A side issue, but an interesting one for future speculation and research, is that of the relation of alcohol to artistic liberation. Protest is easier when one is less inhib-ited, by any means. We are all familiar with the too-publicized wet images of Pollock and de Kooning. Further, alcohol has become déclassé; sterner stuff is the order of the day among those in revolt or who simply, like a Chinese scholar in bad times, want out. Such stimulants were a part of the scholar's milieu and many an "ink-play," an informal and intuitive pictorial accomplishment was produced at a party where convivial friends met, drank, poetized, and painted. The particular freedom and loose charm of Chao Meng-fu's *Rocks, Bamboo and Orchids* (Fig. 54) lies in the almost hit-or-miss informality of its brushwork. The result was only pos-sible because of the legendary discipline of Chao's hand, the most famous of its time, but here relaxed, bland, open, freed on cups of wine.

But all of these points of comparison, whether similarities or contrasts, are, in

140

48 Ch'a Shih-piao, *Landscape after Mi Fei*, Chinese, Ch'ing Dynasty.

49 Ch'eng Cheng-kuei, *Dream Journeys Among Rivers and Mountains*, Chinese, Ch'ing Dynasty.

the last analysis beside the point. For both the Chinese individualists and for the Western avant-garde, the act of painting and its result, the picture or image, is a moral act, a statement of where the artist stands at any given moment in as pure and perfect an expression as is possible. Nothing would be more humiliating to the artist than to "explain" his work as a decorative or thematic complex, as a document of history, or as an illustration of tortured philosophizing in the latest linguistic modes. When the Chinese critic finishes his characterization of a master's art he usually ends with a verdict of divine or merely skillful. Thus when the seventeenth-century individualist Tao-chi described the art of one of the fourteenth-century founders of *wen-jen* painting, Ni Tsan (Fig. 38), he wrote:

> The paintings by master Ni are like waves on the sandy beach, or streams between the stones which roll and flow and issue by their own force. Their air of supreme refinement and purity is so cold that it overawes men. Painters of later times have imitated only the dry and desolate or the thinnest parts and consequently their copies have no far reaching spirit.

Tao-chi himself wrote a treatise on painting in which he extolled the virtues of the single stroke as revealing the beginning and end of painting, the innate character of the man.

> When one has mastered the union of brush and ink, one can express the divisions of yin-yün {breath of life and form}, open up chaos, transmit everything old and new and form a school of one's own. All this must be done with intelligence, one must not carve or chisel the paintings, not be stiff or weak, not make things muddy or confused, not neglect the partitions {of the compositions}, nor leave out reason. The first thing to be established in the sea of ink is the divine essence; then life must be brought in at the point of the brush. On a scroll which is no more than a foot long every hair and every bone can be rendered. One must bring light and clearness into chaos.—Even though the brush is not brush, the ink not ink, the painting not painting, I am in it myself: As I turn the ink it is no longer ink, as I grasp the brush it is no brush, and as I find an outlet for my pregnancy it is no longer pregnancy. By i-hua {one stroke painting}—all the innumerable things of the world may be divided, and these will again unite in regulating the whole. When by this transformation the yin-yün has been achieved it is the consummation of art.

While no direct historical connection may be shown, it is surely true that the later Chinese individualists were almost totally unappreciated in the West until after the Second World War. In Japan they had been collected in the last fifty to seventy-five years by a handful of Confucian-oriented scholar-gentlemen. Their lack of decorative charm, their just plain perverse difficulty, left them outside art history until the growing interest in "difficult" Western art began to provide a climate

142

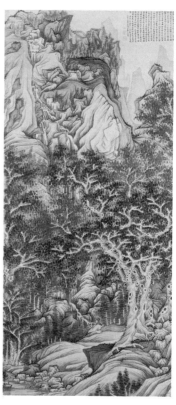

50 Chou Ch'en, *Street Beggars*, Chinese, Ming Dynasty.

51 Ch'en Hung-shou, *Wu-she-shan: The Mountain of the Five Cataracts*, Chinese, Ming Dynasty.

52 Nonomura Sotatsu, *The Zen Priest Choka*, Japanese, Edo Period.

53 Wang Meng, *Writing Books Under the Pine Trees* (detail), Chinese, Yüan Dynasty.

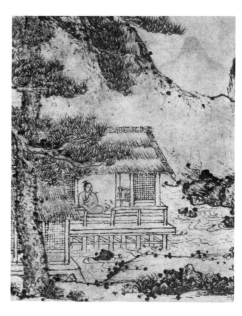

where such an interest could be transferred to the study of Chinese painting. The first showing of the individualists was held in New York in 1948 at a commercial, not a public, institution—and the Western name that recurs in the catalogue of that exhibition is Cézanne. Plainly the master of Aix was one of the first to paint difficult pictures and to consciously be concerned with pictorial morality in the modern sense. On 23 December 1904, he wrote to Emile Bernard:

> Yes, I approve of your admiration for the strongest of all the Venetians; we are celebrating Tintoretto. Your desire to find a moral, an intellectual point of support in the works, which assuredly we shall never surpass, makes you continually on the qui vive, searching incessantly for the way that you dimly apprehend, which will lead you surely to the recognition, before nature, of what your means of expression are, and the day you will have found them, be convinced that you will find also, without effort and before nature, the means employed by the four or five great ones of Venice.

From this one can jump to the atmosphere of the forties, which, in parts, continues to this day. Perhaps the most articulate spokesman for the American avant-garde has been Robert Motherwell, and he reiterates the underlying ethical and moral nature of painting.

> Venturesomeness is only one of the ethical values respected by modern painters. There are many others, integrity, sensuality, sensitivity, knowingness, passion, dedication, sincerity, and so on, which taken altogether represent the ethical background of judgment in relation to any given work of modern art. Every aesthetic judgment of importance is ultimately ethical in background. It is its unawareness of this background that is an audience's chief problem. And one has to have an intimate acquaintance with the language of contemporary painting to be able to see the real beauties of it; to see the ethical background is even more difficult. It is a question of consciousness. . . . Without ethical consciousness, a painter is only a decorator.
>
> Without ethical consciousness, the audience is only sensual, one of aesthetes. (From Perspectives, #9.)

If we confront a detail of Chu Ta's handscroll of *Rocks and Fishes* with Francis Bacon's portrait of Vincent van Gogh (Figs. 55, 56) we can, if we make the effort, be aware of the lonely integrity necessary for the artist in ages essentially unsympathetic to the values of art. Chu Ta's fish is explicitly defined in the poems he wrote as a part of the scroll, to be a symbol of both scholar and soul, passing through the currents of stress and "the dusty world" to reach a lotus water-heaven. The firm, spare, and yet sensuous brushwork is the very model of the scholar's integrity. It stands alone, a thing unto itself. The lonely figure of Vincent, trudging down the road with his canvas on his back, is both a part of nature, attached by his shadow and echoed by the trees, and an outsider to the cagelike world of reason. The menace

144

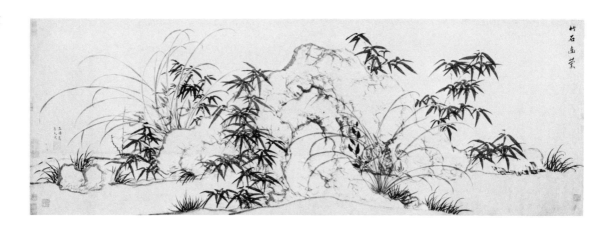

54 Chao Meng-fu, *Rocks, Bamboo and Orchids*, Chinese, Yüan Dynasty.

55 Chu Ta, *Rocks and Fishes*, Chinese, Ch'ing Dynasty.

56 Francis Bacon, *Study for Portrait of Van Gogh II*, 1957

of the cage and the dark foreground is unmistakable. Both these pictures are allegories of the artist's path. To read either work as an illustration of nature or of the history of art is to fail in understanding.

Yet to understand either picture requires a lifeline, however tenuous, back to the past. Judd's "root, hog, or die" is touching because of its naïveté. The Chinese knew better, and so does Picasso.

> *I also often hear the word "evolution." Repeatedly I am asked to explain how my painting evolved. To me there is no past or future in art. If a work of art cannot always live in the present it must not be considered at all. The art of the Greeks, of the Egyptians, of the great painters who lived in other times, is not an art of the past; perhaps it is more alive today than ever it was.*

57 *Shakyamuni Coming Down from the Mountain*, Chinese, Sung Dynasty.

58 *Bodhidharma Meditating Facing a Cliff*, Chinese, late Sung Dynasty.

Zen in Art: Art in Zen

This essay first appeared in The Bulletin of The Cleveland Museum of Art, *volume 59, no. 9 (November 1972).*

Current literature–including that by Sartre, Saussure, Foucault, and Lévi-Strauss, to cite only the most fashionable writers–is pregnant with the discovery of words as things, objects with an archaeological context. To understand words one must know their context, not only in the book or essay and in the oeuvre of the writer but also within the society of record, in historical context, and, not least, within our understanding of these contexts. The resulting complexity of acceptable interpretations of a word or word group is enormous. While the possible refinements are far subtler than those hitherto available, they are equally more incapable of certainty. Current probability has replaced dogmatic surety.

This new "truth" has been known to many in the arts for several decades. Henry Adams' sympathetic but sentimental image (1905) of the creation of Chartres by a unified medieval community at the service of the Virgin has been replaced by a series of images, technically or sociologically oriented, each more precise and restrictive, each more "accurate" from an archaeological and historical viewpoint. Burckhardt's Italian Renaissance (1860), a truly marvelous artistic as well as historical creation, has been thoroughly modified, principally by those who find more and more of the Middle Ages in the Renaissance. Individual works, too, have been thoroughly restudied in an archaeological way and their historical meanings modified, changed radically, or even reversed. For example, the Arena Chapel frescoes of Giotto, key monuments attracting the attention of all students from the time of their creation, are now more thoroughly understood through the glass of late medieval religious drama, studied first without relation to the visual arts, but then placed in meaningful juxtaposition with them.

What does all this and its implications have to do with Zen art? The title of this essay is not capricious, but is an attempt to indicate the depth and complexity of our subject. Zen art was produced by artists and/or artist-monks within a religious context. Where does Zen leave off and art begin? Or where does art leave off and Zen begin? Is the art of Zen painting religious? Is the resulting visual image a work of art, or an aid to meditation? Does the configuration of the visual image derive from Zen, or from art? And, not least, is the work of art always Zen? Or, if not, why and when does it become just art? Why are we always confronted with questions?

We can begin by the briefest of comments about Zen. Brief or lengthy, one can be right or wrong either way. Since one of at least a half-dozen forms of Zen, Sōtō,

stresses immediate enlightenment or illumination, no explanation might well be best. Another Zen form, Rinzai, uses disciplined stages, including *Kōan,* pithy and paradoxical questions and "answers," often in poetic form, on the way to illumination; hence a prolonged discourse might be better. Only one thing is certain: the end is an enlightenment comparable to or identical with that achieved by the historic Buddha, Shakyamuni. The governing word for this form of Buddhism is the Sanskrit word *Dhyāna,* transliterated in Chinese as *Ch'an,* and in Japanese as *Zen,* meaning meditation or contemplation.[1] The essence of the doctrine is clearly meditation (*Zazen*) as the main path to sudden enlightenment (*Satori*). Obviously troubles begin here—how meditate? what enlightenment?

The meditation contemplated by Zen was no wayward and undisciplined wool-gathering. Both sects, Rinzai and Sōtō, stressed its difficulty and the absolute requirement of discipline imposed by master on pupil. Perhaps one quotation will be sufficient to illustrate this. Priest Dōgen in the thirteenth century recalls one old abbot saying:

> *Formerly I used to hit sleeping monks so hard that my fist just about broke. Now I am old and weak so I can't hit them hard enough. Therefore it is difficult to produce good monks. In many monasteries today the superiors do not emphasize sitting {meditation} strongly enough, and so Buddhism is declining. The more you hit them the better. . . .*[2]

Whether meditation was directed to the Buddha mind through the *Kōan* or directly to the realization of the Buddha mind, it was difficult and lengthy. Aids were forthcoming, among them visual images (pictures) comparable to *Kōan,* and that wonderful herb-stimulant, tea. The later, characteristically Japanese, tea ceremony (*cha-no-yu*) can be traced to this earlier use of tea as an aid to Zen meditation.

Since sudden enlightenment, or *Satori,* is ultimately ineffable, impossible to explain or define—"not this, not that"—various subterfuges such as poetry, parable, metaphor, and visual imagery were used to indicate the perimeters of enlightenment.

> *The Law is that which is not created. Not being created means not having any illusion or delusion, but possessing the mind of Emptiness and Tranquillity. Knowing Emptiness and Tranquillity, one can understand the Dharma-Body, one achieves real emancipation. {Shen-hui, d. 760}*[3]

or:

> *The mirror is thoroughly egoless and mindless. If a flower comes, it reflects a flower; if a bird comes, it reflects a bird. It shows a beautiful object as beautiful, an ugly object as ugly. Everything is revealed as it is. There is no discriminating mind or self-consciousness on the part of the mirror. . . . No traces of anything are left behind. Such non-attachment, the state of*

> *no-mind, or the truly free working of a mirror is compared here to the pure*
> *and lucid wisdom of Buddha. {Z. Shibayama, 1967}* [4]

Clearly, though a thorough Zen adept would be the first to deny it, the field of
Zen is mystical as well as ineffable, or outside of logic. Appropriately enough,
its Western apologists relate it to such well-known forms of Western mysticism as
those practiced by Saint John of the Cross, Meister Eckhart, and even William
Blake. From my own viewpoint—a perhaps weird combination of Western pragma-
tism and romanticism—Zen theory makes much of the imagery associated with
Zen art more meaningful, while at the same time making the boundaries of this art
so limitless as to lose almost all meaning and significance. In Zen art, when does
artlessness become carelessness? When does the void in a painting become just
emptiness? When does the seeming naturalness of a stoneware tea bowl become
unnatural for the product of hand and fire? When does ink lose its ability to suggest
color and become just monochrome? Perhaps these and other questions, never to
be fully answered, can be understood better by examining some of the visual images
produced within Zen contexts in China and Japan.

Our museum is particularly fortunate in possessing (an anti-Zen concept!) nu-
merous excellent Zen and Ch'an works. While many of them are illustrated here,
only looking at the originals in the galleries can suffice to offer even a small part
of what they embody in visual form for anyone from skeptic to persuaded mystic.
With the exception of the wood portrait of Hōtō Kokushi (Priest Kakushin), all
are monochrome ink paintings, executed in a free and easy manner appropriate to
the general context of sudden enlightenment. Does this style come from Zen?
Probably only in part.

The spontaneous use of ink on paper or silk in Far Eastern art to produce
"sketchy" images drawn from nature is Chinese in origin and has various, equally
important, derivations. Taoism played a part with its celebration of the rhythm
and continuity of nature, to be known directly and intuitively, whether with the
mind or with brush and ink in landscape painting. Confucianism, too, had its
influence, with carefully developed concepts of principle in nature and of the supe-
rior man who exemplifies and acts on principle. The concept of "untrammelled"
brushwork as a mirror of character derived from such Confucian thought and was an
essential component in the Chinese development of free and spontaneous brush-
work, basic to calligraphy and, by extension, to painting. But the development of
style in painting, of ways of rendering nature and making pictures, was at least
as important as the three attitudes provided by Ch'an, Taoism, and Confucianism.
An artistic elite was continuously refining and experimenting with the wide possi-
bilities of ink and brush as a means of conveying not just the appearance of nature,
but its principles, its morality, its capability of embodying ideas, moods, and emotions
—and under Ch'an Buddhism, of expressing the visual metaphors flashed in medi-
tation. The subjects of these elitist artists were drawn not only from nature but

from traditional and Ch'an Buddhist imagery.

As the font of all Buddhist concepts, the historic Buddha, Shakyamuni, was one of the first and most important subjects for Ch'an and Zen painting. While the famous undated painting of *Shakyamuni Coming Down from the Mountain* (*Shussan-no-Shaka*), by Liang K'ai (ex-Sakai, now Shima Collection),[5] probably dating from the first quarter of the thirteenth century, is the earliest surviving picture of the subject, the Cleveland hanging scroll (Fig. 57) is the earliest dated (1244) Chinese example currently known.[6]

The Buddha—emaciated, worn, but spent of passion—slowly descends the barely indicated mountain slope after days of fasting and meditation. The rough and abbreviated brushwork of his garments and of the gentle slope, is complemented by the more carefully controlled and subtle brushwork depicting his face and body. As an icon stressing the requirements of fasting and meditation, the specific Ch'an nature of the painting is manifest, and its usefulness to neophytes is evident. The poem with date written by a particularly holy and important priest, probably not the artist, both explains the subject and suggests its inner significance for the beholder.

> *Since entering the mountain, too dried out and slim,*
> *Frosty cold over the snow,*
> *After having a twinkling of revelation with impassioned eyes,*
> *Why then do you want to come back to the world?*

> *{Signed} Chi'-chueh Tao-ch'ing*
> *Resident Tai-pie (ming) Shan.*
> *{Translated by Wai-kam Ho}*

The Museum also has a pair of hanging scrolls attributed to perhaps the most famous of all Chinese Ch'an monk-painters, Mu Ch'i (Fa Ch'ang), representing a tiger and a dragon. While the attribution seems to us thoroughly justified, the subject matter could as well be Taoist as Ch'an. A full discussion of their important place in the history of Chinese painting would require far more space than is presently available. They are noted and illustrated here (Figs. 16, 17)[7] because their style is thoroughly within the norms for Ch'an painting; their long presence in Japan certainly had an influence on Japanese Zen painting; and their author was, after all, the Ch'an abbot of a temple in the Hangchou area, Liu-t'ung ssū. For this writer they are the finest examples extant of the tiger and dragon paintings associated with the name of Mu Ch'i. The subject is really a Chinese cosmological one with no direct ties to Ch'an. The dragon is masculine—the animal of the east— and is usually shown in a watery or vaporous context. The tiger, female, stands in the west and in wind. Their power as visual images probably led to their adaptation for Ch'an usage, but as subsidiary icons to explicit Ch'an subjects. Just as one idea calls up another, perhaps less important one, so specifically Zen icons in Ja-

60 Yin-t'o-lo, *The Second Coming of the Fifth Patriarch*, Chinese, Yüan Dynasty.

59 *Bodhidharma Crossing the Yangtze on a Reed*, Chinese, Yüan Dynasty.

pan, whether painted in China or the islands, could have other paintings added to them, making triptychs—one central Zen image, often a white-robed Kannon, with two "flanking pictures"[8] such as the Cleveland pair. These "made-up" triptychs were surely sanctified by fully prepared ones such as the most famous and best documented work by Mu Ch'i, the *White-Robed Kannon, Monkeys*, and *Cranes* in Daitoku-ji,[9] painted as a trinity of central religious image and two complementing images from the world of nature, symbolizing flesh and spirit.

A very recent acquisition is a well-known late thirteenth-century work depicting one of the classic and most devastating of Ch'an subjects (Fig. 58)—*Bodhidharma Meditating Facing a Cliff (with Priest Hui-k'o about to Sever His Arm)*.[10] The painting bears an apocryphal seal, probably added after its early arrival in Japan, of Yen Tz'ú-p'ing, a twelfth-century painter not remotely connected in style or subject matter with the Cleveland hanging scroll. The work is a typical Ch'an one of the late Sung or early Yüan Dynasty deriving from the Ma-Hsia school of the Southern Sung academy, with its diagonal, "one-cornered" composition, rough and calligraphic brushwork in landscape and drapery combined with a more careful and psychologically penetrating representation of the faces of the two protagonists.

152

61 P'u Ming, *Bamboo in the Wind*, Chinese, Yüan Dynasty.

Bodhidharma (Japanese *Daruma*) was the historical, or legendary, Indian founder of Ch'an, coming to China in the early sixth century. As the First Patriarch of the sect, his accomplishments are indeed legendary—he crossed the Yangtze on a reed (Fig. 59) and meditated for nine years before the rock cliff of a monastery at Mount Sung in North China. His successor as Second Patriarch was Hui-k'o, shown in our painting patiently standing behind the fiercely meditating founder. Subsequently, as shown in Sesshū's great masterpiece of *Hui-k'o Showing His Severed Arm to Daruma*,[11] Hui-k'o cut off his left arm and presented it to Bodhidharma as earnest proof of his sincerity and desire to partake of the master's teaching. The less troubling moment shown in our painting embraces a wintry-cold stillness, an equally immovable Patriarch facing the cliff, and the still, small figure of the supplicant, dwarfed and patient, half-visible behind the master. The resulting combination seems to me a haunting image of the patient immobility of meditation, a fitting visual presentation of basic Ch'an concepts. Note, too, the notion of transmittal, from First Patriarch to Second, and on. This "Transmission" from one fulfilled individual to another is basic for Ch'an and led to interest in portraiture, to be discussed shortly.

Yet another Chinese Ch'an painting in the Museum's collection carries us another half-century into the Yüan Dynasty when Ch'an painting continued, but now was divorced from the main stream of later Chinese painting—the literary man's painting (*wen-jen-hua*). This work, a fragment of at least a six-scene handscroll, is the only work by Yin-t'o-lo (Indara) outside Japan,[12] and is a completely Ch'an work in both appearance and literary content. *The Second Coming of the Fifth Patriarch* (Fig. 60) is even more abbreviated and informal than any of the works previously considered. *Yin-t'o-lo* is the Chinese transliteration for Indra, or Indara, and while one tradition has the artist an Indian emigrant, the most likely tradition is that the name was assumed, but that he was an abbot of a Ch'an monastery—whether in north or south is difficult to say. Nevertheless his works are considered by many to be the most quintessential of Zen paintings. The five other sections of the dismembered handscroll of which our painting was a part[13] are registered as National Treasures in Japan and are prized equally for their abbreviated style, Zen allusiveness, and appropriateness for the tea ceremony. The poem suggests the meaning; the painting gives the meaning and its accompanying narrative a matrix both representational and allusive.

> *This boy has no father, but a mother.*
> *Master of Ch'an, please don't ask him when he was born—*
> *Before the green pine tree has grown old,*
> *and after the yellow plum has ripened,*
> *Two lives are but like fleeting moments of a dream.*
> {*seal: Ch'u-shih*}
> {*Translated by Wai-kam Ho*}

154

62 *Portrait of Hōtō Kokushi*, Japanese,
Kamakura Period.

Though by an unknown fourteenth-century Chinese master, *The Bodhidharma Crossing the Yangtze on a Reed* (Fig. 59)[14] is a product of the same environment and tradition that produced the art of Yin-t'o-lo. In this case the subject is the legendary one of the First Patriarch's journey to the place of his nine-year meditation. The poem written by the priest Liao-an Ch'ing-yü is a particularly typical Ch'an exercise in lofty thought brought quickly to earth by physical discipline.

> *Wind rises from the reed flowers, the waves are high,*
> *It's a long way to go beyond the cliff of the Shao-shih mountain,*
> *Above the worlds of Kalpas a flower is opening into five petals,*
> *So that your barefoot heels are just fine for the whipping rattans.*
> *{Translated by Wai-kam Ho}*

The last Chinese painting to be considered is quite different from those preceding and has important implications in understanding the origins, not of subject matter, but of brush style in nonfigural Ch'an and Zen paintings. *Bamboo in the Wind* (Fig. 61) by Priest P'u Ming (Hsüeh Ch'uang)[15] is an immediately attractive, sympathetic, and "easy" subject for a Westerner. But the free brushwork, and particularly the dry "flying white" manner in the rocks is a heritage from the early Yüan literary man's school, especially from comparable paintings by that paragon of official and scholarly life, Chao Meng-fu (1254–1322). Our own collection has a major rock, orchid, and bamboo painting[16] by that now-rare master (Fig. 54), and even a

cursory comparison shows the debt of the less gifted priest-painter to his scholarly, non-Ch'an predecessor. Despite his debt, which one might think would make these Ch'an paintings acceptable to Chinese taste and collectors, such works scarcely survive in China, whether in private collections or in the Imperial collections now separated between the mainland and Taiwan.

By the end of the fourteenth century these abbreviated, "untrammelled" styles were particularly associated with, and used by, the Ch'an monk-painters and by artists working on Ch'an subjects. Most of them found their way with Ch'an or Zen monks to the island empire where Zen was more than flourishing, from the mainland where the restored native rule of the Ming Dynasty (1368–1644) was less than encouraging to Ch'an Buddhism. The Chinese-derived Zen, with its accompanying paintings and texts, was to be the foundation for a completely new structure of Japanese culture and art in the Muromachi Period (1392–1573), notably in ink painting, garden art, the tea ceremony, and Noh drama. To this properly called Zen art we now turn.

If one cannot speak of a purely Ch'an art in China with full confidence—we have seen the mixture there to be too complex to deserve such an all-encompassing label—one can speak of Zen art in Japan. The particular faith and its works of art brought in by the emigrant or traveling priests did provide a unified field within which the artists and priests worked—at least those associated with the more dynamic and "progressive" social order of the period, the samurai landholders and their military rulers of the Muromachi Shogunate. The previous Japanese styles associated with other forms of Buddhism and with the now powerless, subservient, and isolated imperial court, were largely dormant during the some two hundred years of Zen dominance in the arts.

This art was "transmitted" from China and then "transmitted" from teacher to disciple, from chief temple to precinct temple. We have indicated that "transmission" was of particular significance in Zen tradition. This was not just a matter of general knowledge passed on by ritual or group teaching—the earlier monastery method—but rather the direct transmittal from master to pupil of specific paths to *Satori*, a shared experience attained through hardship and, ultimately, mutual respect. Hence the numbered, sequential patriarchs with a *direct* line back to Bodhidharma; hence also the close attention to the physical lineaments of individual grace—the portrait of the master, or as they may be more accurately described, "portraits of longevity." Such portraits, called *Chinsō*, painted on silk or paper, were in Muromachi times customarily given by master to successful pupil. They were a testament from one generation to the next, a reminder of the appearance and, in the best works, of the character of particularized holiness.

Some of the most remarkable of these *Chinsō* are slightly earlier sculptures of the late Kamakura and early Muromachi periods (thirteenth–early fifteenth century). These were obviously not given to pupils to be carried about, but were enshrined in temples (or more properly in the Founder's Hall in these temples) sometimes as

homage to a living monk, as memorials, or as reminders of the founder or of a particularly holy or powerful monk or abbot associated with the temple. They are among the rarest and most moving of Japanese wood sculptures, and the Museum has been particularly fortunate to acquire an early and important carved wood *Chinsō*, that of Hōtō Kokushi (1203–1295), the Priest Kakushin of Myōshin-ji in Wakayama Prefecture (Fig. 62).[17]

If *Chinsō* paintings are derived from China, it is not so clear that the sculptures are equally indebted. Priest portraits of the Nara Period and later are known— and their prototypes in China as well. But these are more generalized "typical" men, and are priests of pre-Zen sects. The searching realism seen in the face of Hōtō Kokushi, combined with the well observed, mixed convention of Chinese costume and Japanese pose within the robes, is unmatched in Chinese sculpture known to date. The origin of the configuration is certainly such Chinese paintings of the same subject as the two most famous examples: *Pu-K'ung Chin-kang* (Kōzan-ji, Kyoto) and *Wu Chun* (1175–1249) (Tofuku-ji, Kyoto).[18] Both paintings show the priest in the same pose as that of the Cleveland sculpture, but in each case with an elaborate "monk's chair" for support rather than the simple bench used for Hōtō Kokushi. It should be noted that both Chinese paintings were "transmitted" to Japan early on. Nothing like them remains in China.

The combination of immobility with austere and purposeful physiognomy is striking in all of these portraits. The bulk is produced by the depiction of the underpadded garments in full plenitude. The realism of the face is the result of long years of tradition in wood carving combined with that of skill in representing such "ugly" and "unusual" faces as those of guardian figures or the "Twelve Generals." These familiar earlier Buddhist types were, in a sense, caricatures, and from this to portraiture is a very short distance. The success of the "portrait," whether realistic or not, is in its conviction. We simply sense the individual as real rather than a stereotype. We experience both reverence and awe, convinced that here is one who could have thrashed or enlightened us—a teacher in the main line of the Zen tradition.

Aside from the restoration of the right eye already noted, the sculpture has suffered little if any restoration. Like the priest, the sculpture is before us, warts and all. The *yosegi* technique of joined blocks of wood for the figure is clearly evident. This technique also made possible the handling of the head as a mask—to be held in the hand and subjected to the most artful turns and cuts of the accomplished carver. Two details of the sculptural technique point to a conservative tradition and support the early date (ca.1286) we assign to the sculpture. The eyes are not inlaid from behind with quartz, a progressive Kamakura technique. Secondly, the cutting strokes of the semicircular gouge on the body are proudly left. This *nata-bori* technique was particularly evident just before the Kamakura Period in the twelfth century, and its residual presence on the image of Hōtō Kokushi is another indication for the early date. The convincing realism of this *Chinsō* sculpture

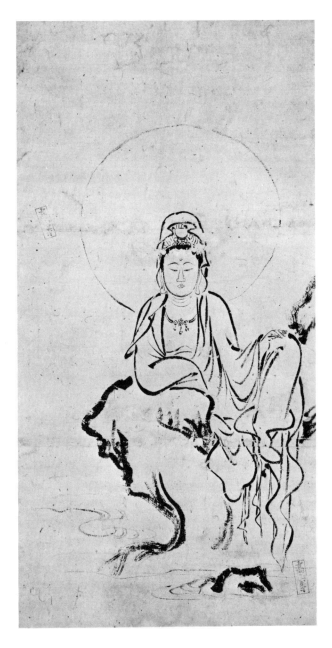

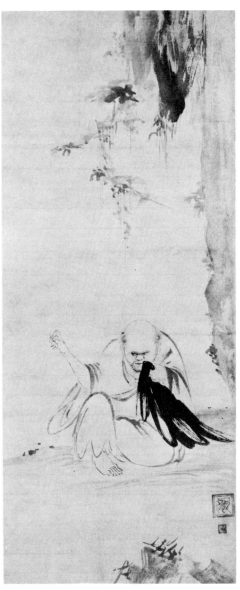

63 *White-Robed Kannon*, Japanese,
late Kamakura Period.

64 Kaō, *Choyo: Priest Sewing Un-
der Morning Sun*, Japanese, late
Kamakura Period.

158

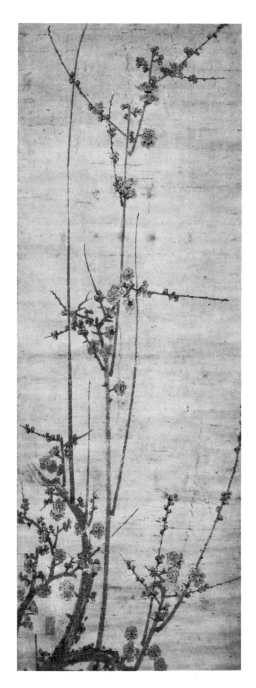

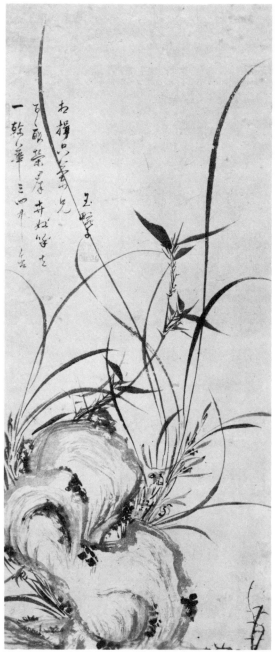

65 *Plum Blossom*, Japanese, Nam-
bokucho Period.

66 Bompō, *Rock, Bamboo and Orchids*, Japa-
nese, Muromachi Period.

is a fitting Zen contrast to the more abstract ink paintings we now present.

The transmission of paintings from the mainland to Japan consisted largely of just that kind of painting represented in the first part of this essay—Ch'an figure subjects and ink paintings of bamboo, prunus, orchid, pine, and landscape that may or may not have had an initially Ch'an meaning. The Museum possesses one of the most famous and earliest Japanese ink copies of such a first-category subject in the *White-Robed Kannon* from Kōzan-ji, acquired and published some time ago (Fig. 63).[19] A still specifically Zen subject by a well-known founder of Japanese ink painting, Kaō, is the hanging scroll of *Choyō: Priest Sewing Under Morning Sun* (Fig. 64), also previously published in this *Bulletin*[20] and one of the most significant of early Zen paintings. The Kōzan-ji painting is surely a very early (late thirteenth century) Japanese version of a Chinese model. It still retains traditional Japanese brushwork in many details outside the figure while skillfully absorbing the freer brushwork of the "untrammelled" style, particularly in the drapery. The next stage is to be seen in the *Choyō* of about 1350, a thoroughly assimilated and creative use of the rough and spontaneous brushwork of such Southern Sung Ch'an artists as Mu Ch'i. The pale-to-dark tones and the combination of roughness in setting with delicacy in the details of face and hands are visual equivalents of the Zen message of riches within poverty expressed in the subject.

But figure subjects were only a part of the burgeoning Zen pictorial production. Figure painting was difficult and failure only too obvious. The Chinese conventions (whether literati or Ch'an) for bird, flower, and landscape painting were also transmitted and only too available for priest-painters of any level of competence. The evidently overwhelming desire to meditate in ink led to a large production of Zen in art rather than art in Zen, and scholars are still wallowing through the resulting morass.[21]

Still, these "amateur" Zen paintings of subjects from flowering nature are an integral part of the Zen artistic experience; so we are grateful to show even a few of these intimate views to Zen. After all, the very beginning of the sect's peculiar insight was reputed to have occurred when the Buddha himself held up a flower and smiled at his disciple Kāsyapa—the first and characteristic transmission of Zen doctrine.

Probably the earliest of these informal Zen scrolls is the recently acquired *Plum Blossom* (Fig. 65), which we date to the Nambokucho Period, (1336–1392), perhaps about 1350.[22] One should first note that the general appearance of the painting is quite unlike that of any possible Chinese prototype. There are, to be sure, several Ming prunus ("prunus" includes plum blossom, as well as apricot and cherry) paintings with something of the calculated decorative tendencies to be seen in our Japanese paintings, but they are almost certainly later than the fourteenth century and products of a Chinese academic, and even somewhat decorative, school about which we know very little—except that it did not influence earlier Japanese painting. The carefully measured and tasteful disposition of the upright prunus branches

in the Cleveland painting display precisely that tendency to decorative emphasis and sheer taste which I consider to be one of the distinctive features of Japanese art. The earlier Chinese prunus paintings are both more realistic and rational than their Japanese descendants. The Cleveland work of ca. 1350 is really closer to much later and more purely decorative works, such as the famous white and red prunus screens by Kōrin.[23] This same "tasteful" tendency is to be found in other early Japanese prunus paintings by less gifted hands,[24] though naturally enough works adhering closely to Chinese methods are also known,[25] but no Chinese prunus painting looks "like" the one now published for the first time.

Why a Zen prunus? The subject, one of the "Three Friends" (pine, bamboo, and prunus) of the Chinese literati tradition, conveys the meanings of lonely nobility, a particularly prized *literatus* quality, as well as purity—obviously desirable in any ideal world view. But it also is a fragment of nature—fragile, impermanent, but endlessly renewing. Note particularly that the artist has suppressed the support of the branches; the trunk of the tree is only to be imagined. Like the flower held by the Buddha towards Kāśyapa, such a fragment of nature can mean far more than its mere physical presence. Like the mustard seed or the drop of water, the flower (prunus) contains within itself the Buddha mind, the ineffable, really true experience of the universe. If a Cézanne still life can adumbrate a Western world view, so can the prunus in Far Eastern painting, and especially so in Zen.

The same more-than-amateur pictorial competence in a similar genre is to be found in a very recent addition to our collections, the *Rock, Bamboo, and Orchids* by Bompō (ca. 1348–ca. 1420) (Fig. 66).[26] A Zen monk, first resident in Kamakura and then an abbot of Nanzen-ji in Kyoto, Bompō was sufficiently respected to advise the Shōgun and to be asked to inscribe at least one famous small screen painted by Jōsetsu for Ashikaga Yoshimochi. He is known to us as artist by relatively few paintings, all of the same subject, and all showing the same extremely refined and elegant approach to brushwork and composition. The derivation of his art from that of the Chinese tradition represented by P'u Ming (Fig. 61) is as evident as the decorative transformation achieved by the Japanese priest in common with his peers, including the painter of our prunus painting. In China the orchid was traditionally associated with "aristocratic restraint" and nobility; so like the prunus, it was eminently adaptable as a vessel for Zen meaning. The method of painting this and other floral fragments was by this time so well organized as to be available to any amateur. Bompō's works reveal more than method, particularly in their implied movement and tasteful disposition.

Further evidence of the artist's pictorial intentions is to be found in almost all of his known pictures, for he usually manages to integrate his poetic inscriptions—whether written right to left or vice versa—into the overall surface of the composition. They are not poems added onto the painting, but literary images written into the fabric of the visual image.

On each stalk are three or four blossoms.
{?}
One hundred acres are in bloom;
All other flowers are just servants,
But to you alone I'll bow—
My orchid elder-brother.
　　　　{Translated by Wai-kam Ho}

Zen ink painting flourished in the fifteenth century and the Museum's holdings of this period have been previously published in the *Bulletin.*[27] Two of these are masterpieces by the greatest masters of the century: Shūbun (ca. 1390–1464), Abbot of Shōkoku-ji (Kyoto) (Fig. 67), and his even more famous follower, Sesshū (1420–1506) (Fig. 68). They are reproduced here as reminders and to provide the visual continuity necessary for this introductory essay on the Museum collection of art in Zen, unrivalled in the Western world. As landscapes they fall, even more than the paintings previously discussed, between Zen and the broader tradition of landscape painting invented and developed by the Chinese and thoroughly assimilated by the Japanese in the fifteenth century. Further, the mastery of Chinese Sung landscape tradition revealed in these very different paintings was the immediate heritage of Sōami (d. 1525), the last of the Zen painters we consider here.

With the name Sōami (Shinsō) we encounter the nebulous but nonetheless significant world of a "culture hero." The son of Geiami (Shingei) and grandson of Nōami (Shinnō), he is one of the "three ami," receiver of an all-embracing Zen inheritance including poetry, drama, painting, gardening, and the developing tradition of ceremonial tea drinking that was to become *Cha-no-yu*, the Tea Ceremony, at this time. Sōami was also the "art expert" for the Shōgun Yōshimasa, and

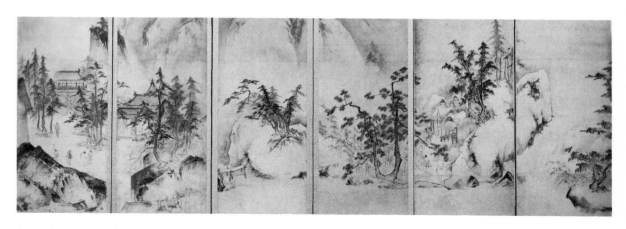

67 Shūbun, *Winter and Spring*, Japanese,
Muromachi Period.

162

was the compiler of the catalogue of that ruler's great collection of Chinese paint-
ing, the *Kundaikan-Sayuchoki*. Unfortunately the hard facts of his career, and par-
ticularly of what works of art are surely from his hand, are conspicuously absent.
He is reputed to be the designer of the two most famous early Zen gardens in Japan:
those at Ryuan-ji and the Daisen-in, both in Kyoto. Some paintings are attributed
to him with more or less speculation; but the works most often given his name
are the some twenty monochrome ink landscapes on sliding screens painted for the
Daisen-in, whose small but beautiful garden is also reputed to be from his designs.

If the facts are uncertain, the legend is well defined and of considerable signifi-
cance in assessing the meanings and methods of "Zen in Art." The numerous artistic
virtues attributed to Sōami make him indeed a culture hero—a kind of universal
artist-critic, master of all things great and small. This peculiar quality, of his
art penetrating into all of the cracks and crannies of the universal rock, is a pure
reflection of the impact of Zen on Japanese life. Nothing was too insignificant to be

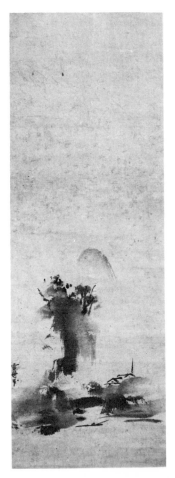

68 Sesshū, *Haboku Landscape*, Japanese,
Muromachi Period.

the bearer of enlightenment. The smallest blossom, the humblest act—whether pouring tea or chopping bamboo—could be the vehicle of release to the world of the Buddha-mind. Since everything, alive or inanimate, contained this essence, nothing was overlooked in either Zen or art. The bent bamboo scoop for powdered tea, its cloth covering, and its wooden case each received their measure of religious and aesthetic attention. Whether Sōami did all attributed to him or not is of relatively little interest when compared with the implications of the legend. And when we look at the Daisen-in landscape paintings, we sense a distinct and unusual personality behind them—one which harmonizes with the legend.

One of the Museum's masterpieces is a single panel, almost certainly one of the twenty painted about 1509 for the Daisen-in,[28] and still attributed to Sōami (Fig. 69). The general effect in the small building—the spacious monochrome ink scenes in juxtaposition with the tiny rock, shrub, and moss garden—must have been particularly satisfying to this Zen arbiter of taste. The built-in paradox of artificially created vastness in sober ink next to a restricted landscape "sculpture" made from nature's own materials, can be thought of as a visual *Kōan*, a problem incapable of rational solution.

The Cleveland painting was long ago removed from this context and now is one of only two works in the Western world giving evidence for the particular contribution of Sōami to Japanese ink and landscape painting.[29] As we might expect, this contribution is eclectic and tasteful in its components, but unified by a particularly broad and reflective personality. One thing is immediately apparent—that Sōami's style does not look like that of any of his Japanese predecessors. One small technical element will stand for others: the broad "dots," largely horizontal in placement used in the distant mountains and for some of the trees in both middle and foreground are seen here for the first time in Japanese painting. They are derived from Chinese landscapes in the "Mi" style. While this distinctive method of brush handling began with Mi Fu in middle Sung China, Sōami undoubtedly adopted the technique from fourteenth- or fifteenth-century "Mi"-style works in the Shōgun's collection, of which he was the "curator." The willow trees and misty flatlands in the right middle-ground reflect the "flung-ink" art of Mu Ch'i (Figs. 16, 17) and Yü-chien, both represented in the Shogunate holdings, pictures still extant in Japanese collections today.[30]

The probable subject of the twenty Daisen-in panels, *Shoso Hakkei*, the eight famous scenes of the river country Hsiao-Hsiang, was derived from this classic Chinese subject as practiced by Sung Ti, Mu Ch'i, Yü-chien, and other late Sung painters, both Zen priest and literati. While a few of the Japanese, including Sesshū, did visit China and may have been exposed to various scenic wonders of the mainland, including the river country of Hsiao-Hsiang in modern Hunan Province, the frequent occurrence of the subject in Japanese ink painting from the fifteenth century on was due to the influence of art upon art—of Chinese paintings

upon the monk-painters closely associated with the new military ruling class of Muromachi Japan. However removed from the physical landscape of China, these painters made the pictorial subject their own by an act of will and a process of assimilation that is one of the major reasons for believing that Zen, at this particular time and place, provided a comprehensive intellectual and emotional environment making this potentially second-hand experience a real one. One thing is certain: that this set of screen paintings attributed to Sōami is the first of a series of total environments—a room surrounded by landscape paintings on sliding screens—constituting one of the most original and significant contributions of the Japanese to the world of art. Zen was as creative in the generalized, all-embracing approach to nature as it was in its particularized vision of fragments of nature—again the

69 Sōami, *Eight Views in the Region of Hsiao-Hsiang*, Japanese, Muromachi Period.

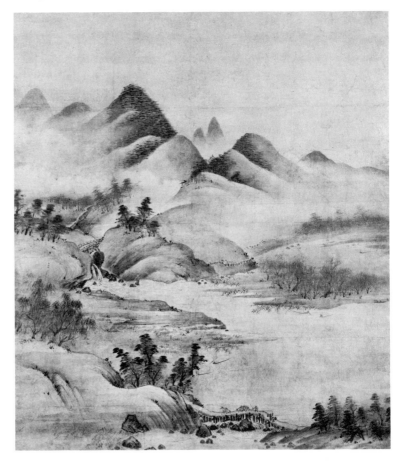

paradox, macrocosm and microcosm contained within an easy unity.

The ultimate question still left open is whether these Zen works of art exist only as such, or whether they exist as works of art meaningful to those of other persuasions, whether religious or secular. Perhaps the confrontation of Hōtō Kokushi (Fig. 70) with Saint Bernardino of Siena (Fig. 71) may be helpful here. The Christian saint was depicted almost immediately after his death; the Zen monk, shortly before his. The difference in death dates, 1295 and 1444, is immaterial; what matters is the image of ancient holiness in specific religious context—Zen and Christian. The images, one in carved wood, the other in egg-tempera paint, are strikingly similar in their concentration on the realistic depiction of the holy men as a means of penetrating to the core of their saintliness. That one is Christian

70 *Portrait of Hōtō Kokushi* (detail), Japanese, Kamakura Period.

71 Pietro di Giovanni Ambrogio, *St. Bernardino Standing on the World* (detail), Italian, 15th century.

and the other Zen is an archaeological matter placing their origins in place and time. But we are confronted with these images—even effigies—today, and we can surely be pardoned if we say that their status as images of art is now dominant. Zen and Christian they were; art they are—depictions of holy old age that is shorn, both fortunately and unfortunately, of parochial context. That they move us today is proof of their universality as images embedded in their historic past, but visible and meaningful outside of time and place.

Zen and its numerous fruits—the tea ceremony, Noh drama, etc.—continued fitfully to the present day; individual attainments and flashes of group achievement still occurred. But its universal power for the Japanese declined after the Muromachi Period and with the rise of a prosperous mercantile class. Perhaps it is best to close with the vituperative excesses, however deserved or effective, of a Zen monk-artist of the eighteenth century, Hakuin (1686–1769). The need for the outburst and its excessive expression tells us all we need to know. He is referring to monks of the Sōtō sect, seekers of sudden revelation.

> *They practice silent, dead sitting as though they were incense burners in some old mausoleum and take this to be the treasure place of the true practice of the patriarchs. They make rigid emptiness, indifference, and blank stupidity the ultimate essence for accomplishing the great matter. If you examine these people you will find they are illiterate, stinking, blind, shaven-headed commoners.* [31]

We have much to learn from Zen, particularly in its role as a unifying force for all of nature and humanity in art. But to practice Zen in art is something else again. Kyoto and Kamakura in the fifteenth century are too far from us today for even paradox to conquer the historical discrepancies. But art in Zen—that could be another story. To quote a legendary Zen paradox: "If you meet the Buddha, kill him!" [32]

Early Ming Painting at the Imperial Court

This essay first appeared in The Bulletin of The Cleveland Museum of Art, *volume 62, no. 8 (October 1975).*

The vagaries of taste are both encouraging and disheartening. We can be pleased that our minds and eyes are open, subject to reexamination and correction, and that we take nothing for granted. We should be discouraged that we don't see more at any one time and that, despite the historic reality of fluctuations of fame and fortune in art, we are still caught unaware by the rediscovery of hitherto unfashionable styles in art. Granted, the great masters hold their exalted positions almost without opposition, the considerable talents and contributions of the second rank seem ignored by some generations and perhaps overpraised by others. Who would have anticipated a major revival since 1950 of the Baroque painters of Bologna, those considered as dull and academic by the critics and scholars of the period before World War II? Why didn't we value the contributions of Art Nouveau until the 1960s? And whatever happened to those later practitioners of the Chinese Southern Sung academy style, so popular in the early twentieth century? If the rival literary man's painting (*wen-jen-hua*) of the Ming (1368–1644) and Ch'ing (1644–1912) Dynasties was ignored in the West before World War II, it has triumphed since then and with its victory came the accompanying defeat of a fascinating and excellent style of Chinese painting, that of the court painters of early Ming.

It is generally agreed that World War II was, among other things, an American watershed in the study of Far Eastern culture in general and Chinese painting in particular. The exposure of millions to Far Eastern culture and of thousands to the intricacies of the Chinese and Japanese languages surely played a major part in a burgeoning scholarly and popular interest in the Far East. The growth of American museum and private Far Eastern collections, the quickening pace of major exhibitions from China, Taiwan, Korea, and Japan, and the amazing increase in the volume of publications of all types led to a more profound understanding of the culture and art of these areas. In the field of Chinese painting a more typically traditional Chinese approach has been wedded to Western art historical methods to give far greater breadth of knowledge and depth of understanding. The appreciation of the later scholarly tradition of Chinese painting represented by such artists as the Four Great Masters of the Yüan Dynasty (1278–1368), Shen Chou, Wen Cheng-ming, and Tung Ch'i-ch'ang of Ming, and the Four Individualists of early Ch'ing has been particularly developed.

But in this rapid and forceful process—assisted by dozens, if not hundreds, of publications and exhibitions—the other traditions in Chinese painting have been submerged in part by the Chinese scholarly tradition itself and in part by our understandable enthusiasm to make up for lost time. As far as I know, only one serious article has been written in the West since World War II on the early Ming court painters,[1] and even within the Chinese art historical tradition these painters deserve more attention.

Now one detects stirrings of interest. Why? The reasons are at least two in number: one Western in origin, the other Chinese. The Western revival of interest in "academic" painting has already been mentioned. Recent publications and exhibitions of the Italian Seicento, the French academicians under Louis XIV, the Regency and Louis XV, the neoclassic tradition and the French, English, German, and Italian nineteenth-century realists cannot but have their effect on students of Chinese painting. If the modern movement in art helped to open our eyes to the later Chinese Individualists, the recent revival of the academics is certainly affecting our attitudes towards their Chinese counterparts.

And in China we have had both the Revolution and the Cultural Revolution. One cannot but notice the ease with which the bronzes, ceramics, jades, and other objects have been assimilated into a proletarian-artisan tradition. With painting, as well as with Buddhist sculpture, the situation is more perplexing. The literary man's (*wen-jen*) tradition is an aristocratic one, "elitist" to the core. What of those painters looked down upon as artisans by the literati? What of the ignoble "Northern" academic tradition invented by the late Ming literary painters and critics led by Tung Ch'i-ch'ang (a wealthy landowner whose estate was burned by rebellious peasants)? It would seem appropriate to look again at the early Ming court painters, few of them famous but perhaps all interesting if seen in the more sympathetic waxing light of today.

First, one should emphasize that the dichotomy between the *wen-jen* and the academicians and/or artisan is largely a creation of the early seventeenth century and specifically of Tung Ch'i-ch'ang (1555–1636) and his circle. The painters of the two groups in early Ming were not really aware of a chasm between them. Wu K'uan (1435–1504) the friend of Shen Chou (1427–1509), the greatest *wen-jen* master of the fifteenth century, did not hesitate to write a colophon in 1485 on a handscroll, *Searching for Flowers* (1469), by the court painter Shih Jui.[2] On the other hand Shen, as well as his mentor Tu Chiung, did not hesitate to borrow from leading masters of the Che school affiliated with the court tradition. A contemporary history of fifteenth-century painting would have been hard put to differentiate between a high and low tradition. Indeed the critical writing of the time does not do so.

Nor, as Vanderstappen shows,[3] do contemporary sources identify or describe an academy (*Hua Yüan*) at the court comparable in any way to the formal organization

72 Sheng Mou, *Travelers in Autumn Mountains*, Chinese, Ming Dynasty.

73 Shih Jui, *Searching for Flowers* (detail), Chinese, Ming Dynasty.

of the Han Lin academy under the Sung emperors—particularly under the Hui Tsung Emperor (reigned 1101–1125). Painters of various types were "called to the court" and some became "officials-in-attendance" (*Tai-chao*)—whether portraitists, calligraphers, or painters of the more traditional subjects, landscape, "fur and feathers," and history. Under the first Ming emperor artistic service at the court by such literati painters as Hsü Pen,[4] Chao Yüan, and Ch'en Jü-yen[5] was disastrous—one jailed and died, the other two executed. Politics, personality, and protocol were more important under the Hung Wu Emperor than painting. Things then improved with *wen-jen* artists such as Sung K'o and Wang Fu who worked successfully at the court. But when the Hsüan Te Emperor, himself an accomplished painter, came to the throne the situation improved further. With few exceptions, painters and court then seemed to have agreed with each other. The painters as "officials-in-attendance" were required to do portraits, decorative paintings for palace buildings, historical or moralistic works, and presumably—to judge from extant paintings—other and more informal works. What they shared was a traditional and eclectic outlook on the accumulated past—T'ang figure painting and colored landscapes, Sung bird and flower painting, Southern Sung landscapes—all as studied in original or, more often, as transmitted by the conservative masters of the preceding Yüan Dynasty. Recent acquisitions for the Oriental Department make it possible for us to see some major aspects of this early Ming court painting.

Among the artists listed as being called to the court by the Hsüan Te Emperor is Shih Jui. He was given the title of *Tai Chao* (official-in-attendance) and was listed in the *Ming Hua Lu* as being a man from Ch'ien-t'ang in Chekiang Province, skilled in "boundary painting" (especially architectural rendering). Influenced by Sheng Mou, a traditional painter of the Yüan Dynasty (Fig. 72), he was excellent in both figure painting and in green, blue, and gold landscapes reflecting the style of the T'ang Dynasty (618–907).[6] In the most complete listing of Chinese paintings Shih Jui is credited with but seven extant works, and two of these have no seals, signature, or documentary evidence of authenticity.[7] The Cleveland handscroll is previ-

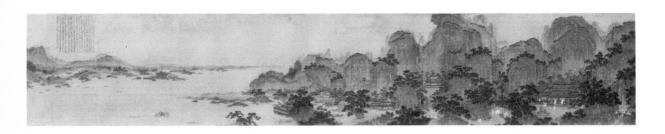

74 Shih Jui, *Landscape in Blue and Green Style*, Chinese, Ming Dynasty.

ously unknown and unpublished. While it has a seal which can legitimately be interpreted as being his, it is so stylistically congruent with Shih's only signed and dated work, also a handscroll (Fig. 73), as to remove any reasonable doubt as to its being by him.[8]

The Cleveland scroll (Fig. 74) fulfills one's expectations of the artist's capabilities in rendering the linear and decorative qualities of the highly colored style begun in the T'ang Dynasty. Indeed, the inscription on the painting by the well-known late Ming Individualist, Hsiao Yün-ts'ung,[9] specifically describes the work as either a T'ang production associated with one of the most famous practitioners of the green and blue style, Li Chao-tao, or by an early Sung practitioner of the same style, Li Sheng of Szechwan. The colors and verticality of the mountains combined with the angular and crystalline brushwork do recall T'ang and early Sung prototypes. The realism of the pine trees and the convincing and almost palpable level distance over water on the left of the scroll, however, speak for a later date, after the absorption of centuries of study in the rendering of space.

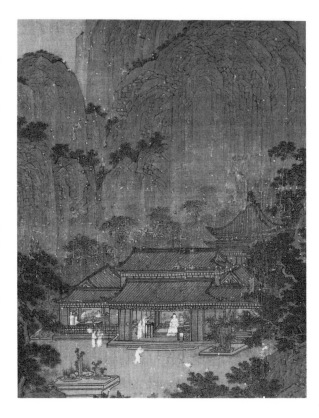

75 *Landscape in Blue and Green Style* (detail).

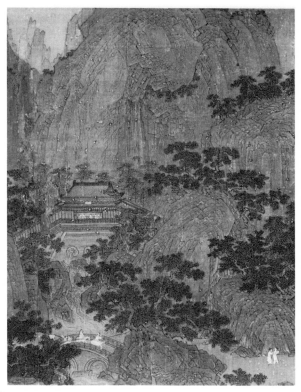

76 *Landscape in Blue and Green Style* (detail).

The subject of this scroll by Shih Jui is not yet known. There are numerous intriguing details reading from right to left as the scroll is unrolled, but none of them give a recognizable clue. We can enjoy the official sitting in a pavilion (Fig. 75) with attendants before him, servants preparing refreshments to his right, and a particularly attractive display of three miniature tree gardens (*p'en-ching*) disposed in trays on a stone bench before the pavilion. A crane near the terrace adds an appropriate nod to the concept of longevity, even immortality. Farther on one sees a pavilion (Fig. 76) above a masonry dam with two waterways issuing from its walls in a torrent which flows down under an arched bridge where an entourage on horseback travels towards the pavilion scene we have just left. Most curious of all, still farther on, is a terrace with two pines (Fig. 77) and beyond these a houseboat moored under a large protective roof of thatch—a detail unknown to this writer in any other Chinese painting. The distant hamlets in the water ending of the scroll are rustic in character, sharply contrasting with the elegant pavilions of the first two-thirds of the scroll, just as the mountain background contrasts with the level distance. A rather nice touch is the enormous flight of blackbirds just barely visible in the distance; it is a clever device suggesting distance, atmosphere, and movement.

Judging from the general composition of the scroll, it could well have extended considerably farther to the left. The beginning seems only to have lost a small bit, what could be expected from various remountings.[10] Still, the other known handscroll by Shih Jui, *Searching for Flowers*, is also a short one of approximately the same proportions as the Cleveland scroll. The question of the original size must remain open. The charming, delicate, and refined touch of the artist is not in doubt. A typical Chinese comment would stress the flavor of antiquity present in the scroll.

We have already cited the accepted sources of this flavor as mentioned in the inscriptions on the painting, i.e., the art of Li Chao-tao of the T'ang Dynasty. But even in early Ming times genuine works by such legendary masters were hardly numerous, if visible at all. What can we point to as the immediate sources of Shih Jui's archaistic art? One certainly calls out for immediate recognition—the archaistic T'ang style works produced in the fourteenth century by such famous *wen-jen* ancestors as Chao Meng-fu and Ch'ien Hsüan.[11] But even more likely is a work in the Imperial Collection, *The Isles of the Immortals*, ascribed to Wang Shen, an eleventh-century painter.[12] One of its former owners, the perceptive eighteenth-century collector An Ch'i, noted in a colophon on the painting its resemblance to the work of Ch'ien Hsüan. This might well set the time of its execution in the late thirteenth or fourteenth century, immediately before the productions of Shih Jui. The painters of the Yüan Dynasty were transmitters as well as innovators, and they passed on all of the traditional styles of Chinese painting.

One other known, unsigned work commonly and justly attributed to Shih Jui—a

large, hanging scroll landscape[13] formerly in the Inoue Collection—is related to
our painting and the Hashimoto one. The case for the Inoue work is made even
stronger by the identification of the Cleveland scroll. A detail in the Inoue painting
of the upper middle distance, a terrace with pine trees, is almost identical with
the terrace by the moored houseboat in the Cleveland scroll. One can also find
almost identical brushwork in the treatment of the rocks at the upper right of the
hanging scroll to most of the rocks and hills in the handscroll. These three works—
the Hashimoto handscroll, the Cleveland handscroll, and the ex-Inoue hanging scroll
—confirm Shih Jui's position as a court master of the traditional blue, green, and
gold landscape style of antiquity.

Three other paintings by Shih Jui lead us into another important category of
court painting. Each of these illustrates a Confucian moral precept, and there may
well have been more in the series.[14] The figures dominate the little morsels of
early Southern Sung style landscape used to provide a setting. This is only proper
since the intent of the paintings is surely to be moralistic through the figures as
subjects. Thus, in the ex-Shimomura painting Chu Mai-chen, a pre-Han paragon
of studiousness and perseverance, is shown in the middle foreground carrying a
balanced load of two faggot bundles and intently studying a volume of the classics
as he walks. Of such is the kingdom of scholarly and official achievement. The
brush strokes delineating the figures in these three paintings are, not surprisingly,
archaistic ones based on the fluttering rhythms of the famous Southern Sung figure
and history painter Ma Ho-chih. The importance of an eclectic traditionalism for
the painters-in-attendance to the Hsüan Te Emperor is here reaffirmed.

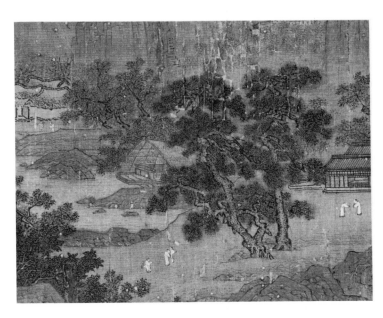

77 *Landscape in Blue and Green Style* (detail).

174

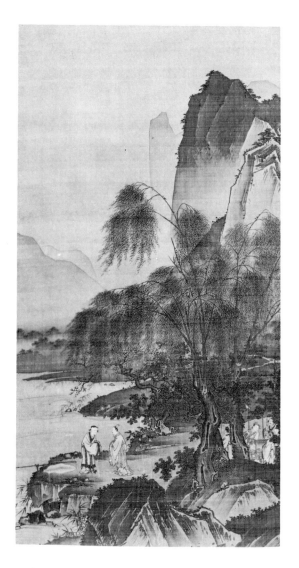

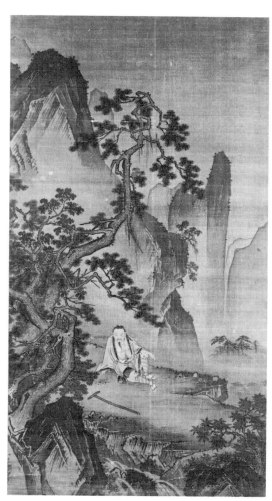

78 Tai Chin, *Fishing on the Banks of the Wei River*, Chinese, Ming Dynasty.

79 Tai Chin, *The Hermit Hsü Yu Resting by a Stream*, Chinese, Ming Dynasty.

In the lists of names of painters-in-attendance to the Hsüan Te Emperor the name of Tai Wen-chin (Tai Chin) follows shortly after that of Shih Jui in the section of landscape painters.[15] And of all the painters at court, Tai Chin (1388–1462)[16] has been accepted, both in China and the West, as the major master of this conservative, eclectic school. Sirén lists no less than forty-two paintings by or attributed to him. That he left the court under duress may or may not have anything to do with his reputation and his acceptability to the nonofficial *wen-jen* school of criticism. Whatever the political or social reasons for his break with the court and his recognition as a major master, he remains a traditionalist. He brilliantly used the Ma-Hsia style of the Southern Sung academy as transmitted by such fourteenth-century painters as Sun Ch'un-tse and other still unknown practitioners of the "one corner" compositions so much despised by the late Ming and Ch'ing scholar critics.

Shih Jui was an archaizing practitioner of the colored style of late T'ang and early Sung; Tai Chin was more advanced in that he worked in a thirteenth-century vocabulary and syntax. It must be admitted, however, that Tai Chin added a new dimension to this tradition—a pictorial unity of brush, atmosphere, and composition little known to the brush and motif orientation of his models. This pictorial approach has been more appreciated in Japan and the West. Further, he is accounted the founder of the Che school of landscape painting—*Che* as the first character of the name of his native province, *Che*kiang, also the home of Shih Jui. Historically placed by the Chinese in opposition to the Wu school, founded by Shen Chou, the Che school is thus condemned to second place behind the progressive, anti-academic literati tradition of Wu. Tai Chin's works stand as models of the early Ming conservative and courtly tradition.

The *Ming Hua Lu* briefly gives his history. His studio names (*hao*) were Ching An and Yü Ch'üan Shan Jen; he was from Ch'ien-t'ang in Chekiang. Influenced by the Northern Sung masters Kuo Hsi and Li T'ang (the former name is simply a bow to tradition; the latter indicates the origins of his figure style), he was a master combiner. Because he used the color red on a fisherman's garment (red was usually reserved for officials), he was slandered at court and forced to leave. His individualist quirks may have encouraged jealousy—if this is not a later *wen-jen* interpolation. He died in poverty but later was recognized as a master.[17]

While some of his handscrolls—notably two with fishermen as subjects now located in the Freer Art Gallery[18]—are freely brushed and almost as cooly abstract as the scrolls of Shen Chou, Tai Chin's most characteristic works are hanging scrolls in ink on silk with bold landscapes dominating the figures. The figures are a significant part of each picture, however, and the moral-historical subjects they embody fit in perfectly with the court tradition we have already mentioned in connection with the three hanging scrolls by Shih Jui in Japan. Thus, one of his most famous works in the Palace Collection in Taiwan (Fig. 78) is a summery scene with

willows in the foreground and towering mountains in a one-sided, diagonal composition. But the figures give the official subject of the picture: Wen Wang, the first and model King of Chou, visiting T'ai Kung-wang, a paragon of humble virtue and accomplishment, on the banks of the Wei River. The seal of the artist is at the lower left. Since there is no indication of a date, we cannot say whether the picture was executed before or after Tai Chin's departure from the court. The soft atmospheric unity of the scroll pulls together the sharp, "axe-cut" strokes defining rocks and mountains, while the decorous figures, executed very much in the manner of the twelfth-century Sung master Li T'ang, take their legendary place in dominant nature. The nature of the subject requires a royal entourage, but it is discreetly hidden by the willows and foreground grass-covered rocks. The result is a picture, not a brush display, though one can admire the brushwork after penetrating the pictorial whole.

This work should enhance our understanding of a hanging scroll acquired by this Museum in 1974 (Fig. 79).[19] It represents a lone, male figure in shepherd's costume with his staff nearby. He is seated on a plateau beneath an overhanging pine with towering mountains behind on the left. A seal, like the one on the palace scroll by Tai Chin, is at the lower left; the measurements of the two pictures are almost identical ($54\frac{1}{4} \times 29\frac{3}{4}$ inches, Cleveland; $54\frac{15}{16} \times 29\frac{11}{15}$ inches, Taipei). The subject of the Cleveland picture is almost certainly *The Hermit Hsü Yu Resting by a Stream*. Hsü, a recluse at P'ei-tse, refused the throne offered by the legendary Emperor Yao (before the Shang Dynasty (1523–1028 B.C.) retreating to Chu-shan by the Yung River. He was then offered the governorship of nine states and, yet again, refused. He epitomized the Confucian concept of "Chu'u-ch'ü," "to serve or not to serve."[20] The essence of the problem was to choose the appropriate moment for service—the right time and the right circumstance. The costume of Hsü in our painting is typical of him in the role of recluse; it should be noted that his staff, with its cross piece, is a practical support, not the gnarled stick of an immortal such as Li T'ieh-kuai.

Again we have a moral paragon, but this time a single figure, hence larger in scale but still assimilated neatly into the Southern Sung style landscape. Again we find the sharp, axe-cut and nail-head brush strokes, the sharply defined crags and cliffs of the mountains. And again we cannot but be impressed with the unified pictorial nature of the whole. Even details such as the small rocks at the far edge of the main plateau and the "inward lean" of a far distant, almost vertical mountain, are the same in both pictures. The possibility exists that the two are part of a now lost or dispersed set of Worthies or Paragons, a fit subject for a court painter in the newly revived native court—just as were the subjects of Shih Jui's three paintings of worthy officials. But Tai Chin's scrolls are far more complex and at the same time less obvious than Shih Jui's paragons. In a sense the landscape imparts superhuman virtue to the human figures. The combination is also more satisfying as

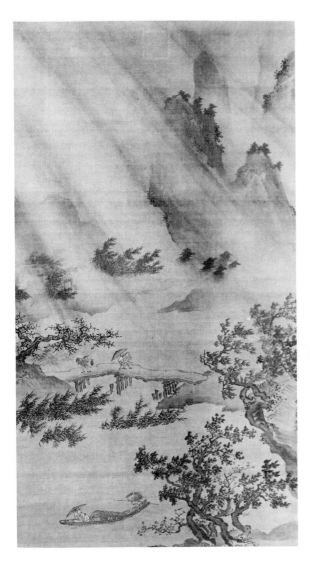

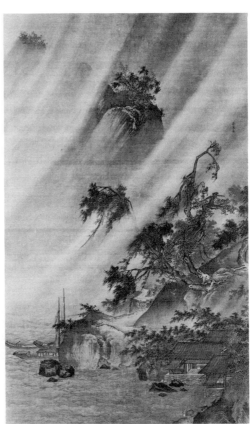

81 Lü Wen-ying, *River Village in a Rainstorm*, Chinese, Ming Dynasty.

80 Tai Chin, *Boat Returning in a Storm*, Chinese, Ming Dynasty.

178

82 *River Village in a Rainstorm* (detail).

83 *River Village in a Rainstorm* (detail).

decoration for official chambers and this was often the function of such works—just as is the case of the scrolls or panels prominently displayed in the offices and waiting rooms in mainland China today.

The unified pictorial character of much of Tai Chin's work has been stressed here. The application of this approach to one particular subject—landscapes with wind and rain—leads us to honor Tai Chin with developing a major subject: pictures of raging, almost cosmic storms. Wind and rain had been part of the vocabulary of earlier painters. Bamboos in the wind,[21] nearby trees bent by the wind,[22] and misty rainy landscapes (as part of a series)[23] are occasionally found in the work of Sung and Yüan masters. But they were either focused details of nature—rather than the total subject of a picture—or subtle evocations of rain or mist. In general, earlier landscapes, whatever the season, seem calm and timeless when compared with one of Tai Chin's classic works in the Palace Collection, *Boat Returning in a Storm* (Fig. 80).[24]

"Invention" of this subject would be too strong, for Tai Chin took the hints contained in the earlier works and completed them in a fully realized larger scroll portraying a large-scale storm in a grand landscape. Nature is not shown in its universal and calm rationality but in raging perversity. But the picture does seem pieced together from a variety of small units, and the large diagonal, straight, windy gusts of rain do not fully unify the composition.[25] Other works by the artist may well have done so, but we are left to his immediate followers at the court for even more complete statements of the storm subject.

One of the most dramatic paintings by one of these followers is the third, recently acquired painting of the early Ming court tradition to be discussed here. Lü Wen-ying's *River Village in a Rainstorm* (Fig. 81)[26] is a previously unrecorded and unpublished masterpiece of the stormy landscape type. It adds a completely new dimension to the work of this little-known artist. Like Tai Chin, Lu came from Chekiang province but from the town of Kuo-ts'ang. He was summoned to the palace by the Hung Chih Emperor (reigned 1488–1505). He is often paired in the record books with the better known bird and flower painter Lü Chi—Lü Wen-ying being called "Little Lü." To date only two scrolls[27] were known by Lü Wen-ying, both pictures of toy peddlers, a genre well known to such Southern Sung court painters as Li Sung, one of whose finest album paintings of the subject is in Cleveland.[28]

In Li Sung's large-scale versions the virtuosity of his brushwork displayed in the depiction of the myriad toys and the active figures is subordinated to the decorative use of thick color bounded by firm wirelike lines. Their possible use as room decorations is never out of mind. One of them, now unlocated, does have windblown willow leaves and rather freely brushed rocks that may indicate other possibilities for the artist—but hardly what the newly published Cleveland picture fully displays.

On a large scale Lü's storm picture shows a veritable typhoon in process. A little

180

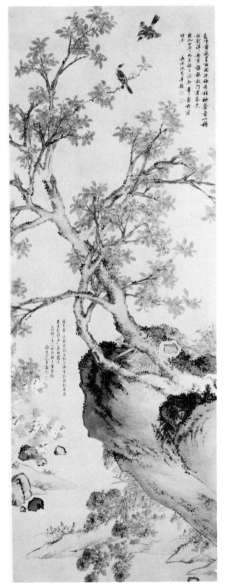

85 Pien Wen-chin, *Bird on a Prunus Branch*,
Chinese, Ming Dynasty.

84 Shen Chou, *Acacia Tree and Chrysanthe-
mums*, Chinese, Ming Dynasty.

inlet with stone breakwater and tile roofed buildings escapes a part of the weather, but as one moves out of the sheet of the water things become more turbulent, though three boats are moored in the rougher water beyond the rocky point. Above, tall trees bend to the wind's force, and above them we see a startlingly clear glimpse of a rocky cliff with trees and a veiled hint of higher peaks beyond to the upper left. The sheets of rain do not move in diagonal straight paths as in the work by Tai Chin, but the directions of force are curved so that they seem more natural and organic than the straight diagonals of the other pictures. They have a grand and flowing sweep which gives Lü's storm a convincing realism unsurpassed by any Chinese master. Details (Figs. 82,83) give a clear idea of the varied sharpness and wetness of the brush strokes employed to bring off the picture and also convey some idea of the freedom and speed with which the strokes were made—so different from the careful, decorative forms of Lü's other two known works. The picture is signed with one seal seemingly the same as that on the *Toy Peddler* which now belongs to the Cultural Properties Commission. No other seals are to be found on the Cleveland painting, and presumably it is one of the numerous Che school scrolls imported by the Japanese which heavily influenced the later development of Japanese painting in the Chinese style—particularly the Kanō school. If Che paintings were unfashionable in Chinese critical circles from middle Ming on, they were valued by the Japanese because of their clear embodiment of Southern Sung style and Zen affiliated ideals. Sesshū mentioned only Li Tsai and one other artist at all favorably after his trip to China in 1468–1469, and Li was one of the listed court painters-in-attendance to the Hsüan Te Emperor.

Scrupulous objectivity should also reveal that the Che school and particularly its daring and dramatic storm pictures had considerable influence on contemporary and later *wen-jen* painting. The album leaf by Wen Cheng-ming in Kansas City[29] is striking evidence of the partial dependence of this leading *wen-jen* on Che concepts in his early work.

Why should there be so few of Lü's paintings known? And only one of his landscapes? The answer must be twofold. Many have been irretrievably lost. The Che school had few strong partisans after 1600, particularly among major collectors. But many also may be masquerading under other names. In the great London exhibition of Chinese art held in 1934–1935, one of the popular hits of the show was a long handscroll *Ten Thousand Miles of the Yangtze River* attributed to Hsia Kuei, the great Southern Sung master, and lent from the Palace Collection then at Nanking but now on Taiwan.[30] While typical of some other important works ascribed to earlier times, it was certainly produced by one of the artists-in-attendance at the Ming court. Even forty years ago the scroll was not fully accepted as by Hsia Kuei. Its turbulent, dramatic character was seen by some to be at variance with a Sung Dynasty date. It falls very near the manner of Tai Chin's and Lü Wen-ying's storm scenes. Again in an early Ming court context, the "Hsia Kuei"

becomes a major work demonstrating the real capabilities and achievements of these official artists.

The last painting to be considered represents still another facet of Ming court painting—the one most indebted to the past and most dependent upon its decorative function. Paintings of birds and flowers were a special category going back to the Five Dynasties Period (907–960), particularly in the work of Huang Ch'üan (900–965) and his son, Huang Chü-ts'ai (933–after 993). Their brightly colored and highly decorative renditions of "feathers" made them popular at the court academies of their day. Nevertheless the eleventh-century arch-prototype, the *wen-jen* scholar-painter-critic, Mi Fei, gave Huang Ch'üan short shrift describing his work as "for all his opulent beauty, he is invariably vulgar."[31] We may well consider this to be a classic case of sour grapes if we can rely on the best work attributed to the younger Huang, *Pheasant and Sparrows Among Rocks and Shrubs* in Taiwan.[32] For a firm grasp of the form and spirit of birds placed in a bold and carefully defined environment, this work would be hard to overpraise.

The genre continued in popularity through Sung and Yüan with some variations. A reduction of scale and an increase of intimacy is to be found in the marvelous album paintings of Southern Sung, while essays in monochrome handling by the Yüan master Wang Yüan were designed to reduce the sensuousness inherent in color. But as landscape and its components—trees, bamboo, prunus, rocks—became *the* accepted, almost mandatory, subjects for literati painting, "fur and feathers" were looked upon as fit only for the court painters and artisans. Fewer and fewer bird and flower paintings in large-scale format were produced by the *wen-jen* as the Ming Dynasty progressed. Significantly, in the fifteenth century Shen Chou, the great master of the Wu school, did not consider it beneath him to brush several major works (Fig. 84) in this genre. The relations of Wu and Che were better in their heyday than in the writings of later critics and formulators of the *wen-jen* tradition.

In the list of painters-in-attendance to the Hsüan Te Emperor one specialist in birds and flowers stands out—Pien Wen-chin (active 1413–ca.1435). His masterpiece, *The Three Friends and the Hundred Birds*, is a complex and bold harmony of color and brush, sumptuous and at the same time taut in detail still with a hint of the part by part approach of the earlier album paintings with their concentration on the detail of nature rather than on its overpowering abundance.[33] Its purpose was both decorative and ceremonial since it would have been appropriately displayed at the time of the New Year's celebration.

The Museum possesses a monochrome ink album leaf[34] by Pien (Fig. 85). Freely brushed in a manner like that of the later bird painters of the Che school, it is unlike the more grand and decorative manner of the large, colored hanging scrolls exemplified by the recently acquired painting we now consider.

The *Hundred Birds Admiring the Peacocks* by Yin Hung (Fig. 86)[35] clearly belongs

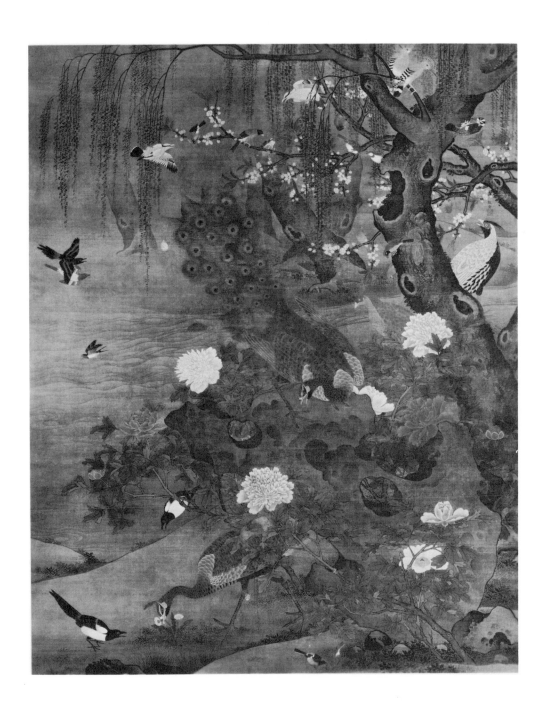

86 Yin Hung, *The Hundred Birds Admiring
the Peacocks*, Chinese, Ming Dynasty.

to the long tradition of bird and flower painting going back to Huang Ch'üan. Yin's immediate predecessors were Pien Wen-chin and his equally famous pupil Lü Chi, but time has obscured his rank and achievement. Only one other painting by Yin is known,[36] and his biography is limited to his origin at Ch'en-chün in Honan and to his indebtedness to Pien and Lü. Even his dates are unknown. We can only suggest a time around 1500 on the evidence of his two extant pictures. The second work by Yin in the Chen Collection is surely based on Lü Chi's classic works with broad, interlocked planes of rock and water. Even the birds are assimilated to these curving outlines, and the nearby background defines the flowing decorative pattern dominating the realistic rendering of the birds. In this it is close to the most famous of Lü Chi's works, the four scrolls of *The Seasons* in the Tokyo National Museum and particularly to the Spring panel.[37]

With the Cleveland painting Yin reveals a more adventurous and up-to-date spirit. The foreground is traditional with the brightly colored birds, the perforated and metamorphic rock, the differently colored peonies in various stages of growth, and the nearby willow trunk and prunus branch. But behind this decorative facade the artist has extended the composition into deep space by drawing and atmospheric perspective. The rushing stream is more real than decorative and extends the ground plane back to the far shore where distant tree trunks depicted in pale washes seem ghosts of the bold specimen in the foreground. In this pictorial realization of real space and a more unified atmosphere, Yin Hung reveals his awareness of the achievements of such Che school masters as Tai Chin or Lü Wen-ying and produced something that is both decoration and something more.

The details of the painting display Yin's mastery of sharp, fine line brushwork in the drawing of birds and flowers, his subtle use of tone in the shading of the rock, and his varied calligraphic use of thick and thin strokes in the painting of tree trunks, branches, and foliage.[38]

Such signed large-scale paintings of any quality designed for palace use have become excessively rare. This is the first work of the type to enter our collection and one of the few in any Western collection. It repays close and extended examination —particularly so if one is interested in birds. There are twenty-five in all, two peacocks and twenty-three others, some in pairs of male and female, some shown singly.[39] If the generic "One Hundred Birds" is to be taken seriously, there may have been still more on another painting or three other paintings originally made to complete a pair or a set. The original purpose of such a sumptuous decoration would have been threefold: as decoration, as an auspicious accompaniment to seasonal observances, and as a metaphor of the contented relationship of Imperial subjects to the Imperial Presence. Its functional and symbolic usage was typical of much of the work produced by the painters of the early Ming court.

The presence of many of these works in Japan, along with the landscapes and figure subjects of the Che school is no coincidence. Their adaptability to Japanese

taste in decorative style is evident and scrolls by Lü Chi, Yin Hung, and others played a major role in the development of Japanese decorative screen and panel painting. As early as the fifteenth century this influence is discernible in the bird and flower screens attributed to Sesshū, Shūgetsu, and others. From these to the rise and development of the Kanō school in the late Muromachi, Momoyama, and early Edo periods is a major step involving large-scale changes by the Japanese masters. The most notable of these changes were the use of a solid "abstract" background—usually gold leaf—and a decorative, unnatural disposition of realistic flower and bird units on the picture surface. The inspirational influence of such decorative Chinese paintings for those Japanese developments cannot be overestimated.

If fashion has ill regarded early Ming court paintings in the past, can we be sure that such a regard will continue? Careful contextual study of these recent additions to our Chinese painting collection should lead to an understanding of their merit and that of their peers in other collections. The study of history should reassure us that no work of any real merit is forever consigned to oblivion. The works of the painters-in-attendance of early Ming deserve a better fate.

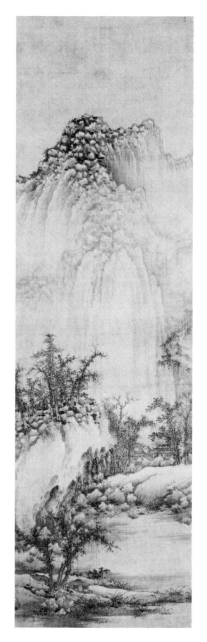

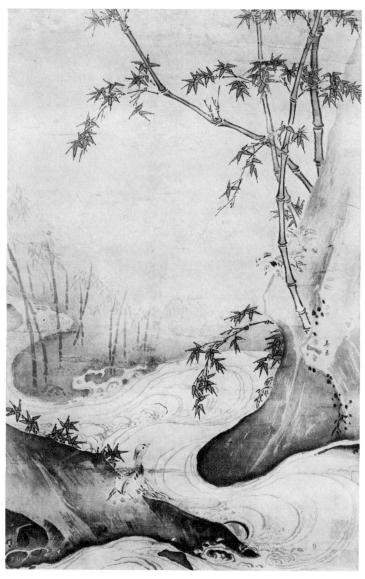

88 Ma Yuan, *Spring*, Chinese, Sung Dynasty.

87 Style of Chü-jan, *Buddhist Monastery
by Stream and Mountain*, Chinese,
Northern Sung Dynasty.

This essay was written for Quality: Its Image in the Arts, *edited by Louis Kronenberger (Atheneum, 1969). While the debate about aesthetic values may be eternal, Lee's position is that of a moderate relativist. Some values he would admit to be of long-term importance, if not absolutes.*

The historical definition of the word "quality" contains indications of meaning and usage we ignore at our peril—and have ignored if we think of the word as meaning excellence in an absolute sense. The *Oxford Unabridged Dictionary* patiently provides three particularly significant qualifications for the word "quality": excellence, comparison, and kind, which I will assume for purposes of applying the word to the pictorial arts. Even further, one can weave these into a phrase: excellence by comparison within a kind.

There have been numerous theoretical efforts, principally since the Renaissance, to deal with the problem of levels of excellence in the arts. The most important of these have been ably considered by Jakob Rosenberg in *Quality in Art, Criteria of Excellence, Past and Present* (1967): the progressive concepts of the sixteenth-century Vasari; the statistical point system of the seventeenth-century Roger de Piles (not as silly as it might at first seem, and not intended by the inventor as an absolute scale of worth); the ideas of nobility and sublimity of the eighteenth-century Sir Joshua Reynolds; the exposition of significant form by the twentieth-century Roger Fry. While these are found wanting in particulars, Rosenberg accepts them as partial and evolutionary answers that can be combined to approach closer to ultimately unattainable absolute standards of quality. To these can be added the Chinese idea of levels of quality ascending from mere technical skill to inspired production. Paintings can be either divinely inspired, as in earlier expositions, or inspired by the revelation of superior human character, as in the later literati ideas after the twelfth century.

All these concepts fail to withstand modern analysis. Psychoanalology, anthropology, and linguistics have made us justifiably dissatisfied with absolute answers applicable beyond a clearly definable structure, or kind. The arts have arrived, if belatedly, at a position where one simply can dismiss as irrelevant any discussion of the relative excellence of say, Michelangelo and Cézanne, of sculpture and painting, or of Chinese art and Greek art.

The seventeenth-century battle of the ancients against the moderns proved to be as futile as the continuing war between the Establishment and the avant-garde, however stimulating the struggle, and however many insights may result from the melee. Quality involves choice, often from a seemingly infinite number of candidates. Prior to contemporary works, this choice has been made more obvious, or at

89 Style of Ma Yuan, *The Lonely Traveler*, Chinese, 14th Century.

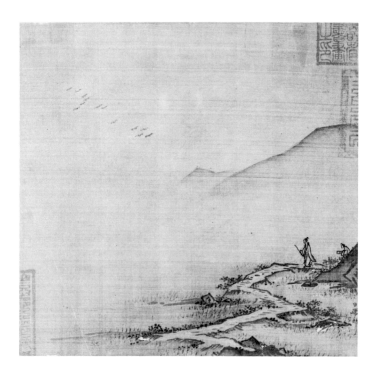

least less difficult, by the winnowing effect of time. Many objects have disappeared; others have been subjected to the continuing process of evaluation by comparison—and this process, if not infallible, is still a reasonably just means of providing a perimeter around an area within which we choose. Further, the encompassing cultural structure—the context of the object—has been subjected to continuing scrutiny and becomes better understood in an objective, removed sense; we know our larger, more complex contemporary structure by immersion rather than historic examination. Thus, our choice in contemporary art is from a more ambiguous context than that of the past and is accompanied by a wider margin of error.

If we accept "excellence by comparison within a kind" as a definition of quality, we can find the concept viable for the arts within any given cultural structure. If we move outside that structure, then we must add the phrase "value judgment," with all the weight of preference implied. This preference is rendered about the structure as a whole rather than about any part of it, whether art, literature, music, or what you will. We can prefer humanism or the Enlightenment to tribalism or barbarism with poor justification but strong personal satisfaction. But to say that we aesthetically prefer, much less qualitatively evaluate, such specific units within noncomparable structures, such as Chinoiserie to African tribal sculpture, or the *Stanze* of Raphael to Lascaux, is to take an indefensible position. A true qualitative judgment—comparison within a structure—must be more objective than the more

sweeping value judgment. The limitation of a context, the acceptance of a discernible boundary, permits this objectivity.

We often proceed from generalities to specifics, from recognition of a type to discerning quality within a type. Conversely, if quality requires tedious and careful consideration, the recognition of a type may come by what is nearly instantaneous revelation. African tribal sculpture as a type was first recognized by the Cubists and Expressionists to be a fruitful stimulus to new ways of seeing and feeling sympathetic to their still half-formed new pictorial thoughts. Thus a type, once rejected, was accepted; but the range of quality within this type was still little known. There had been no time for comparison of a laboriously sought out, quantitatively significant variety of specimens.

Even more, the nature of the newly accepted type—its intellectual, emotional, social, and other conditioning structures—was not yet well enough known to develop the understanding of the structural context necessary for a recognition of quality. It is well known to specialized connoisseurs of Far Eastern art and of Occidental art that the disciple of one usually chooses badly from the other. The leading Western avant-garde master becomes enthralled by a late and decadent example of Zen monochrome painting; while his Oriental counterpart is seized with admiration before the dimmest provincial reflections of classical sculpture. Both have been moved by types unfamiliar to them. Further acquaintance might have led them to the qualitatively high prototypes for the works that first drew their attention. The creative artist, sometimes a perceptive guide to the art of his own métier, is often a poor judge of those things beyond, or beneath, his ken. In a sense, he looks at other works as a scavenger does. What can it provide? How does it answer his needs? He is interested only in a type, within which he can develop or from which he can expand. Comparing the quality of nearly identical works of art represents a problem outside of and irrelevant to his interests. The almost obsessive study and comparison of similar works of art is the isolated realm of the connoisseur, currently a déclassé, minor shade from the past.

If the discernment of quality is ill-served by the application of a priori systems, it surely finds its severest tests in pragmatic situations where rationalized and felt, researched and immediate decisions are made and lead to a final, almost irrevocable result. Such situations continually confront the collector or curator who buys or chooses a work of art. The curator of the general art museum, in particular, is constantly *forced* to choose—often between objects of different types, but as often between works of the same type. The former choice is the more agonizing, for it means a value judgment, often modified by rational requirements of space, psychology, or politics, removing one apple and adding one orange, when both are equally desirable. The latter choice, repeated again and again, is the school of connoisseurship. Here the rigid discipline of comparison comes fully into play, and the only guide to quality is wide-ranging and precise comparison, yours and those of your predecessors, comparison rooted in history. If the general art museum is

90 Tuti Nama, *The Poisoned Prince*, fol.
33ᵛ, Basawan, ca. 1560.

91 Tuti Nama, *A Visit to a Sage*, fol. 219ᵛ,
School of Basawan, ca. 1560.

different from other museums, it is so in its dedication to showing the best, not
merely illustrating the history of its discipline, i.e., recognizing types.

The general art museum does not choose between classical antiquity and the
Renaissance. Each is recognized as a sovereign type, despite the partial dependence
of the latter on the former. An "inter-type" area for choice, given optimum collect-
ing conditions, begins to appear when one weighs the neoclassicism of the late
eighteenth and early nineteenth century against the ancient Greek and Roman
works. Under ideal conditions of acquisition, one could understand the museum
that had five galleries of classical art and perhaps two of neoclassic art. One could
begin to quarrel with one that reversed the proportion.

Confronted with the original Greek vase painting which preserves intact its linear
intentions and with an engraving in the neoclassic style after Flaxman, equally
linear in character, we should be able to distinguish between the tense, springing
nature of the Greek line and the mechanical "neat and tidy" control consciously
exercised by the Englishman. The hands of the Erotes really grasp the vine scrolls;

the foot of Atalanta really pushes against the base line; the extremities of Thetis and Achilles are mere substitutes for observed, felt, and realized images. To the smallest detail, as in the zigzag drapery of Atalanta compared with that above Achilles, the qualitative superiority of the early fifth-century image over the late eighteenth-century one is manifest. Cold restriction and cool restraint are not the same thing.

This is not to say that the neoclassic style in the hands of a great master like Ingres cannot achieve Olympian levels. The French artist's *Venus Wounded by Diomedes* (formerly von Hirsch collection, Basel) is a little masterpiece of youthful intelligence and sensitivity, masterly by the degree to which Ingres departed from the more obvious and superficial typological elements of classical originals. The combination of linearity with effects of low relief, and the lively and sensuous undulating rhythms are particularly notable and demonstrate the artist's desire to *use* the prototype rather than reproduce it. Perhaps it is no coincidence that Ingres's starting points for his *Venus Wounded* probably included minor and provincial classical works, such as a late Etruscan vase from his own collection, now preserved at the Musée Ingres, Montauban.

And yet there is certainly room for argument, though I suspect disagreement would be sophistic in motivation. Why not then narrow the field a little further, but within a comparable structure? What of the Renaissance and its early nineteenth-century German epigones, the Nazarenes? Peter Cornelius's *Recognition of Joseph* (National Gallery, Berlin) owes much to such works as Raphael's *Sacrifice at Lystra* (Victoria and Albert) but, despite its modest virtues, who would deny the lower level of Cornelius's work? Where the German's drapery restricts and diminishes his figures, the Florentine's bestows generous amplitude. Where the former's left and right edges fade into insecurity, Raphael's edges firmly anchor a rich, if turbulent, composition. The great sensibility that rolls the architectural background in counterpoint to the figures, that places the distant statue of Mercury as a triple foil to the foreground—as sculptural echo of the tripod base, as a vertical figure making a triad with Paul and the axe bearer, and as a placid foil to foreground activity—this sensibility is foreign to that of Cornelius, whose architectural background leads the eye away from the scene of apprehensive reunion and whose foreground platform destroys the firm ground plane necessary to support the action. Choose, you must, if both are by happy chance offered to you with only one to remain. Is there really any question which work possesses the higher quality?

Such problems and confrontations plague—and purify—curators in all fields. One really cannot make blanket qualitative judgments between early and late Sung landscape painting. Like Romanesque and Gothic art, each is an autonomous structure, however much one is derived from the other or simply follows it in time. No expert can confuse an eleventh-century Chinese landscape painting such as the one shown with one of the thirteenth century (Figs. 87,88); but no one can dem-

92 Baptismal bowl, Hagi ware, 17th century.

94 Incense burner (Lu), Kuan ware, 12th century.

93 Lobed vase, Kuan ware, 12th century.

onstrate the higher quality of either. Where the one is wholeheartedly monumental and rationally naturalistic, the other is equally committed to a romantic and decorative approach. The balanced and towering symmetry of one is simply a different kind of thing from the fragmented asymmetry of the later work. Here one hopes that a choice will never be offered, much less forced.

On the other hand, within the idiom of the scroll by Ma Yuan one can find levels of clearly distinguishable quality. Probably a century separates *Spring* from *The Lonely Traveler* (Fig. 89); they are equally disparate in quality. Observe only what the Chinese consider the highest criterion for judgment, brushwork. Almost any single stroke in the Ma Yuan has a suppleness, a beginning, middle, and ending, a varied life of its own; almost any single stroke in the other seems an extrusion from a tube, endless, seamless, characterless. The mechanical and repetitive "axe"-shading of the rock at the very right edge of *The Lonely Traveler* should be compared with the "axe" strokes of the fold in the rock at the lower left of the Ma Yuan. Or simply, by Western standards now, feel your way with the stream and then try to move with the zigzag path in the smaller painting. Is there really any question that higher quality resides in the scroll by Ma Yuan?

Even within the discipline one might expect in a single workshop, one can and must distinguish the work of the master from that of artisan. Whether Western or Oriental, the illuminated manuscript is often a school for connoisseurship. Nowhere is this more evident than in the *Tuti Nama* begun under the patronage of the Mughal Emperor Akbar where young but soon to be celebrated masters worked

95 "Medici" porcelain plate, ca. 1580.

96 Blue and white bowl, Period of Ch'êng Hua (1465–87).

with other artists from various regions of the empire. The damaged scene by Basa-wan (Fig. 90) uses the dramatic possibilities of drapery in support of the narrative unfolding on the picture's stage. The other scene (Fig. 91), later in the manuscript and by a lesser hand, finds the drapery upstaging the actors. These, in turn, are less responsive to the demands of expression; arranged in rows on a schematic floor plan, they seem little more than stand-ins. Basawan's figures, simply arranged in two triads, exist in depth and with movement. Further, details reveal the difference in psychological characterization, in sheer believability, between the master and the follower. Such differences exist in almost every comparable detail, whether the corrugated eaves of the roof or the foliage of the background trees. Even the color of the page by Basawan is modified to become a part of the psychologically somber action. That of the other is rich, pure, and decorative, but hardly complements the narrative. Within the idiom adopted by both artists, a qualitative decision is possible; other pages frankly adopt a purely decorative idiom, and these are not so amenable to evaluation.

We speak of idioms or structures. These involve that much-abused concept, the intention (or, better still, the assumptions) of the artist, the school, or the culture. The interweaving of these assumptions is always complex, but perhaps it can be most clearly seen in a relatively restricted and specialized non-pictorial medium, ceramics. The vagaries of taste, based largely on preference rather than on quality, have led us from worship of later decorated Chinese porcelain, through the less obvious joys of Sung monochrome wares, to the seeming rude roughness of the Japanese ceramics associated with the tea ceremony. The arguments among the devotees of the various wares confuse the issues and are classic examples of the mis-application of inappropriate standards imposed upon the differing idioms. The tea-oriented amateur, accustomed to the "natural" dripping of the glaze on the rough surface of the pot—a surface with all its warts and blemishes of a piece with the rugged, rock-like naturalness of the shape (Fig. 92)—will extol the virtues of a small Chinese Kuan (official or Imperial) ware vase (Fig. 93), actually a reject from the carefully supervised kilns accustomed to the production of unctuous and perfect jade-like wares with antique bronze-like shapes (Fig. 94). The Chinese connoisseur would be appalled by such a choice and he would be justified. But he in turn would surely reject the consistent naturalness of Japanese pottery, looking for such qualities in nature itself rather than in the products of man. We can probably never agree that the incense burner is better or worse than the Hagi bowl; but we can see, preference aside, that the incense burner is superior to its smaller, misfired kin.

An idiom may not be confined to a single culture; and qualitative judgments are possible, if sometimes obnoxious, between structures as

widely separated geographically as Ming China and Renaissance Florence. When
the Italian potter emulated the apparently miraculous blue and white porcelain
of China, he produced the extremely rare and much sought-after "Medici" porcelain
(Figs. 95,96). But the apparent technical sophistication of the glaze and body,
not fired high enough to coalesce into true porcelain, is belied by the almost
peasantlike character of the decoration with its rote-produced border, however
charming as folk art. The Chinese elder brother shown here possesses a sophisticated
consistency of paste, glaze, color, spacing, and drawing. In effect, the Medici por-
celain has a folk-art décor on a porcelainlike base. The decoration, visually a coun-
terpart to a simpler pottery foundation, generates a tension between itself and
its more sophisticated base, a tension supplanted in the Chinese porcelain by a
remarkable fusion of manufacturing technique and visual appearance.

Qualitative judgments of comparable validity are possible in less simple media,
not that the technique of producing so sensuous and material a substance as porce-
lain is simple. The result is just less complex to our senses and our knowledge
than that presented to us by such a useless fine art as painting. In some ways, the
more complex the paintings the easier it may be to discern their relative qualities.
The obsessive reductions and specializations explored by Mondrian and his follow-
ers do not in turn simplify the comparative process. Their very specificness produces
ambiguities usually eliminated by more complex works. "Less is more" is a value
judgment prescribing the rules of the game within this particular structure, which
also includes concepts of precision, vigorous logic, and meticulous taste. The

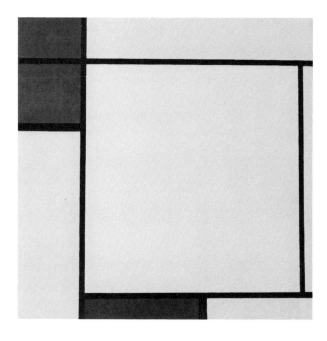

97 Piet Mondrian, *Composition with Red,
Yellow, and Blue,* 1927.

latter phrase is a key one, for Mondrian was vehement in his denial of the mathematical or purely intellectual motivation of his art. His painting (Fig. 97) epitomizes rigorous consistency in the artist's insistence on straight line, right angle, primary colors, the flatness of the actual and suggested picture plane, and the interlocking of these elements with each other and the picture's boundary. Apparently simple, subtlety appears at every closely examined turn. Thus the wide black vertical line at the right merges tonally somewhat with the yellow rectangle, which in turn modifies the line and its relation to the central off-white rectangle. The ambiguity of the lines rests on their double function as linear boundaries and as rectangles in their own right when their linear extension is reduced. The final effect is one of pure essence, a visual embodiment of Plato's ultimate visual art of geometric forms. Glarner's work (Fig. 98) owes much to Mondrian's achievements and in using them the later artist modifies with personal touches, slight diagonals, disappearing planes or bands, shifting dislocations of horizontal and vertical edges, and varying sharpness in these edges. The result seems, given the rules of the game, less inevitable, less rigorously consistent than Mondrian's result, even in the choice of the circular shape. Glarner's interior structure works well with the circle but, except for the quadrants, does not seem to be necessarily complete. Despite the widening of the bands to the cardinal directions, the visual possibility of extension is left, and this tends to weaken the consistent closure we can justifiably

98 Fritz Glarner,
Tondo No. 12, 1949.

expect in such a work. If Mondrian is pure, Glarner seems quixotic within these limits, and I think few would place his circle at the same level as Mondrian's rectangle.

The complex work of art, within its cultural context, leaves less to the beholder's imagination, is less ambiguous, and seems more susceptible to ready evaluation. The perfect crime, practically impossible to commit, leaves the fewest possible clues. The "normal" crime provides the *knowledgeable* observer, whether Holmes or Wimsey, with a plethora of indications which must be recognized to be read, understood, and structured. And so it is with pictures. Most of us have seen enough to easily place Rubens's marriage picture *The Artist and His Wife* on a plane well above van Moor's *Burgomaster of Leyden and His Wife* (Figs. 99, 100). In doing so, we recognize the superiority of Rubens's pictorial style, his representational skill, and his meaningful reverberations of past marriage symbolism. The fusion of these three aspects of the post-Renaissance Western tradition is what we, as inheritors of that tradition, can expect in a great master such as Rubens. The unifying swinging arcs of the composition, the transparency of the color, the precision of the painterly detail, coalesce in both a general and a particular image of healthy, extroverted, and serene connubial bliss. The gestures of the hands, all flesh exposed, with their connotation of male support and specific representation of the marriage symbol par excellence—the ring—are remarkably different from, and more meaningful than, the unknowing Dutchman's portrayal of the fashionably gloved female hand, the separateness of the two figures, almost as if two separate portraits had been juxtaposed at random. The oval frame finds no response within, and however pleasant one may find the restrained textures and subdued light of van Moor's painting, we recognize it as a minor note, not to be discarded, but not to be compared with the authority and presence of the work by Rubens.

Within the same genre, but even more specifically, the two *Jewish Brides* by Rembrandt and Aert de Gelder (Figs. 101, 102) witness the clear difference in quality regardless of almost congruent subject matter. Here the representation is especially decisive, proof enough that not all questions of quality can be decided on purely formal stylistic criteria. If we must not judge African sculpture on its representational sensitivity, we must allow this criterion to influence us in evaluating Renaissance and baroque painting. It is simply given as one of the articles of faith within the total structure. This is exactly where the modernist goes wrong in evaluating earlier painting. The odd *oeuvre* of an Arcimboldo, however prescient he may seem to a surrealist-oriented curator or critic, must be seen as what it is, an oddity —useful today, but not to be praised beyond its modest merit. The interest in physiognomic exaggeration, so characteristic of the seventeenth century and visible in such disparate painters as Rembrandt, Arcimboldo, and Le Brun, accompanies that period's experiments in expressiveness. The qualitatively highest achievements are to be found in Rembrandt, who went through an early phase examining the distor-

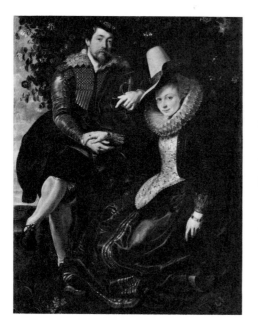

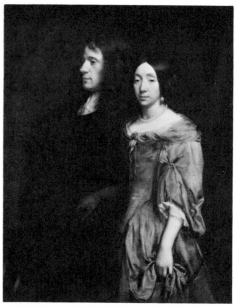

99 Peter Paul Rubens, *The Artist and His Wife*, ca. 1610.

100 Karel van Moor, *Burgomaster of Leyden and His Wife (Portrait of a Man and a Woman)*.

tions and oddities of facial expression. The final result in *The Jewish Bride* leaves the method behind to apparently breathe the deepest and most haunting expressions with paint onto the canvas. The richness of texture, the delight in weighty cloth, light and air, is not lost in the process but absorbed into the total aesthetic and psychological structure of the picture. The literalness of de Gelder's work, the diffusion of his figural motifs with their unrelated verticality and their vacant facial expressions, is properly subject to devaluation when compared with the nonpareil. Expressiveness need not be based in emotional tone or feeling, as in Rembrandt. The intellectual synthesis of expressive gesture, representation, and design achieved by Poussin is one of the great artistic achievements of Western painting. A measure of its stature can be seen when one recalls the failure of Ingres's religious works, beautifully designed but devoid of either intellectual or emotional expression.

This fusion of paint, design, subject, and meaning can be disturbed on the highest levels by the physical condition of the work of art. No curator would deny Giorgione's *Fête Champêtre* an honored place in his museum. But we must push ourselves to acknowledge that it suffers by comparison with the same artist's *Tempest*, and solely because of the poor condition of the former when compared with that of the smaller, equally enigmatic picture. Giorgione's particular poetry exists in a richly colored, atmospheric space where every touch of pigment, every nuance of

glaze combine to produce the total effect. This peculiar unity is lacking in the
Louvre picture *when compared* to the Accademia canvas. The flatness of the men's
costumes, the worn, abraded, and flattened foreground, the spatially irreconcilable
heads of the two men, the uncertain middle distance, and the streaked and flat-
tened sky do less than justice to the master, and solely because of their condition.
We can read in, furnish the picture with what we know would have been but really
isn't there. We have, like Walter Pater, projected too much into the damaged
framework, however splendid the remaining general concept and poetic invention.
The damaged *Fête* is so unique in poetic imagination that we forgive it everything
—but we ought to know that we do so. The nuances still present in the *Tempest*
tell us all of Giorgione.

By now we are only too aware that we have been, in a sense, nit-picking, select-
ing here and there minor virtues and flaws, transient and obscure details, many
of them not at first visible to the beholder, much less justifiable in logical argument.
These nuances, and the word should be used again and again in any consideration
of quality, often are literally the differences between night and day, the victor and
the also-ran. The recognition of nuances is not achieved by exposition but by experience
—conscious, calculated, and desired. If simple contact with works of art were
enough, then every museum would produce as many connoisseurs as it has guards
and attendants. The searching comparison of works of art, like with like, or with
unlike, brings the kind of understanding that we disarmingly describe as innate.
Any devotee, an amateur in the good old sense of that word, applies himself to

101 Rembrandt van Rijn, *The Jewish Bride*,
ca. 1665.

102 Aert de Gelder, *The Jewish Bride*, 1689.

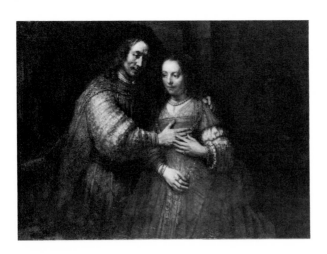

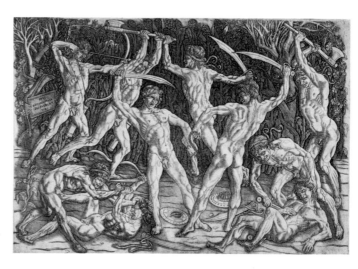

103 Antonio Pollaiuolo, *Battling Nudes*. First state.

his game and, at best, is literally obsessed by it. One can begin, or end, with explanation, but in the long stretch between beginning and ending, the discipline of comparison is the only answer to questions of quality.

There have been many "schools" of comparison, but one has been especially significant and will serve to indicate the nature of the discipline. Prints, by the very nature of their process, provide numerous works reasonably subject to objective and demonstrable comparison and evaluation. While each is unique for its particular inking pressure, and number in the sequence of subtly deteriorating impressions, a given print series has some elements of chance or variety removed from the beholder's consideration. The plate from which the impressions derive provides a mold, a structure within which the visual elements must operate. The rules of the game have been deliberately constricted and the "specialization" permits fewer areas of uncertainty and argument. One cannot, in evaluating one impression against another, evaluate the placement of a shadow: both points will show the same location for the shading, but the peculiar character of that shading becomes the subject of scrutiny. In short, one is forced to study nuances, and hence the success of a print seminar in the education of connoisseurs. Why are they not more often given in our schools and universities? And particularly at earlier stages of training, before the tyranny of the photographic reproduction dulls perception? The photograph, negatively considered, is the best proof of the real existence of quality in the nuances of an original work of art. The perceptive connoisseur knows from experience that the better works look worse in reduction; the inferior works gain by the smaller scale and the loss of texture.

Antonio Pollaiuolo's *Battling Nudes* offers a particularly meaningful object lesson in comparison, nuance, and the total effect of a work of pictorial art. Until re-

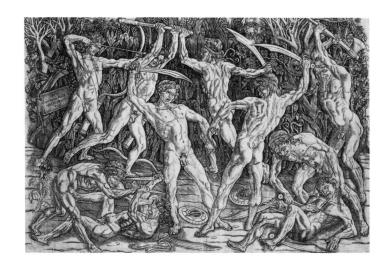

104 Antonio Pollaiuolo, *Battling Nudes.* Second or later state.

cently, some impressions of a "first" state (that is, prints supposedly taken from the engraved copper plate in its first, pristine, condition before reworking because of changes in conception or condition) have been known and ranked as to condition and excellence of printing. Of these, the Amsterdam impression shown here is one of the best and presents the general impression common to the others. The pale but heavily shaded figures move in tense counterpoint before a dark wood. The effect is dramatic and technically not unlike that of Greek red-figured vase painting. The Cleveland impression—recently exposed to public view after centuries in the vaults of the Princes of Lichtenstein—is more even, silvery, with far less contrast between figures and background. Without going further and establishing the context of each engraving, one could think the Amsterdam impression the "better" one, sharper, more dramatic. But a closer examination proves the "silvery" impression to be earlier, made from the copper plate *before* strengthening the shading in some muscled areas and, in the background, areas that had become worn from repeated printing, before the plate became scratched in the area of the left buttock of the principal figure seen from behind. The simple fact that the "silvery" print is an earlier state, and that its details provided the model for nearly contemporary copies made from this famous print, compels one to rethink the structure within which we evaluate the work of art. We suddenly remember that silverpoint, a delicate instrument beloved of early draughtsmen, produced precisely the same general effect of the Cleveland print impression; and we remember that the engraving, like the printed book, was thought of, not only as a work of art in its own right, but as a substitute for drawing. We can then see that, regardless of our personal preference, conditioned by decades of acceptance of the other impressions, the silvery impression is the superior one, more subtle, both supple *and* tense,

more like the image the artist created, more truly expressive of the even tonalities of the Quattrocento. To arrive at such a position took far more time, concentration, and dispersion of disbelief than to read these few summarizing lines (Figs. 103, 104).

The overall quality of a work of art—its emotional or visual tone, whether harmonic or dissonant—is just as decisive a factor in judgment as are the most minute nuances. Bretherton's direct copy, even forgery, of Rembrandt's most famous landscape etching, *The Three Trees* (Figs. 105, 106) can be painstakingly proved to be different from the original. One needs only patience and the ability to count the strokes and calculate the directions of the etcher's needle. But the closer one looks at details, without going back to their relationships to the whole, the more one is amazed at the stroke-by-stroke veracity of Bretherton's almost psychopathic adherence to the original. It is in the general effect, the bloom of the work, that the qualitative differences are most revealing. The billowing thunderhead cloud at the left becomes a papery puzzle in the copy; the flatlands, so flat and yet well placed in space by shadowy light, are slightly more tilted in Bretherton's page and are starkly lit, destroying one's belief in their flatness and recession. What is feathery in foliage becomes lumpy. What is mysterious and evocative in one becomes inky and descriptive in the other. One could, of course, argue that inky and descriptive are effects qualitatively not inferior to mysterious and evocative. But sophistry and rationalization really have no place in the judgment of pictorial quality, unless one wishes to evaluate words and not the visual images they describe. The careful study of prints, bronze plaquettes, or coins—the "repeatables" of the art world—develops this visual language we so often lack in our verbal-literary culture.

The now fashionable, if one can use such a word in a proletarian context, revival of "repeatables" on the grounds that they provide a more democratic dispersal of art is noble and properly corrective of the aristocratic idea of uniqueness—but beside the point where art is concerned. The revival is a politico-sociological event, a nonevent in the world of art—unless, and only unless, the concept of difference, nuance, and hence individuality is included in the program. Quality rests in "excellence by comparison within a kind," not in the universal extension of single images, whatever the verbal program forcing the issue. Many of these modern repeatables are also minimal or popular in idiom. Even more than the Mondrian, these minimal works rely on any irreducible minimum of color, shape, texture, etc., thus increasing the ambiguity of the artistic structure and permitting a wider, more verbose participation or "involvement" by the beholder.

In trying to find the innermost dimensions of quality, we have seen that precision is essential, both in description and in evaluation. If we still accept the end as ineffable, then the approaches must, on the contrary, be as objective and precise as possible. While we can still justifiably speak of the ultimate mystical universality of a Ma Yüan, we must have previously demonstrated the superiority of his brushwork over that of his epigones. If one can justifiably revel in the *terribilità* of Mi-

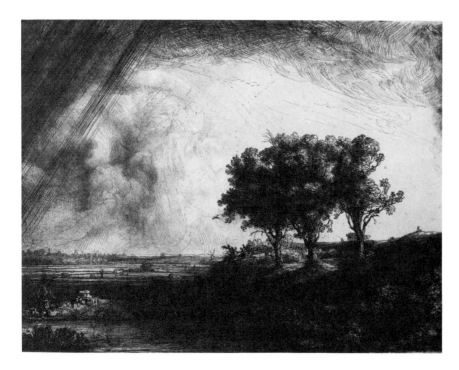

105 Rembrandt van Rijn,
The Three Trees, 1643.

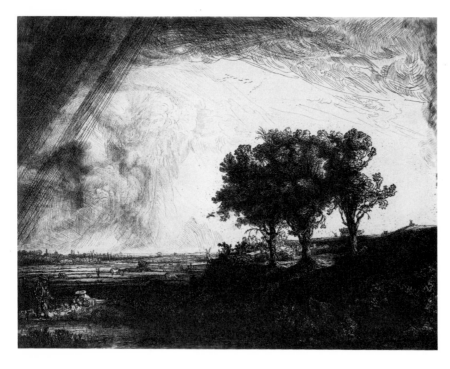

106 James Bretherton,
*The Three Trees (after
Rembrandt)*, 18th century.

chelangelo, one must have almost surgically differentiated his use of anatomy from that of his followers.

But this description and analysis is useful insofar as it is not mere literary virtuosity. Carefully describing the concrete "thingness" of a work of art, as in current "linguistic" circles, does not automatically bestow quality upon the works described. At this point, comparison in depth is essential. One cannot possibly evaluate the quality of a new and original work of art except by accident or in a wider context where comparison is possible. In short, the evaluation must be a historical one, not a news report or a passionate and sophisticated rationalization. Where history begins and current events end is hardly susceptible of precise definition. Whether it is one, five, ten, or twenty-five years really doesn't matter, as long as the principle is accepted. The instant art history of some of the more subtle and productive writers is particularly misleading precisely because it pretends to be history rather than news or opinion. The establishment of aesthetic tables of consanguinity reaching from the distant past of Jackson Pollock through Morris Louis to Kenneth Noland are devious appeals to historical justification—but without the broadly based comparisons that are the inevitable result of historical study.

But what of contemporary painting? Are we left with crosswinds of rumor and opinion? In part, yes. But some tentative judgments can be made, though we must always be reconciled to the probability of overlooking the totally new and revolutionary work, if and when it does in fact occur. The kind of tentative qualitative evaluation one can attempt within the present must rest on close comparison of comparables. To opt for a type as representing "the wave of the future" is dangerous and irrelevant.

It is far easier to be permissive, to welcome innovation from one and all, or to be stubbornly exclusive, permitting to only a self-identified elect the name of art. Battles among the Surrealists, Abstract Expressionists, Minimalists, light sculptors, et al., for recognition as the sole bearer of the truth, only succeed in laying waste to the field of art. Comparison, *le goût de comparaison*, is historically and pragmatically a well-established means of finding the hazy boundaries of quality within the realm of art and, not just incidentally, circumscribing the area of non-art—entertainment, propaganda, social amelioration, therapy, philosophy, and others. The appreciation of excellence by comparison within kind, with its requirements of patience, study, and judiciousness, makes often frustrating demands upon us. We can meet these today, but only if we civilize the major part of our current fashions in, not art, but the understanding of it.

Notes to the Text

The Art Museum in Today's Society

1. Jan van der Marck, *Christo: Wrap in Wrap Out*, Exhibition Catalogue, Chicago Museum of Contemporary Art (18 January–2 March 1969).

2. Thomas Hoving, "Introduction," *Harlem on My Mind*, Exhibition Catalogue, Metropolitan Museum of Art (New York: Random House, 1968).

3. Thomas Hoving, *Metropolitan Museum of Art Bulletin*, 27 (January 1969), p. 243.

4. John Stuart Mill, *Autobiography* (Boston: Houghton Mifflin, 1964), p. 96.

5. Herbert Marcuse, "A Redefinition of Culture," *Daedalus*, 94 (Winter 1965), pp. 192–3.

6. W. H. Auden, *The Listener* (17 March 1966), p. 377.

7. Christopher Ricks, *McLuhan Pro and Con*, ed. R. Rosenthal (New York, 1968), p. 105.

8. George Orwell, *1984* (New York: Harcourt Brace Jovanovich, Inc., 1963), p. 204.

9. Robert Brustein, "The Third Theatre Revisited," *New York Review of Books* (13 February 1969), p. 26.

10. J. Huizinga, *Homo Ludens* (Boston: Beacon, 1955), p. 13.

11. Marcuse, op. cit., p. 195.

12. George Orwell, *Animal Farm* (New York: Harcourt Brace Jovanovich, Inc., 1954), p. 114.

Art Against Things

1. Alain Robbe-Grillet, *The Voyeur* (New York, 1958), p. 193.

2. Denise Thomas-Goorieckx, "Les Vid du Support," Institut Royal du Patrimonie Artistique, Koniklijk Institut voor het Kunstpatrimonium, *Bulletin*, 5 (1962), p. 150. a study of the Rubens *Descent from the Cross* in Antwerp.

3. Don Judd, "Black, White, Gray," *Arts Magazine*, 37 (March 1964), p. 37.

4. Don Judd, *Perspecta*, 11 (1967).

5. Marcia Tucker, *Robert Morris* (New York: Whitney Museum of American Art, 1970), p. 55.

6. Etienne Gilson, *Painting and Reality* (Princeton, 1957), pp. 277, 278.

7. Gervase Matthew, *Byzantine Aesthetics* (New York, 1964, 1971), p. 102.

8. "Bankers Evaluate Art," *Art Digest*, 5.21 (15 January 1947), p. 32.

9. Mao Tse-Tung, *The Quotations from Chairman Mao Tse-Tung* (New York: Bantam Books, 1972).

10. J. E. Bowlt, ed., *Russian Art of the Avant-Garde: Theory and Criticism 1902–1934* (New York, 1976), pp. 167, 170, 201.

11. *Art and Artists*, April 1975; May 1975; July 1975; August 1975; September 1975.

12. E. W. Schafer, *Tu Wan's Stone Catalogue of Cloudy Forest* (Berkeley and Los Angeles: University of California, 1961).

13. P. Coremans, R. J. Gettens, J. Thissen, "La technique des 'Primitifs flamands'," *Etudes de conservation*, I (1952–53), pp. 1–29.

14. *The Art Bulletin*, 58 (June 1976), p. 291.

15. Etienne Gilson, *Painting and Reality* (Princeton, 1957), p. 228.

16. R. Goldwater, and A. Traves, eds., *Artists on Art* (New York, 1945), pp. 218, 231, 235, 263.

17. E. Fromentin, *The Masters of Past Time* (London, 1948), pp. 33, 37.

18. Ernst Gombrich, *Art and Illusion* (Washington, D.C., 1960), pp. 54, 55.

19. Paul Valéry, "Reflections on Art" in his *Aesthetics* (New York, 1964), p. 147.

20. Ernst Gombrich, *Art and Illusion* (Washington, D.C., 1960), p. 313.

Life, Liberty, and the Pursuit of . . . What?

1. Howard Mumford Jones, *The Pursuit of Happiness* (Cambridge, Mass., 1953), p. 67.

2. Ibid., pp. 66, 67.

3. Ibid., pp. 24–26.

4. Ibid., p. 30.

5. Ibid., p. 129.

6. Stuart Hampshire, "Private Pleasures and the Public Purse," *Times Literary Supplement* (13 May 1977).

7. Arnold Hauser, *The Philosophy of Art History* (New York, 1959), p. 341.

8. Robert J. Oppenheimer, *Science and the Common Understanding* (New York: Simon and Schuster, 1954), pp. 97–98.

9. Charles Fried, "The University as Church and as Party," *American Academy of Arts and Sciences* (October 1977).

10. P. Brocklebank, "Culture and Nullity," *Times Literary Supplement* (14 October 1977).

11. James Fenimore Cooper, *The American Democrat*, XXXVI.

12. Charles McCutchen, "Bring Back Patrons," *The Sciences* (November 1977), pp. 19–21.

13. Stuart Hampshire, op. cit.

14. Arnold Hauser, op. cit., p. 335.

15. Etienne Gilson, *Painting and Reality* (Princeton, 1957), p. 65, fn. 33.

16. Arnold Hauser, op. cit., p. 333.

17. S. Hoddupp, *The Shopper's Guide to Museum Stores* (New York, 1977).

18. George Orwell, *1984* (New York, 1961), p. 210.

19. Peter Gay, *Art and Act* (New York, 1976), p. 5.

The Illustrative and Landscape Watercolors of Charles Demuth

1. The most concise and useful biography is that by Henry McBride, which can be found in the catalog *Charles Demuth* (New York: The Whitney Museum of American Art , 1937). Other material, including reproductions, is available in: William Murrell, *Charles Demuth* (New York: the Whitney Museum of American Art); Albert E. Gallatin, *Charles Demuth* (New York: William Edwin Rudge , 1927).

2. This is reported by everyone who knew him. My information came from Mrs. Edith G. Halpert.

3. *From Mt. Gilboa*, ca. 1914 art market, New York; *Landscape, Etretat*, ca.1914 art market, New York.

4. *Angel Fish and Mermaid*, ca. 1916 art market, New York.

5. McBride, in *Charles Demuth*, op. cit., lists the illustrations:

1 for McAlmon's *Distinguished Air*, 1930.

2 for Zola's *Nana*, 1916.

1 for Zola's *L'Assommoir*, 1916.

1 for Balzac's *The Girl with the Golden Eyes*, ca. 1916.

1 for Poe's *Mask of the Red Death*, ca. 1916.

7 for Wedekind's *Erdgeist*, ca. 1917.

3 for James's *Beast in the Jungle*, 1919.

4 for James's *Turn of the Screw*, 1918, 1919, to which should be added one already known and one hitherto unpublished. (See following pages.)

6. The *Nana* series and the *Erdgeist* must be similar, for the subject is the same, decadence, sensuality, and the demimonde. The choice of subject at this time (1916) places Demuth with other men who turned to dregs and realism as antidotes against the times.

7. *At Laura's*, 1916, The Museum of Modern Art, New York.

8. All three of these, c. 1919, are illustrated in Gallatin, op. cit. These are owned by Mr. Frank C. Osborn. It is possible that other scenes exist.

9. See for example: *Erotic Scene: Two Half Nudes*, 1917, art market, New York. These sketches are not to be confused with the finished "sketchiness" of the illustrations.

10. A. C. Barnes, *The Art in Painting*, pp. 345–346, has a good concise account of Demuth's form, especially in relation to these pictures.

11. See Ibid. on Castagno.

12. *Trees No. 1*, 1916, art market, New York.

13. These paintings, many of them reproduced in Murrel, op. cit., were executed under the direct influence of Sheeler as well as the Cubists. They are much tighter and less varied than the watercolors. Demuth must have felt, mistakenly I believe, that he could get more strength in the heavier medium.

14. Reproduced in Murrell, op. cit., p. 51.

15. *End of the Parade*, 1920, reproduced in Murrell, op. cit., p. 35.

16. This can hardly be unfinished as Demuth did not work part by part in a still-life manner. This blank method is probably an extension of the blank pencil-drawn shapes mentioned in connection with the late pictures of the 1920s.

Contrasts in Chinese and Japanese Art

1. Sherman E. Lee and Wai-kam Ho, "A Colossal Eleven-Faced Kuan-Yin of the T'ang Dynasty," *Artibus Asiae*, XXII, 123–124.

2. Momoo Kitagawa, *Muro-ji* (Tokyo: Bijutsu Shuppan-sha, 1954), pl. 35.

3. *Chinese Art Treasures* (Geneva: Skira, 1961), pls. 36, 37.

4. *Sesshū* (Tokyo: Tokyo National Museum, 1956), pl. 10.

5. *1000 Jahre Chinesische Malerei* (Munich: Haus der Kunst, 1959), pl. 79.

6. *Pageant of Japanese Art* (Tokyo: Tokyo National Museum and Tōtō Bunka, 1952), II, pl. 64.

7. James Cahill, *Chinese Painting* (Geneva and Cleveland: Skira and World, 1960), pl. 48.

8. *Pageant of Japanese Art*, III, pl. 44.

9. Chen-to Cheng, *Ch'ing-Ming shang ho tu* (*Ch'ing-Ming Festival along the River Pien*) (Peking: Cultural Objects Press, 1958).

10. Robert Treat Paine and Alexander Soper, *The Art and Architecture of Japan* (Harmondsworth, England, and Baltimore: Penguin Books, 1955), pl. 69.

11. *Sekito meiga-fu* (*A Catalogue of Shih-t'ao's Paintings*) (Tokyo: Shurakusha, 1937), "Album of Landscape Painting I, Kōzanhaasho-gasatsu."

12. Susumu Suzuki et al., *Ike-no Taiga sakuhin shu* (*The Works of Ike-no Taiga*) (Tokyo: Chuo-koron bijutsu shuppan, 1960), pl. 483–10.

13. Sherman E. Lee, *Chinese Landscape Painting*,

revised ed. (Cleveland and New York: The Cleveland Museum of Art and Abrams, 1962), p. 21.

14. Sherman E. Lee, *Japanese Decorative Style* (Cleveland and New York: The Cleveland Museum of Art and Abrams, 1961), p. 35.

15. Fujio Koyama et al., *Sekai tōji zenshu (Ceramic Art of the World)* (Tokyo: Zauho Press and Kawade Shobo, 1955), VIII, pl. 101.

16. Fumio Miki and Roy Andrew Miller, *Haniwa, the Clay Sculpture of Proto-Historic Japan* (Rutland, Vt., and Tokyo: Charles E. Tuttle and Kodanshā, 1958 and 1960), pl. 30.

17. Osvald Sirén, *Chinese Painting, Leading Masters and Principles* (London and New York: Lund Humphries and Ronald Press, 1956), Part I, III, pls. 120–123.

18. *Japanese Decorative Style*, p. 29.

19. Kei Suzuki, *Yün na t'ien (Chinese Famous Paintings)* (Tokyo: Hei Bon sha, 1957), ser. I, p. 9.

20. Kota Kodama, *Zusetsu Nippon bunka-shi taikei (An Illustrated Cultural History of Japan)* (Tokyo: Shogakkan, 1956–1958), VIII, pl. 4.

21. Edward F. Strange, *Chinese Lacquer* (New York: Scribner's, 1926), pls. 50, 51.

22. Yukio Yashiro, *2000 Years of Japanese Art*, ed. Peter C. Swann (London: Thames & Hudson, 1958), pls. 155, 156.

23. *Chinese Art Treasures*, p. 263.

24. *Sekai tōji zenshu*, VI, pl. 20.

25. Fritz Low-Beer, "Chinese Lacquer of the Middle and Late Ming Period," *Bulletin of the Museum of Far Eastern Antiquities*, XIV, pl. 137.

26. *Japanese Decorative Style*, pl. 127.

27. *Chinese Landscape Painting*, p. 116.

28. *Nihon nanga-shu (Japanese Southern School Paintings)* (Tokyo: Tokyo National Museum, 1951), p. 40, lower right.

The Water and the Moon in Chinese and Modern Painting

1. *The Prose-Poetry of Su Tung-P'o*, with Introductory Essays, Notes and Commentaries by C. D. Le Gros Clark (New York: Paragon Books, Reprint, 1964) p. 128.

Zen in Art: Art in Zen

1. The literature in Zen, perversely enough, is copious. The most prolific author available in English translation is Daisetzu Suzuki. However, I would recommend first three books about Zen in art as a beginning: J. Fontein and M. Hickman, *Zen Painting and Calligraphy* (Boston, 1970); Y. Arakawa, *Zen Painting* (Tokyo, 1970); S. Hisamatsu, *Zen and the Fine Arts* (Tokyo, 1971). As for Zen itself, original texts are available in W. T. De Bary, ed., *Introduction to Oriental Civilizations: Sources of Chinese Tradition*, I. (New York, 1960), pp. 346–368; *Sources of the Japanese Tradition* (New York, 1958), pp. 232–266. An interesting and helpful book by a Western religious is that by T. Merton, *Zen and the Birds of Appetite* (New York, 1968).

2. De Bary, *Sources of the Japanese Tradition*, p. 254.

3. De Bary, *Sources of Chinese Tradition*, p. 6.

4. Merton, p. 6.

5. O. Sirén, *Chinese Painting: Leading Masters and Principles* (London, 1956) III, Part I, pl. 325.

6. CMA 70.2 *Shakyamuni Coming Down from the Mountain* Ink on paper, inscription dated 1244, 29⅜ × 12¹³⁄₁₆ inches (75.2 × 32.9 cm.). China, Southern Sung Dynasty. Purchase, John L. Severance Fund. Ex coll: Hisamatsu, Yamashita, and Hara.

7. CMA 58.427–.428 *Dragon and Tiger*. Pair of hanging scrolls, ink on silk, 48¾ × 22 inches each (123.7 × 55.8 cm.). Attr. to Mu Ch'i, Chinese, Sung Dynasty. Purchase from the J. H. Wade Fund. Ex coll: Ashikaga Yoshimitsu; Tokugawa Iemitsu; Viscount Sakai, Tokyo. Publ: Catalog of the Sakai Collection; J. Cahill, *The Art of Southern Sung China* (New York, 1962), cat. no. 3B. [Cahill expresses guarded doubts about the attribution]; S. Lee, "Contrasts in Chinese and Japanese Art," *Journal of Aesthetics and Art Criticism*, 21 (Fall 1962), p. 5, fig. 6.

8. Fontein and Hickman, p. 29.

9. Sirén, pl. 336–338.

10. CMA 72.41 *Bodhidharma Meditating Facing a Cliff*. Ink on silk 45¾ × 18¼ inches (116.2 × 46.3 cm.). China, late Sung Dynasty, late 13th century. Purchase, John L. Severance Fund. Ex coll: T. Inouye, K. Miura. Publ: B. Harada, *Pageant of Chinese Painting* (Tokyo, 1936), pl. 136; *Tōsō Gemmin Meiga Taikan*, 2 vols. (Tokyo, 1929), p. 75; Sirén, Vol. II, p. 89.

11. Fontein and Hickman, pp. 130–136.

12. CMA 67.211 *The Second Coming of the Fifth Patriarch*. Ink on paper, 12⅞ × 17⁹⁄₁₆ inches (32.7 × 45.5 cm.). Yin-t'o-lo, Chinese, active ca. mid-14th century. Purchase from the J. H. Wade Fund. Ex coll: Masuda. Publ: S. Lee and W. K. Ho, *Chinese Art Under the Mongols* (Cleveland, 1968), pl. 208. The painting is damaged and retouched above on the upper willow leaves and to the left, down the left one-fourth to one-third of the tree trunk. The damaged seal of the artist at lower left reads (as reconstructed from the same seal on another part of the dismembered scroll in the Seikado

208

Foundation, Tokyo): "People say in the Immortal's grottos the peach blossoms are blooming in the warmth of spring. I wonder if such flowering branches ever exist in our world."

13. a. *The Monk from Tan-hsia Burning a Wooden Image of the Buddha*, K. Ishibashi Collection, Tokyo; see Fontein and Hickman, p. 37.

b. *The Priest Yao-chan Speaking to Li Ao*. Ex coll: Kuroda.

c. *Han-shan and Shih-te*. Asano Collection.

d. *Pu-tai and Devotee*. Nezu Collection.

e. *Kuei-tsung and Chang Chieh*. Seikado Foundation.

All the paintings, including the Cleveland one, have a poem and a seal by Ch'u-shih Fan-ch'i (1297–1371). The Japanese-owned works are reproduced in K. Suzuki, "Shin Kokuho Indara no Zenkizukan," *Museum*, 35 (February 1954), pp. 12–14; and in *Kokuho (National Treasures of Japan)* (Tokyo: Mainichi Shimbunsha, 1963–) v, Part I, pl. 27–30; only four of the five paintings in Japan are reproduced in this latter publication.

14. CMA 64.44 *Bodhidharma Crossing the Yangtze on a Reed*. Ink on paper, 35⅛ × 12¼ inches (89.2 × 31.1 cm.). China, Yuan Dynasty. John L. Severance Fund. Publ: S. Lee, *Tea Taste in Japanese Art* (New York, 1963), cat. no. 3; Lee and Ho, *Chinese Art Under the Mongols*, pl. 209.

15. CMA 53.246 *Bamboo in the Wind*. Ink on silk, 30 × 17⅝ inches (76.2 × 45.6 cm.). Signed Hsüeh Ch'uang, with two seals bearing same legend. P'u Ming (Hsüeh Ch'uang), active 14th century, Chinese, Yüan Dynasty. John L. Severance Fund. Publ: B. Harada, p. 397; *CMA Bulletin*, 43 (February 1956), pp. 22–24; *Kokka*, No. 424 (March 1926), pl. 5; Sirén, VII, p. 129; *Arte Cinese* (Venice, 1954), cat. no. 788; Lee, *Tea Taste in Japanese Art*, cat. no. 6; Lee and Ho, *Chinese Art Under the Mongols*, pl. 244.

16. See the entry in Lee and Ho, cat. no. 235.

17. CMA 70.67 *Portrait of Hōtō Kokushi (Priest Kakushin)*. Wood with remains of a lacquer (?) coating, H. 36 inches (91.4 cm.). Japan, datable to Kamakura Period, ca. 1286. Purchase, Leonard C. Hanna Jr. Bequest. Publ: O. Kurata, *Kumano* (Tokyo, 1968), p. 60. The illustration there shows the sculpture *in situ* before restoration of the hole obliterating the right eye of the figure. The restoration is wood-paste and approximates the appearance of the original. Two other life portraits of Kakushin are known: one dated 1275 (Ankoku-ji, Tomo, Hiroshima prefecture), and one dated 1286 (Kokoku-ji, Yura, Wakayama prefecture).

The Cleveland portrait comes from a location near the latter example. The faces of the two portraits from Wakayama prefecture are clearly similar, and so the Cleveland example must represent the priest at about the same age—probably at the specific age of eighty when a second "portrait of longevity" might have been set up in Myoshin-ji. Stylistically, the two works are comparable and confirm a date of about 1286 for the sculpture acquired by this Museum. The Museum also acquired from another source the sculptured portrait of Kakushin's mother (CMA 70.68 *Portrait of the Mother of Hōtō Kokushi {Priest Kakushin}*. H. 23¾ inches [63 cm.]. Purchase, Edward L. Whittemore Fund), some 100 to 150 years later in date, if style is a criterion. While a minor work, it is fitting that it be reunited with its companion from Myoshin-ji.

18. Sirén, pls. 209–210.

19. S. Lee, "A White-Robed Kannon from Kozan-ji," *CMA Bulletin*, 39 (December 1952), pp. 235–237.

20. W. K. Ho, "Kao—Myth and Speculations," *CMA Bulletin*, 50 (April 1963), p. 46, fig. 11. It should be noted that there is at least one copy of this painting in Japan, sometimes, but ineffectually, attributed to Mu Ch'i (see Arakawa, pl. 12). The attribution to the Chinese painter is quite unfounded; at best it is a middle-to-late Ashikaga work by a rank amateur—Zen or not.

21. See, for example, the extraordinarily wide range of competence, or lack of it, in the quite acceptably genuine paintings reproduced in T. Matsushita, *Suiboku Painting of the Muromachi Period* (Tokyo, 1960).

22. CMA 70.75 *Plum Blossom*. Ink on paper, 40¾ × 14¾ inches (103.5 × 37.4 cm.). Japan, Nambokucho Period, 14th century. Purchase, John L. Severance Fund. One seal, tentatively reads "Baishû." The identification of the artist is now being pursued.

23. See my *History of Far Eastern Art* (New York, 1964), colorplate 53, as well as the article "Contrasts in Chinese and Japanese Art" for a more extensive discussion of the decorative tendencies of such Japanese painting.

24. Matsushita, no. 87; a work by Chuan Shinko, ca. 1450. The earliest known and documented ink paintings of plum blossoms are the pair datable before 1297, with poems written by Hakuun Egyō. See *Nippon No Bijutsu*, fig. 23.

25. Fontein and Hickman, no. 38, by Kyūshū Kyōkyaku, late 14th century.

26. CMA 72.15 *Rock, Bamboo, and Orchids*. Ink on paper, 39⅛ × 12¾ inches (79.2 × 32.7 cm.). Bompō,

1348–ca. 1420, Japanese, Muromachi Period. Purchase, John L. Severance Fund. The painting has been somewhat reduced in size in various remountings. At least two inches on the left and perhaps a little less on the right is now lost. It is previously unknown and unpublished. The most complete information in a Western language on Bompō is in Fontein and Hickman, p. 97.

27. S. Lee, "Winter and Spring by Shūbun," *CMA Bulletin*, 46 (October 1959), pp. 173–180; S. Lee, "Shin and Sō," *CMA Bulletin*, 43 (June 1956), part one, pp. 115–18.

28. CMA 63.262 *Eight Views in the Region of Hsiao-Hsiang*. A section from the original twenty panels in Daisen-in, Kyōto, dated ca. 1509. Ink on paper, 50⅝ × 44 inches (129 × 111.7 cm.). Sōami, Japanese, Muromachi Period. John L. Severance Fund. Ex coll: Matsudaira. Publ: *Nihonga Taisei*, III (Tokyo, 1931–34), pl. 60; *Kokka*, VI, no. 64. pl. 1; S. Shimada, *Japanese Paintings in Western Collections* (Tokyo, 1969), Vol. II, pl. 1, p. 122, and Vol. II, p. 2, pl. 99. Halfway up the left side an old repair marks the original location of the metal handle for the sliding panel. Like some of the other paintings from the same series remounted as hanging scrolls, the scene was cut at the bottom. Other paintings from the ensemble are reproduced in *Kokka*, fol. 17, no. 199, and in *Nihonga Taisei*.

29. There is a pair of sixfold screens in The Metropolitan Museum of Art attributed to Sōami, clearly showing his style. See Miyeko Murase, *Japanese Screens from New York Collections*, p. 46.

30. Sirén, III, pls. 340, 341, 346, 347, 348, 349; all works listed in Shōgun Yoshimasa's catalog.

31. Quoted from P. Yarnpolsky, *The Zen Master Hakuin: Selected Writings* (New York, 1972), in *The Times Literary Supplement* (24 March 1972), p. 342.

32. Merton, p. 77.

Early Ming Painting at the Imperial Court

1. H. Vanderstappen, "Painters at the Early Ming Court (1368–1435) and the Problem of a Ming Painting Academy," *Monumenta Serica*, XV, Fasc. 2, pp. 259–302; XVI, Fasc. 1 and 2, 1957, pp. 315–346. Since this article was finished, S. Wilkinson has published "The Role of Seeing in the Development of Ming Painting; and the Relation of the Che, Wu and Professional Schools," *Oriental Art*, U. of K., n.s. (Summer, 1975), pp. 126–135. Now there are twice as many articles as before! Wilkinson is particularly interesting in connecting Wu and Che schools and in confirming the more communal or public character of the court painting en-

vironment.

2. S. Hashimoto, *Hashimoto Shūzū Min-Shin-ga Mokuroku* (Tokyo, 1972), no. 2.

3. Vanderstappen.

4. See S. Lee and W. Ho, *Chinese Art Under the Mongols: The Yüan Dynasty (1279–1368)* (Cleveland, 1968), no. 262.

5. Ibid., nos. 264–265.

6. Vanderstappen, p. 299.

7. O. Sirén, *Chinese Painting: Leading Masters and Principles* (London, 1958), Pt. 2, VII, (Annotated Lists of Paintings and Reproductions of Paintings by Chinese Artists).

8. CMA 73.72 *Landscape in Blue and Green Style*. Handscroll, ink and color on silk, 25.5 × 70.2 cm. China, Ming Dynasty. Purchase, John L. Severance Fund. Ex collection: A. W. Bahr. The related handscroll is *Searching for Flowers*, signed and dated 1469, colophon by Wu K'uan. Published: *Kyuka Inshitsu Kanso Guroku* (Kyoto, 1920), pl. 4; then in the Hashimoto Collection, S. Hashimoto, 32.7 × 122 cm.

9. Hsiao's art is represented by two major works in the museum collection: CMA 54.262 *Pure Tones of the Hills and Waters*. Handscroll, ink and color on paper, dated 1664, 12⅛ × 307¾ inches. China, Ch'ing Dynasty. Purchase, John L. Severance Fund. Also, CMA 55.302a-g. *Album of Seasonal Landscapes*. Ink and color on paper, dated 1668, 8¼ × 6³⁄₁₆ inches each leaf. China, Ch'ing Dynasty. Purchase, John L. Severance Fund. Each of them employs a coloristic approach characteristic of the seventeenth century but with an awareness of such T'ang style works as that by Shih Jui. The two later colophons on the Cleveland scroll also ascribe the work to Li. A. W. Bahr considered the work to be Sung, as unlikely an attribution as T'ang—an error from the heart, for the quality and mood of the painting are worthy of its earlier prototypes.

10. The difference in size of the two reproductions (see fn. 8) of *Searching for Flowers*, the one of 1920, the other of 1972, gives some idea of the constricting consequences of remounting.

11. J. Cahill, *Chinese Painting* (Switzerland: Skira, 1960), pp. 102–103.

12. *Chinese Art Treasures* (catalog of an exhibition from the Government of the Republic of China, Washington, D.C., 1961–1962), no. 30. The catalog notes the uncertainty of the date inscribed on the painting.

13. *Kokka*, XX, no. 230, pl. 2.

14. *Chu Mai'chen Carrying Faggots and Studying*, ex collection: Shimomura, Kyoto, reproduced in S. Ta-

jima, *Selected Relics of Japanese Art* (Kyoto, 1903), *Ning Ch'i Riding a Buffalo* and *I Kuan Ploughing*, reproduced in *Kokka*, XXIV, no. 283, pl. 2 and 3. Each of the three paintings has two seals of the artist—Ch'en-t'ang (a reference to his home in Chekiang) and I-Ming Shih (his family name). The two paintings shown in Kokka each have four near contemporary inscriptions, while the Shimomura work has none. They are certainly members of the same set however.

Another work in a somewhat similar manner, but on paper, is reproduced in Chang Ta-chien, *Ta Feng T'ang* (catalog, Kyoto, 1955–1956), I, pl. 26, *Tartar Shepherds in Autumn*. A just comment on this painting, however, cannot be made from the reproduction. If it is by Shih Jui, then it shows him using the fine and even line style of Li Kung-lin for the figures.

15. Vanderstappen, p. 333.

16. E. J. Laing, *Chinese Paintings in Chinese Publications* (1956–1968) (Ann Arbor, 1969), p. 190.

17. Vanderstappen, p. 300.

18. Both illustrated in Sirén, VI, pls. 149 and 150 for the ink and color scroll; pl. 151 for the ink scroll *Breaking Waves and Autumn Winds*.

19. CMA 74.45 *The Hermit Hsü Yu Resting by a Stream*. Hanging scroll, ink on silk, 54¼ × 29¾ inches. China, Ming Dynasty. Purchase, John L. Severance Fund. Published: *CMA Bulletin* (March 1975), no. 163.

20. See Lee and Ho, *Chinese Art Under the Mongols* (Cleveland, 1968), p. 90. I am particularly indebted to Wai-kam Ho for his assistance on this point. See also F. W. Mote, "Confucian Eremitism in the Yüan Period" in A. Wright, ed., *The Confucian Persuasion* (Stanford, 1960), for later applications of the principles of eremitism and service.

21. See for example in our own collection CMA 53.246 *Bamboo in the Wind* by P'u Ming, mid-fourteenth century, S. Lee, *The Colors of Ink* (New York, 1974), no. 16; or Ts'ui Po, *A Tall Bamboo in Strong Wind*, Palace Collection, Taiwan, Sirén, III, pl. 213.

22. *Rainstorm Representing "Summer,"* Kuonji, Yamashiro, Northern Sung (?), Sirén, III, pl. 243; and "Hsia Kuei," *Rainstorm Over a Pavilion Among Trees on a River Bank*, ex Kawasaki Collection, pl. 301r.

23. Mu Ch'i, *Night Rain Over Hsiao-Hsiang*, ex collection Masuda, ibid., pl. 341.

24. Tai Chin, *Boat Returning in a Storm*, signed and sealed, ink and some color on silk, Palace Collection, Taiwan.

25. See a work by Wu I-hsien, *Men in a Boat in a Violent Rainstorm*, Berlin (Sirén, VI, pl. 157) which uses the same straight diagonals of wind-blown rain to better effect.

26. CMA 70.76 *River Village in a Rainstorm*. Ink and slight color on silk, 66⅝ × 40¾ inches. Lü Wen-ying, Chinese, late 15th century. Purchase, John L. Severance Fund.

27. See *Kokka*, XLII, no. 505, pl. 7 (This picture is now owned by the Cultural Properties Commission of Japan); and IV, no. 47, pl. 5 (present whereabouts unknown).

28. CMA 63.582 *The Knick-Knack Peddler*. Album leaf, dated 1212, ink and slight color on silk, 9½ × 10¼ inches. Li Sung, Chinese, Southern Sung Dynasty. Purchase, Andrew R. and Martha Holden Jennings Fund.

29. S. E. Lee, *Chinese Landscape Painting* (Cleveland, 1962), pl. 54a.

30. *Illustrated Catalogue of Chinese Government Exhibits for the International Exhibition of Chinese Art in London* (Nanking, 1935), III, no. 38.

31. A. Soper, *Kuo Jo-hsü's Experiences in Painting (T'u-Hua Chien-Wen Chih)* (Washington, D.C., 1951), p. 147, fn. 350.

32. *Chinese Art Treasures*, no. 16.

33. Cahill, p. 117 (detail only). The Three Friends (pine, prunus, and bamboo) were a favorite scholarly subject; here the birds and color dominate. The whole painting can be glimpsed in a poor reproduction in *Chung-Kuo Li-Tai-Ming-Hua-Chi* (Chinese Paintings of All Periods from the Collection of the Palace Museum) (Peking, 1964), IV (Ming Dynasty), pl. 5.

34. CMA 67.249 *Bird on a Prunus Branch*. Album leaf, ink on silk, 9⁹⁄₁₆ × 8¼ inches. Chinese, inscribed: "Painted by Pien Chingchao of Lung Hsi, painter-in-attendance of Wu-ying-tien." Two seals of the artist (I-ch'ing-tung-chih; Pien Wen-chin Shih). Gift of Dr. and Mrs. Sherman E. Lee. Published: *The Colors of Ink*, no. 25.

35. CMA 74.31 *Hundred Birds Admiring the Peacocks*. Ink and color on silk, 92½ × 75 inches. Yin Hung, Chinese, Ming Dynasty. Purchase, J. H. Wade Fund. Ex collection Satake, Tokyo (sale catalog, Tokyo Art Club, November 3–5, 1917, no. 46). Signed Yin Hung; sealed Chin Ta Shih Chia.

36. *Flowers and Birds*, 66 × 40 inches, in J. D. Chen, *Chinese Paintings from the King Kwei Collection (Chen-Kuei Ts'ang-hua-chi)* (Kyoto, 1956), pl. 29. Signed Yin Hung, like the Cleveland painting and with the same seal, Chin Ta Shih Chia. See J. D. Chen,

Notes and Comments on the Paintings of the King Kwei Collection (Chen-Kuei Ts'ang Hua Ping Shih) (Hong Kong, 1956), II, p. 125.

37. See Y. Yonezawa, *Painting in the Ming Dynasty* (Tokyo, 1956), p. 10.

38. There is one other work that seems to have some relationship to the Cleveland Yin Hung, the anonymous work reproduced (rather badly) in *Chung-Kuo Li Tai . . .* , pl. 160. It seems to stand somewhere between the painting in the Chen collection and the one here. The brushwork in the willow tree and the use of a background stream to produce recession in the middle ground point to the Cleveland scroll.

39. The birds are tentatively identified here: peacocks or peafowl (2), blacknaped oriole (2), grayheaded bullfinch (1), yellow billed grosbeak (2), Lidth's jay (1?), hoopoe (2), great spotted woodpecker (1), silver pheasant (2), scarlet finch (1), golden-fronted (or orange-bellied) leaf bird (2), flycatcher (?) (2), white wagtail (2), Korean magpie (2), house swallow (1), and black magpie (2).

List of Illustrations

Sherman E. Lee: A Bibliography 1941–1982

1941

"A Critical Survey of American Watercolor Painting" (Ph.D. thesis), Cleveland, Western Reserve University, 15 May 1941.

"Two Chinese Ceramics: Hill Censer, Han Dynasty, and Ting Ware Bowl, Sung Dynasty," *Detroit Institute of Arts Bulletin*, 21 (November 1941), pp. 14–15.

1942

"Bronze Image of Visnu," *Detroit Institute of Arts Bulletin*, 20 (December 1942), pp. 20–22.

"Buddhist Art," *Pictures on Exhibit*, 6 (October 1942), pp. 10–11.

Exhibition catalog *Buddhist Art*, Detroit, The Detroit Institute of Arts, 1942.

"East Indian Bronzes," *Detroit Institute of Arts Bulletin*, 21 (January 1942), pp. 27–31.

"East Indian Painting," *Pictures on Exhibit*, 5 (March 1942), pp. 12–13.

"Illustrative and Landscape Watercolors of Charles Demuth," *Art Quarterly*, 5, no. 2 (1942), pp. 158–176.

"Kleijkamp Collection of Chinese Bronzes and Pottery Shown at The Detroit Institute," *Pictures on Exhibit*, 5 (June 1942), pp. 10–11.

"Manuscript and a Bronze from Nepal," *Detroit Institute of Arts Bulletin*, 21 (May 1942), pp. 65–70; [Abstract] *American Journal of Archaeology*, 47 (April 1943), p. 244.

"Meaning of Buddhist Art," *Art News*, 41 (15–31 October 1942), pp. 20–21, 28–29.

"Philadelphia Padmapani," *Art Quarterly*, 5, no. 1 (1942), p. 110.

1943

"Cambodian Bronze Garuda," *Detroit Institute of Arts Bulletin*, 23 (November 1943), pp. 12–14; *Art Quarterly*, 6, no. 3 (1943), pp. 230–231, 233–234.

"Cambodian Bronze Hoard," *Art in America*, 31 (April 1943), pp. 78–83; [Abstract] *American Journal of Archaeology*, 47 (July 1943), p. 353.

"Jaina Relief from Khajuraho," *Detroit Institute of Arts Bulletin*, 22 (May 1943), pp. 76–78.

"Ming Scroll by Kuo Hsü," *Detroit Institute of Arts Bulletin*, 22 (January 1943), pp. 28–32.

1946

"Daniel's Dream: a Significant Misnomer," *Art Quarterly*, 9, no. 3 (1946), pp. 257–260.

"Pair of Bronze Ornaments in the Form of Tiger and Antelope," *Detroit Institute of Arts Bulletin*, 25, no. 3 (1946), pp. 61–62.

1947

"Gupta Relief of Gautama Buddha," *Detroit Institute of Arts Bulletin*, 26, no. 1 (1947), pp. 14–16.

"Los Urthona and Blake's Illustrations to Dante," in *Art and Thought*, London, Luzac & Co. Ltd., 1947, pp. 151–157.

"Six of Five Hundred Rakan," *Art Quarterly*, 10, no. 2 (1947), pp. 124–132.

1948

"Occupied Japan: First Report," *Art News*, 46 (February 1948), pp. 18–19, 52–53; [Correction] *Art News*, 47 (June 1948), p. 61.

"Story of Chinese Painting," *Art Quarterly*, 11, no. 1 (1948), pp. 9–31.

"Sung Ceramics in the Light of Recent Japanese Research," *Artibus Asiae*, 11, no. 3 (1948), pp. 164–175.

1949

"An Early Pala Ivory," *Journal of the Indian Society of Oriental Art*, 17 (1949), pp. 1–5.

"Five Early Gilt Bronzes," *Artibus Asiae*, 12, no. 1 (1949), pp. 4–22.

"Japanese Art at Seattle," *Oriental Art*, 2 (1949–50), pp. 89–98.

"Kushan Yakshi Bracket," *Artibus Asiae*, 12, no. 3 (1949), pp. 184–188.

"A Probable Sung Buffalo Painting," *Artibus Asiae*, 12, no. 4 (1949), pp. 292–301.

"Seven Early Japanese Paintings," *Art Quarterly*, 12, no. 4 (1949), pp. 309–324.

"Two Medieval Ivories in the Seattle Art Museum," *Art Quarterly*, 12, no. 2 (1949), pp. 191–193.

1950

"Two Baroque Bronzes in the Seattle Art Museum,"

216

Art Quarterly, 13 (1950), pp. 260–261.

1951

"A Bozzetto Attributed to Bernini," *Art Quarterly*, 14 (1951), pp. 67–71.

"Japanese Monochrome Painting at Seattle," *Artibus Asiae*, 14, nos. 1–2 (1951), pp. 43–61.

1952

Introduction to *Italian Art, Samuel H. Kress Collection*, Seattle Art Museum, 1952, pp. 4–10.

"A White-Robed Kannon from Kozan-ji," *CMA Bulletin*, 39 (December 1952), pp. 235–237.

1953

"Creative Art of Japan," *Chicago Art Institute Quarterly*, 47, no. 3 (September 1953), pp. 42–56.

"An Etruscan Mirror with Eos and Memnon," *CMA Bulletin*, 40 (February 1953), pp. 32–34.

"One of the Ten Fast Bulls," *CMA Bulletin*, 40 (November 1953), pp. 199–200.

"Poet Taira-No-Kanemori," *CMA Bulletin*, 40 (January 1953), pp. 7–9.

"A Rajput Miniature from Basohli," *CMA Bulletin*, 40 (March 1953), pp. 50–51.

"A Roman Imperial Portrait of Lucius Verus," *CMA Bulletin*, 40 (March 1953), pp. 47–50.

"Royal Portrait of Amenhotep III," *CMA Bulletin*, 40 (October 1953), pp. 179–182.

"Sōtatsu and the Tale of Isé," *CMA Bulletin*, 40 (April 1953), pp. 62–64.

"Two Early Chinese Ivories," *Artibus Asiae*, 16, no. 4 (1953), pp. 257–264.

1954

"Chinese Carved Jades," *CMA Bulletin*, 41 (April 1954), pp. 67–68.

"Chinese Landscape Painting," *CMA Bulletin*, 41 (November 1954), pp. 199–201.

Exhibition catalog, *Chinese Landscape Painting*, Cleveland, The Cleveland Museum of Art, 1954.

"Cleveland Kouros," *CMA Bulletin*, 41 (March 1954), pp. 43–46.

"A Cup by Douris," *American Journal of Archaeology*, 58 (July 1954), p. 230.

"Greek Bronze for British Museum," *Museum Journal*, 54 (1954–55), p. 247.

"Greek Youth in Cleveland," *Archaeology*, 7 (1954), p. 252.

"Kumano Mandala," *CMA Bulletin*, 41 (June 1954), pp. 116–118.

"More Early Chinese Jades," *CMA Bulletin*, 41 (December 1954), pp. 215–217.

"'Rocks, Orchids, and Bamboo' by Shih-T'ao," *CMA Bulletin*, 41 (January 1954), pp. 8–14.

"The Shêng Player: a T'ang Wine Pitcher," *Far Eastern Ceramic Bulletin*, 6, no. 3 (1954), pp. 6–11.

"Some Little-Known Indian Bronzes," *Art Quarterly*, 17, no. 1 (1954), pp. 16–29.

1955

Review of Robert T. Paine and Alexander Soper, *The Art and Architecture of Japan*, Far Eastern Quarterly, 15 (1955–56), pp. 417–420.

Review of Benjamin Rowland, *Art in East and West*, College Art Journal, 15 (1955–56), pp. 68–69.

"Early Ming Blue and White Porcelains," *CMA Bulletin*, 42 (February 1955), pp. 27–31.

"An Etruscan Dancing Maenad," *CMA Bulletin*, 42 (October 1955), pp. 186–188.

"The Golden Image of the New-Born Buddha," *Artibus Asiae*, 18, no. 3 (1955), pp. 224–237.

"A Heavenly Musician from Horyu-ji," *CMA Bulletin*, 42 (November 1955), pp. 199–201.

"Irises by Watanabe Shikō," *CMA Bulletin*, 42 (April 1955), pp. 63–67.

"Japanese Wood Sculpture of the Kamakura Period," *CMA Bulletin*, 42 (March 1955), pp. 45–48.

"Roshu's Utsunoyama: The Pass Through the Mountains," *CMA Bulletin*, 42 (December 1955), pp. 219–221.

Streams and Mountains Without End; a Northern Sung Handscroll and Its Significance in the History of Early Chinese Painting [with Wen Fong], Ascona, *Artibus Asiae*, 1955.

1956

"'A Bamboo in the Wind' by P'u Ming," *CMA Bulletin*, 43 (February 1956), pp. 22–24.

"A Bronze Yaksha Image and Its Significance," *Royal Ontario Museum of Art and Archaeology Bulletin*, no. 24 (1956), pp. 23–25.

"Celadon Tradition," *CMA Bulletin*, 43 (March 1956), pp. 46–52.

"A Chinese Lacquer Sculpture," *CMA Bulletin*, 43 (January 1956), pp. 6–9.

"An Early Javanese Bronze, the Gupta International Style and Clay Technique," *Artibus Asiae*, 19, no. 3 (1956), pp. 271–278; [Condensed in] *CMA Bulletin*, 44 (December 1957), pp. 217–222.

"The Embracing Crescent-Crested Lord," *CMA Bulletin*, 43 (October 1956), pp. 179–182.

"The New-Born Buddha," *CMA Bulletin*, 43 (November 1956), pp. 203–204.

"Shin and Sō," *CMA Bulletin*, 43 (June 1956), pp. 115–118.

1957

"An Album of Landscapes by Hsiao Yün-Ts'ung," *CMA Bulletin*, 44 (June 1957), pp. 121–125.

"Chinese Domestic Furniture," *CMA Bulletin*, 44 (March 1957), pp. 48–53.

"The Decorative and the Super-Real: Two Rajasthani Miniatures," *CMA Bulletin*, 44 (October 1957), pp. 180–183.

"An Early Javanese Bronze," *CMA Bulletin*, 44 (December 1957), pp. 217–222.

"Hand and an Image of Wood," *CMA Bulletin*, 44 (January 1957), pp. 1–9.

"Raigō: Descent of the Buddha of the West," *CMA Bulletin*, 44 (April 1957), pp. 57–63.

"Some Problems in Ming and Ch'ing Landscape Painting," *Ars Orientalis*, 2 (1957), pp. 471–485.

"Two Basement Excavations, a Twelfth Century Bargain, and a Gift," *Far Eastern Ceramic Quarterly*, no. 37 (1957), pp. 41–43.

1958

Review of Arthur Waley, *An Introduction to the Study of Chinese Painting*, *Journal of Aesthetics*, 16 (1958–59), pp. 390–391.

"Fortieth May Show: With Catalog," *CMA Bulletin*, 45 (May 1958), pp. 114–151.

"The Haven of T'ao Yüan-Ming," *CMA Bulletin*, 45 (November 1958), pp. 211–214.

Foreword to exhibition catalog, *Some Contemporary Works of Art*, Cleveland, The Cleveland Museum of Art, 1958, p. 3–4.

"The Two Styles of Chu Ta," *CMA Bulletin*, 45 (November 1958), pp. 215–219.

1959

Review of *The Arts of the Ming Dynasty*, *Journal of the American Oriental Society*, 79, no. 3 (July–September 1959), p. 208.

Review of Bernard Groslier and Jacques Arthaud, *The Art and Civilization of Angkor*, *Archaeology*, 12, no. 4 (Winter 1959), pp. 291–292.

"Bronze from the Age of Pericles," *CMA Bulletin*, 46 (February 1959), pp. 17–24.

"A Colossal Eleven-Faced Kuan-Yin of the T'ang Dynasty [With Wai-Kam Ho], *Artibus Asiae*, 22, nos. 1–2 (1959), pp. 121–137; [Condensed in] *CMA Bulletin*, 47 (January 1960), pp. 3–6.

Exhibition catalog, *1000 Jahre Chinesische Malerei* [with Roger H. Goepper], Munich, Haus der Kunst, 1959.

"Forty-First May Show; With Catalog," *CMA Bulletin*, 46 (May 1959), pp. 71–102.

Review of (Lady David) Sheila David, *Illustrated Catalogue of Ch'ing Enameled Wares in the Percival David Foundation of Chinese Art*, *Far Eastern Ceramic Bulletin*, 11, no. 1 (June 1959), pp. 31–32.

Introduction to exhibition catalog, *Shiko Munakata*, Tokyo, Charles E. Tuttle, 1959, pp. 7–16.

"Winter and Spring by Shūbun," *CMA Bulletin*, 46 (October 1959), pp. 173–180.

1960

"Amenemhat III," *CMA Bulletin*, 47 (November 1960), pp. 205–211.

"Annual Report for 1959," *CMA Bulletin*, 47 (June 1960), pp. 110–117, 128–131.

A Colorslide Tour of The Cleveland Museum of Art . . . 32 Masterpieces of Painting Visited with Sherman E. Lee, Director (Colorslide Art Program, Panorama, a Service of Columbia Record Club) New York, Abrams, 1960.

"A Colossal Eleven-Faced Kuan-Yin of the T'ang Dynasty" [with Wai-Kam Ho], *CMA Bulletin*, 47 (January 1960), pp. 3–6.

Foreword to Edward B. Henning, *Paths of Abstract Art*, New York, Abrams, 1960, pp. ix–x.

Exhibition catalog, *1000 Jahre Chinesische Malerei* [with Roger H. Goepper], Munich, Franzis–Druck; Zürich, Neue Zurcher Zeitung, 1960.

"Forty-Second May Show," *CMA Bulletin*, 47 (May 1960), pp. 75–77.

Contribution to Kurt Galling, *Die Religion in Geschichte und Gegenwart, Handbuch für Theologie und Religionswissenschaft*, 3rd ed., Tübingen, n.p., 1960, v. 4.

"Notable Quotes" [with Albert Dorne], *American Artist*, 24 (October 1960), pp. 54, 59.

Exhibition catalog, *Rajput Painting*, Tokyo, C. Terry, 1960.

"Tiger and Dragon Screens by Sesson," *CMA Bulletin*, 47 (April 1960), pp. 64–69.

"Year in Review–1960," *CMA Bulletin*, 47 (December 1960), pp. 222–225.

1961

"Annual Report for 1960," *CMA Bulletin*, 48 (June 1961), pp. 107–111.

"Divine and the Terrible," *CMA Bulletin*, 48 (January 1961), pp. 5–9.

Review of James Cahill, *Chinese Painting*, *Journal of Aesthetics and Art Criticism*, 20 (Winter 1961), p. 211.

Review of Jane Gaston Mahler, *The Westerners Among the Figurines of the T'ang Dynasty of China*, *Archaeology*, 14, no. 4 (December 1961), p. 310.

Exhibition catalog, *Japanese Decorative Style*, Cleveland, The Cleveland Museum of Art, 1961.

"Jên Jên-Fa: Three Horses and Four Grooms" [With Wai-Kam Ho], *CMA Bulletin*, 48 (April 1961), pp. 66–71.

"Nikko, the Sun Bodhisattva," *CMA Bulletin*, 48 (December 1961), pp. 259–265.

"Year in Review, 1961," *CMA Bulletin*, 48 (November 1961), pp. 219–220.

1962

"Annual Report for 1961," *CMA Bulletin*, 49 (June 1962), pp. 115–119.

Chinese Landscape Painting, 2d rev. ed. Cleveland:

The Cleveland Museum of Art; distributed by Abrams, 1962.

"Contrasts in Chinese and Japanese Art," *Journal of Aesthetics and Art Criticism*, 21, (Fall 1962), pp. 3–12.

Review of Michael Sullivan, *The Birth of Landscape Painting*, *Journal of Aesthetics and Art Criticism*, 21 (1962–63), pp. 351–353.

"An Opportunity for Re-assessing Japanese Decorative Style," *Connoisseur*, 150 (August 1962), pp. 235–241.

"Secret Five," *CMA Bulletin*, 49 (September 1962), pp. 157–166.

"Year in Review, 1962," *CMA Bulletin*, 49 (November 1962), pp. 198–199.

"Yen Hui: 'The Lantern Night Excursion of Chung K'uei,'" *CMA Bulletin*, 49 (February 1962), pp. 36–42.

1963

"Annual Report for 1962," *CMA Bulletin*, 50 (June 1963), pp. 111–116, 128.

"Art Museum and Antiquity," *Apollo*, n.s. 78 (December 1963), pp. 435–446.

Review of *Chinese Calligraphy and Painting in the Collection of John M. Crawford, Jr.*, *Artibus Asiae*, 26 (1963), pp. 339–347.

"The Forty-Fifth May Show," *CMA Bulletin*, 50 (May 1963), pp. 82–83.

"Indian Miniatures from the Archer Collection," *Apollo*, n.s. 78 (October 1963), pp. 314–315.

Introduction to exhibition catalog, *Indian Miniatures from the Collection of Mildred and W. G. Archer*, London, Washington, D.C., Smithsonian Institution, 1963, pp. 7–9.

"Janus in Limbo: Yüan Dynasty, a Limbo for Students of Chinese Ceramics," *CMA Bulletin*, 50 (January 1963), pp. 2–6.

"Newly Discovered Tuti-Nama and the Continuity of the Indian Tradition of Manuscript Painting" [with Pramod Chandra], *Burlington Magazine*, 105 (December 1963), pp. 545–554.

Preface to exhibition catalog, *Style, Truth and the Portrait* by Rémy G. Saisselin, Cleveland, The Cleveland Museum of Art, 1963, pp. 3–4.

"Tea Taste in Japanese Art," *Arts*, 37 (April 1963),

pp. 62–65.

Exhibition catalog, *Tea Taste in Japanese Art*, New York, The Asia Society, 1963; New York, Arno Press, 1976 [Reprint].

"Year in Review for 1963," *CMA Bulletin*, 50 (December 1963), p. 263.

1964

Introduction to exhibition catalog, *Ancient Sculpture from India*, Cleveland, The Cleveland Museum of Art, 1964, pp. 11–22.

"Annual Report for 1963," *CMA Bulletin*, 51 (June 1964), pp. 127–133, 144.

Review of Douglas Barrett and Basil Gray, *Painting of India*, *Journal of Aesthetics and Art Criticism*, 22 (Spring 1964), 349.

"The Forty-Sixth May Show," *CMA Bulletin*, 51 (May 1964), pp. 98–99.

A History of Far Eastern Art, Englewood Cliffs, N.J., Prentice-Hall; New York, Abrams; London, Thames & Hudson, 1964, 1973, 1982.

Foreign language editions:
Elsevier, Amsterdam, 1965.
Dumont, Cologne, 1965.
Garzanti, Milan, 1965.
Editions Sequoia, Paris, 1966.
Izdovocki Zovad, Belgrade, 1968.

Review of Jon C. Covell, *Masterpieces of Japanese Screen Painting*, *Journal of Aesthetics and Art Criticism*, 22 (Spring 1964), p. 351.

"Mughal Art, Principally Painting, in New York," *Art International*, 8, no. 1 (15 February 1964), pp. 16–20.

"Scattered Pearls Beyond the Ocean," *CMA Bulletin*, 51 (February 1964), pp. 21–40.

1965

Review of Alain Daniélou, *Hindu Polytheism*, *Journal of Aesthetics and Art Criticism*, 24 (Winter 1965), pp. 325–326.

"Annual Report for 1964," *CMA Bulletin*, 52 (June 1965), pp. 141–142, 151–153.

Review of Mario Bussagli, *Painting of Central Asia*, *Journal of Aesthetics and Art Criticism*, 23 (Summer 1965),

pp. 508–510.

Introduction to exhibition catalog, *Master Bronzes of India*, Chicago, Art Institute of Chicago, 1965, pp. 8–11.

Review of Peter C. Swann, *Chinese Monumental Art*, *Journal of Aesthetics and Art Criticism*, 23 (Summer 1965), pp. 508–510.

"Year in Review," *CMA Bulletin*, 52 (November 1965), pp. 124–157.

1966

Foreword, "Cleveland's Fiftieth Anniversary" in Joseph Alsop, "Treasures of The Cleveland Museum of Art," *Art in America*, 54, no. 3 (May–June 1966), p. 20.

"Dialectics of Chinese Art," *Apollo*, n.s. 84 (August 1966), pp. 158–160.

"The Forest and the Trees in Chinese Painting," *National Palace Museum Quarterly* (Taipei, Taiwan), I., no. 2 (October 1966), pp. 1–14.

"Golden Anniversary Acquisitions," *CMA Bulletin*, 58 (September 1966), pp. 181–182.

"James J. Rorimer," *Metropolitan Museum of Art Bulletin*, n.s. 25, no. 1 (Summer 1966), pp. 43–45.

"Kleinkunst: Two Early Chinese Wood Sculptures," *Archives of Asian Art*, 20 (1966–67), pp. 66–69.

"Literati and Professionals: Four Ming Painters," *CMA Bulletin*, 53 (January 1966), pp. 1–25; [Condensed in] *Burlington Magazine*, 108 (May 1966), p. 254.

"The Literati Tradition in Chinese Painting," *Burlington Magazine*, 108 (May 1966), pp. 254–258.

"'Tuti Nama', Tales of a Parrot," *Art in America*, 54, no. 3 (May–June 1966), pp. 49–56.

1967

Foreword to Athena Tacha Spear, *Rodin Sculpture in The Cleveland Museum of Art*, Cleveland, The Cleveland Museum of Art, 1967, pp. v–vi.

"Clothed in the Sun: Buddha and a Surya from Kashmir," *CMA Bulletin*, 54 (February 1967), pp. 42–51.

"Rembrandt: Old Man Praying," *CMA Bulletin*, 54 (December 1967), pp. 295–301.

220

Introduction to *Selected Works: The Cleveland Museum of Art*, Cleveland, The Cleveland Museum of Art, 1967, pp. vii–x.

Streams and Mountains Without End; a Northern Sung Handscroll and its Significance in the History of Early Chinese Painting [with Wen Fong, 2d rev. ed.], Ascona, *Artibus Asiae*, 1967.

Introduction to William D. Wixom, *Treasures from Medieval France*, Cleveland, The Cleveland Museum of Art, 1967, pp. xi–xiii.

1968

Exhibition catalog, *Chinese Art Under the Mongols: The Yüan Dynasty, 1279–1368* [with Wai-Kam Ho], Cleveland, The Cleveland Museum of Art, 1968.

Encyclopedia of World Art, 15 vols., New York, McGraw-Hill, 1959–68.

> Hsia Kuei: VII, cols. 650–654;
> Liang K'ai: IX, cols. 239–244;
> Ma Yüan: IX, cols. 590–594;
> Mu Chi: X, cols. 371–374;
> Yen Li-pen: LIV, cols. 880–882.

"The Idea of an Art Museum," *Harper's Magazine*, 237 (September 1968), pp. 76–79.

1969

Exhibition catalog, *Ancient Cambodian Sculpture*, New York, Asia Society, 1969.

"Annual Report for 1968" [with Emery M. Norweb], *CMA Bulletin*, 56 (June 1969), pp. 209–247.

"Art Museum in Today's Society," *Art News*, 68 (April 1969), pp. 27, 64–68; *Bulletin of The Dayton Art Institute*, 27, no. 3 (March 1969), pp. 2–6.

"The Idea of an Art Museum," *The American Review*, 13, no. 3 (April 1969), pp. 56–61.

"Quality in Painting" in Louis Kronenberger, *Quality: Its Image in the Arts*, New York, Atheneum, 1969, pp. 115–145.

"Year in Review for 1968," *CMA Bulletin*, 56 (January 1969), pp. 3–4.

1970

Ancient Cambodian Sculpture, New York, Intercultural Arts Press, 1970.

"Annual Report for 1969" [with Emery M. Norweb],

CMA Bulletin, 57 (June 1970), pp. 163–165.

Exhibition catalog, *Asian Art: Selections from the Collection of Mr. and Mrs. John D. Rockefeller 3d*, New York, The Asia Society, 1970.

Asian Art: Selections from the Collection of Mr. and Mrs. John D. Rockefeller 3d, New York, Intercultural Arts Press, 1970.

"Financial Perspicacity in Art," *Art in America*, 58 (July 1970), pp. 14–15.

"Sōsetsu and Flowers," *CMA Bulletin*, 57 (November 1970), pp. 261–271.

"The Water and the Moon in Chinese and Modern Painting," *Art International*, 14, no. 1 (20 January 1970), pp. 47–59.

1971

Preface to exhibition catalog, *Caravaggio and His Followers*, Cleveland, The Cleveland Museum of Art, 1971. pp. v–vi.

"Fifty-Second May Show: May 5 Through June 13, Annual Exhibition of Artists and Craftsmen of the Western Reserve," *CMA Bulletin*, 58 (May 1971), pp. 130–131.

"Guido Reni: The Adoration of the Magi," *CMA Bulletin*, 58 (December 1971), pp. 278–289.

Introduction to exhibition catalog, *Florence and the Arts: Five Centuries of Patronage*, Cleveland, The Cleveland Museum of Art, 1971, p. 3.

"Opere Cinesi," in *Il Tesoro e il Museo*, Florence, Sansoni, 1971, pp. 101–128.

"Year in Review for 1970 with Catalogue of Acquisitions," *CMA Bulletin*, 58 (February 1971), pp. 21–72.

1972

"Annual Report for 1971, Oriental Art," *CMA Bulletin*, 59 (June 1972), pp. 147–149.

"The Art Museums as a Wilderness Area," *Museum News*, 51 (October 1972), pp. 11–12.

"Disposal of a Work of Art from a Museum's Collection," *College Art Journal*, 32 (Winter 1972–73), p. 209.

"Eye Object," *Art News*, 71 (November 1972), pp. 36–37.

Japanese Decorative Style, New York, Harper & Row, Icon editions, 1972.

"The Tombs and Prince Liu and Princess Tu," *Sunday Times (London)*, 10 September 1972, p. 61 ff.

"To See Big Within Small: Hsiao-Chung-Chien-Ta," *Burlington Magazine*, 114 (May 1972), pp. 314–322.

"Tutankhamun's Chinese Rivals," *New York Times Magazine*, 10 September 1972, p. 58 ff.

"Year in Review for 1971," *CMA Bulletin*, 59 (January 1972), pp. 2–39.

"Zen in Art: Art in Zen," *CMA Bulletin*, 59 (November 1972), pp. 237–259.

1973

"Annual Report for 1972," *CMA Bulletin*, 60 (June 1973), pp. 171–173.

"The Changing Taste for Chinese Ceramics," *Apollo*, 97 (March 1973), pp. 248–255.

"Some Japanese Tea Taste Ceramics," *CMA Bulletin*, 60 (November 1973), pp. 267–278.

Foreword to William G. Archer, *Indian Paintings from the Punjab Hills, a Survey and History of Pahari Miniature Painting*, London, New York, Sotheby Parke Bernet; Delhi, Oxford University Press, 1973, v. I, pp. xi–xii.

"Year in Review for 1972," *CMA Bulletin*, 60 (March 1973), pp. 63–65.

1974

American Assembly, *Report: Art Museums in America* (Prepared under the editorial supervision of Sherman E. Lee), New York, Columbia University, 1974.

Foreword to exhibition catalog, *Ancient Art: the Norbert Schimmel Collection*, Mainz, Verlag Philipp von Zabern, 1974, pp. 9–10.

"Annual Report for 1973," *CMA Bulletin*, 61 (June 1974), pp. 179–181.

The Colors of Ink; Chinese Paintings and Related Ceramics from The Cleveland Museum of Art [with James Robinson], New York, The Asia Society, 1974.

"William Mathewson Milliken on His 85th Year: Preface," *CMA Bulletin*, 61 (December 1974), pp. 318–320.

"Year in Review for 1973," *CMA Bulletin*, 61 (February 1974), pp. 31–32.

1975

"Annual Report for 1974," *CMA Bulletin*, 62 (June 1975), pp. 175–178.

Exhibition catalog, *Asian Art: Selections from the Collection of Mr. and Mrs. John D. Rockefeller 3rd*, Part II, New York, The Asia Society, 1975.

Introduction to *The Cleveland Museum of Art*, Hanover (Germany), Knorr & Hirth Verlag, 1975, pp. 5–6

"Early Ming Paintings at the Imperial Court," *CMA Bulletin*, 62 (October 1975), pp. 241–259.

Foreword to exhibition catalog, Gabriel P. Weisberg, *Traditions and Revisions: Themes from the History of Sculpture*, Cleveland, The Cleveland Museum of Art, 1975, p. vii.

Foreword to exhibition catalog, Hugh Honour, *The European Vision of America*, Cleveland, The Cleveland Museum of Art, 1975, pp. vii–ix.

"In Memoriam: Warren H. Corning, 1902–1975," *CMA Bulletin*, 62 (December 1975), p. 282.

Foreword to exhibition catalog, *Johann Liss*, Cleveland, The Cleveland Museum of Art, 1975, pp. 9–11.

"John D. Cooley: Originality, Scholarship, Persistence," *Art News*, 74 (January 1975), p. 75.

Preface to exhibition catalog, Mary Ann Goley, *Seventeenth-Century Dutch and Flemish Paintings from The Butkin Foundation on Permanent Loan to Cleveland State University*, Cleveland, The Butkin Foundation, 1975, pp. iii–iv.

"Noh: Masks and Robe," *CMA Bulletin*, 62 (February 1975), pp. 25–35.

Introduction to *On Understanding Art Museums*, Englewood Cliffs, N.J., Prentice-Hall Inc., 1975, pp. 1–4.

Preface to exhibition catalog, Richard E. Spear, *Caravaggio and His Followers*, rev. ed., New York, Harper & Row, Icon Editions, 1975, pp. v–vi.

Preface to exhibition catalog, Stanislaw Czuma, *Indian Art from the George P. Bickford Collection*, Cleveland, The Cleveland Museum of Art, 1975, p. v.

"Two Cheers for Irrelevance," in *Art Studies for an Editor: Twenty-Five Essays in Memory of Milton S. Fox*, New York, Abrams, 1975, pp. 187–190.

Foreword to exhibition catalog, William D. Wixom, *Renaissance Bronzes from Ohio Collections*, Cleveland, The

Cleveland Museum of Art, 1975, pp. vii–viii.

"Works of Art, Ideas of Art, and Museums of Art," in *On Understanding Art Museums* [with Edward B. Henning], Englewood Cliffs, N.J., Prentice-Hall Inc., 1975, pp. 5–33.

"Year in Review for 1974," *CMA Bulletin*, 62 (March 1975), pp. 62–104.

1976

Preface to exhibition catalog, *L'Amerique vue par l'Europe*, Paris, Éditions des Musées Nationaux, 1976, pp. ix–xi.

"Annual Report for 1975," *CMA Bulletin*, 63 (June 1976), pp. 155–160.

"Art Against Things," Sydney, the Art Association of Australia, 1976.

The Colors of Ink; Chinese Paintings and Related Ceramics from The Cleveland Museum of Art [with James Robinson], New York, Arno Press, 1976, [1974].

Introduction to exhibition catalog, *Japanese Screens from the Museum and Cleveland Collections*, Cleveland, The Cleveland Museum of Art, 1976, pp. 3–9.

Introduction to exhibition catalog, Pramod Chandra, *The Cleveland Tuti Nama Manuscript and the Origins of Mughal Painting*, Cleveland, The Cleveland Museum of Art, 1976, pp. 7–9.

Tea Taste in Japanese Art, New York, Arno Press, 1976.

Foreword to *Tuti Nama: Tales of a Parrot*, Graz (Austria), Akademische Druck-u. Verlagsanstalt, 1976, II, pp. 1–3.

"Year in Review for 1975," *CMA Bulletin*, 63 (February 1976), pp. 31–33.

Preface to exhibition catalog, *Zenbei Bijutsukan Shushu Sekai Meisaku Ten: Kodai Ejiputo Kara Gendai Made* (Masterpieces of World Art from American Museums: from Ancient Egyptian to Contemporary Art), Tokyo, National Museum of Western Art, 1976, pp. 12–13.

1977

American Appreciation of East Asian Art, Washington, D.C., United States Information Agency, 1977.

"Annual Report for 1976," *CMA Bulletin*, 64 (June 1977), pp. 155–158.

"Art Museums and Education," *Art International*, 21 (January 1977), pp. 48–51.

Foreword to exhibition catalog, *Fiberworks*, Cleveland, The Cleveland Museum of Art, 1977, p. 3.

"Japanese Art in the World," *Sun, Heibonsha*, Special Issue, no. 21 (Winter 1977), pp. 61–64.

Introduction to exhibition catalog, Jay Hoffman and others, *A Study in Regional Taste: the May Show, 1919–1975*, Cleveland, The Cleveland Museum of Art, 1977, p. 7.

Foreword to exhibition catalog, Marianne Doezema and June Hargrove, *The Public Monument and Its Audience*, Cleveland, The Cleveland Museum of Art, 1977, p. 5.

Foreword to exhibition catalog, Marjorie Williams, *In the Nature of Materials: Japanese Decorative Arts*, Cleveland, The Cleveland Museum of Art, 1977, p. vii.

Review of Pierre Cabanne, *Pablo Picasso*, *The New Republic*, 22 October 1977, pp. 32–33.

"Varieties in Portraiture in Chinese and Japanese Art," *CMA Bulletin*, 64 (April 1977), pp. 118–136.

"Year in Review for 1976," *CMA Bulletin*, 64 (February 1977), pp. 39–42.

1978

Foreword to exhibition catalog, *The Afro-American Tradition in Decorative Arts*, Cleveland, The Cleveland Museum of Art, 1978, pp. vii–viii.

"Annual Report for 1977," *CMA Bulletin*, 65 (June 1978), pp. 177–179.

"Art Museums and Education," in *The Art Museum as Educator: a Collection of Studies*, Berkeley, Los Angeles, London, University of California Press, 1978, pp. 21–26.

"The Characteristics of Japanese Art and Their Relevance Today," *Japan Foundation Newsletter*, 6, no. 4 (1978), pp. 5–9.

"Charles Demuth, American Watercolorist," in *Homage to Charles Demuth: Still Life Painter of Lancaster*, Marrickville, N.S.W., Science Press, 1978, pp. 47–62.

Introduction to David A. Bershtin, *Six Persimmons*, New York, The Scriptorium, 1978. p. 1.

Preface to exhibition catalog, Edmund P. Pillsbury and Louise S. Richards, *The Graphic Art of Federico Barocci: Selected Drawings and Prints*, Cleveland, The

Cleveland Museum of Art; New Haven, Yale University Art Gallery, 1978, p. 3.

"John D. Rockefeller 3rd," *Oriental Art*, 24, no. 4 (Winter 1978–79), p. 419.

"Life, Liberty and the Pursuit of . . . What?," *College Art Journal*, 37 (Summer 1978), pp. 322–326.

Foreword to Muhammed A. Simsar, *The Cleveland Museum of Art's Tuti-Nama: Tales of a Parrot by Ziya' u'd-din Nakhshabi*, Cleveland, The Cleveland Museum of Art; Graz (Austria), Akademische Druck-u. Verlagsanstalt, 1978, pp. 13–14.

"Year in Review for 1977," *CMA Bulletin*, 65 (January 1978), pp. 3–5.

1979

"Annual Report for 1978," *CMA Bulletin*, 66 (June 1979), pp. 187–190.

Janet G. Moore, *The Eastern Gate: an Invitation to the Arts of China and Japan*, Cleveland and New York, Collins, 1979, pp. 13–14.

Foreword to exhibition catalog, Pierre Rosenberg, *Chardin*, Cleveland, The Cleveland Museum of Art, 1979, pp. 5–7.

"River Village—Fisherman's Joy," *CMA Bulletin*, 66 (October 1979), pp. 271–288.

Foreword to exhibition catalog, *Sculpture from Notre-Dame, Paris: a Dramatic Discovery*, New York, Metropolitan Museum of Art, 1979, p. 5.

Foreword to exhibition catalog, *The Spirit of Surrealism*, Cleveland, The Cleveland Museum of Art, 1979, p. vi.

Foreword to exhibition catalog, *21 Contemporary Japanese Printmakers*, Cleveland, The Cleveland Museum of Art, 1979, p. 1.

"Year in Review for 1978," *CMA Bulletin*, 66 (January 1979), pp. 2–5, 47.

1980

"Annual Report for 1979," *CMA Bulletin*, 67 (June 1980), pp. 159–163.

"Art Against Things" (The First Franz Philipp Lecture in the History of Art, Sydney, 1976), *Australian Journal of Art*, 2 (1980), pp. 5–16.

Essay and catalog entries, *Eight Dynasties of Chinese Painting: the Collections of the Nelson Gallery-Atkins Museum, Kansas City, and The Cleveland Museum of Art* [with Wai-Kam Ho, Laurence Sickman, and Marc F. Wilson], Cleveland, The Cleveland Museum of Art, 1980, 35–46.

"5000 Years of Korean Art," *Korean Culture Magazine*, 1, no. 1 (Winter 1980), pp. 22–26.

"The Glories of Bronze Age China," *The New York Times*, 6 April 1980, Sec. 2, pp. 1, 31.

Review of Margaret Sterne, *The Passionate Eye: The Life of William R. Valentiner*, *ARLIS/NA Newsletter*, 9, no. 1 (1980), pp. 31–32.

"Year in Review for 1979," *CMA Bulletin*, 67 (March 1980), pp. 58–62, 99.

1981

"Annual Report for 1980," *CMA Bulletin*, 67 (July 1981), pp. 223–225.

Convocation Address on the Occasion of the Dedication of the Snite Museum of Art, Notre Dame, University of Notre Dame, [1981?]

The Genius of Japanese Design, New York, Kodansha International, 1981.

"In Memoriam: Hayward Kendall Kelly, 1897–1980," *CMA Bulletin*, 68, (February 1981), p. 63.

Catalog, *One Thousand Years of Japanese Art (650–1650) from The Cleveland Museum of Art* [with Michael R. Cunningham and Ursula Korneitchouck], New York, Japan Society, 1981.

"Year in Review for 1980," *CMA Bulletin*, 68 (June 1981), pp. 163–164, 219.

1982

"Annual Report for 1981," *CMA Bulletin*, 69 (June 1982), pp. 159–162.

"Arts d'Asie, le Goût Rockefeller," *Connaissance des Arts*, no. 360 (February 1982), pp. 62–69.

Introductory essay to exhibition catalog, Jenifer Neils, *The World of Ceramics*, Cleveland, The Cleveland Museum of Art, 1982, pp. vii–x.

"Poussin's Holy Family Feud," *Art News*, 81 (February 1982), pp. 78–82.

"Year in Review for 1981," *CMA Bulletin*, 69 (February 1982), pp. 38–41.